BASIC FUNDAMENTALS of MODERN TATTOO

by C.R. Jordan

BASIC FUNDAMENTALS of MODERN TATTOO

©2008-2011 Tattoo Books Online LLC
www.TattooBooksOnline.com

Tattoo Books Online
TBO Publishing
Post Office Box 1592
Avondale Arizona, 85323-1592

ISBN-10: 0-615-28147-8
ISBN-13: 978-0-615-28147-6

BASIC FUNDAMENTALS of MODERN TATTOO

Expressed Liability of Content

The author of this publication has taken as much effort as possible to provide correct factual information. Nothing in this text is considered official regulation or advice as far as state related tattoo or body modification legislation. This book is not to be utilized as a substitute for written legislation from any of the local laws that may apply to the reader.

The author is not responsible for the actions taken by the reader. The author stresses that the only way an individual can properly learn to tattoo is by completing an apprenticeship in conjunction with following country, state, and county requirements. IAW (In Accordance With) local laws and OSHA regulations you may not even be permitted to tattoo in your city or state. There is a serious risk that can occur any time that an individual comes in contact with bodily fluids from the client or the tattoo professional.

This book is meant to be an apprentice's guide in conjunction with formal classroom training, not a substitute for. The author of this publication has taken care to attempt to source all quoted materials. Most of the tattoo techniques described in this book are derived from a verbal heritage of many tattoo artists, and are considered to be common knowledge. The author of this text does not contend to hold intellectual property rights to any tattoo technique.
A lot of effort went into the composition of this text, and the author has expressed his consent for anyone who wishes to note specific sections of this text without written consent. Reproduction of this text in its entirety is prohibited without consent.

Copyright ©2009 by Tattoo Books Online LLC, Phoenix Arizona. All rights reserved. Printed in USA. Except as permitted under the Copyright Act of 1976, no part of this publication may be reproduced or distributed in any form or by any means, or stored in a database retrieval system, without written permission of the publisher.

WARNING
Please tattoo at your own risk in a professional studio or tattoo shop. The author of this text does not condone or promote tattooing at home. This publication is for educational purposes only. The author provides no warranty or guarantee for those who purchase or utilize this publication, and assumes no liability for the actions taken by following procedures in this book.

for Yolanda...

who lovingly forced me to print this book.

About the Author

Charles Jordan, has been tattooing since the year 2000. He is a member of Alliance of Tattoo Professionals, Arizona Artist's Guild, Association of Internet Professionals, National Tattoo Association, and the Veterans of Foreign Wars (after serving in Iraq with the US Army as a 25 year old Staff Sergeant). Charles is also a founding chair member of the Arizona Tattoo Guild.

He completed his apprenticeship in Wiesbaden Bierdstadt Germany under Sven Bohmer at BoJo Tattoo und Piercing. Charles has tattooed on three different continents, and prides himself in his sterile 100% disposable technique. He holds a degree in Graphic Design, and another in Information Science. His unique blend of IT background and artistic desire has led him in many directions over the years. From developing touch screen tattoo flash kiosks to organizing special publications for tattoo artists; Charles is constantly working toward some type of fusion of art and technology.

Currently, Charles is the Managing Editor of Arizona Tattoo Magazine and is licensed to tattoo in the state of Hawaii. He does not consider himself an "advanced tattoo artist" by any means, but he has found that the tattoo industry needs a "push" to maintain its integrity in these modern times. Charles has vowed to dedicate his life to the promotion of professionalism and ethics in the tattoo community, while advocating a strong working relationship between tattoo professionals and their local legislation. You can find him tattooing at various studios in Arizona and Hawaii.

www.TeachMeToTattoo.com

1. Welcome
 1.1. Introduction
 1.2. Purpose of the Book
 1.3. Goals that you should strive for
 1.4. History Of Tattoo

2. Sanitation
 2.1. Diseases / Infections
 2.2. Autoclave
 2.3. Disposables
 2.4. Chemical Sanitation
 2.5. Universal Precautions
 2.6. Barrier Control Devices
 2.7. Work Area Set-up
 2.8. Manufacturers / Distributors

3. The Machine
 3.1. History of the Machine
 3.2. Brands / Distributors
 3.3. Machine Parts
 3.3.1. Metals
 3.3.2. Frame
 3.3.3. Coils
 3.3.4. Front Spring
 3.3.5. Rear Spring
 3.3.6. Capacitor
 3.3.7. Armature Bars
 3.3.8. O Rings
 3.3.9. Contact Points
 3.4. Machine Build
 3.5. Machine Tuning

4. The power Supply
 4.1. Voltage Theory
 4.2. Amps
 4.3. Leads
 4.4. Clip Cord
 4.5. Brands / Distributors

5. The Needle
- 5.1. Needle Parts
- 5.2. Making Needles
 - 5.2.1. Round
 - 5.2.2. Mags
- 5.3. Pre Sterilized
- 5.4. Sterilization Process for Needles

6. The Pigment
- 6.1. Lining Inks
- 6.2. Mixing for Shading
 - 6.2.1. Grey Wash
 - 6.2.2. White on Black
- 6.3. Color Inks
 - 6.3.1. Color Theory
 - 6.3.2. Color Process (Old School)
 - 6.3.3. Color Process (Revisited)
- 6.4. Brands / Distributors

7. Stencils
- 7.1. Materials used
- 7.2. Stencil Application
- 7.3. Stencil repair / correction / re-use tips

8. Tattoo Process
- 8.1. Outlining
- 8.2. Shading

9. Aftercare
- 9.1. Bandaging
- 9.2. Healing durations
- 9.3. Healing Phases of the Skin

10. Tattoo Tips / Tricks

11. Shop Etiquette
- 11.1. Customer Care
- 11.2. Money
 - 11.2.1. Tipping

 11.3. State Laws
 11.4. Customer Comforts
 11.4.1. Body Position
 11.4.2. Ambience
 11.4.3. Atmosphere

12. Conclusion
 12.1. Closing Remarks
 12.2. Recommended Reading

13. Works Cited

1.1 Introduction

In the year 2000 I began my search for adequate materials that would provide not only comprehendible instruction, but also a dependable methodology that would work as a beginners guide to the art of tattoo. I have found a lot of texts that make the claim of being the "ultimate bible for tattoo beginners", but it always seems to be the same story over and over. I found that the most basic information was always 'dummied' down to a point of leaving the reader feeling stupid. On the other hand, the more advanced books lacked the detail that one would need to figure out what the heck the author is trying to show or say…again leaving the reader feeling stupid.

The 17 year old "me" was in love with the art and hungry for knowledge. He scoured the internet forums for weeks and months and years. He saved up and shelled out hundreds of dollars for VHS tapes and books and tools and anything else he could find. The 17 year old me used every extra dollar he made working crappy jobs just to get tattoos in spots where he could watch the artist and ask questions, because this seemed to be the only way to get face time with these 'gods'.

Nine years ago I ended up getting that tattoo "kit" from a well known magazine ad company, and you know what? I don't regret it for a moment. I have heard, read, and seen so many posts on forums that go something like: "WHAT!!! You got a kit? OMG! You newbie – go get an apprenticeship or give up, and by the way, they are MACHINES not GUNS!!!"

Wow, I would think; and still do…Wow. I mean, what other industry out there do you see such animosity? I pay attention, believe me and I have never noticed anyone in an automobile forum say, "You have cheap wrenches from Wal-Mart?! You Newbie!! You will never fix a car or become a mechanic for real – and BTW they are called crescents!!" On a side note, I have to let you know that kits from tattoo magazines really aren't

the best way to go. There are the benefits you will have with a proper apprenticeship, which I highly encourage.

This book, along with any other books or videos, is definitely not a substitution for hands on training. None the less, I did start with a needle and thread, then I graduated to the kit and finally to professional tools with an apprenticeship. If you do your homework, you will find out that most of the best artists out there started in a similar way. These same artists will also tell you that their work progressed leaps and bounds when they finally studied under a professional. It can sometimes be hard to find an artist that is mediocre and still admits to once being a scratcher. Tattoo artists like to believe in what I call "im-macul-ink conception". This means that they woke up one day, decided to be a tattoo artist, ran to their friendly neighborhood tattoo studio and got that coveted apprenticeship thus leaving anyone who asked to believe – nothing shady is in their past, they did it the right way…the only way. This is where one finds the entrance to the hypocrisy that is so deeply embedded in the cliché of tattoo. It's true…the cliché that is all too often self perpetuated in the tattoo industry. Along with some trick about coins, but we will get into that later.

> *"This book, along with any other books or videos, is definitely not a substitution for hands on training."*

Thanks to Strong Bad we know that technology is magic.
I step back and I think to myself all the time, we're in the future. We are in a new century. So, why then are the ideas about tattoo still the same ones from the 1950s? I know there is so much opposition from the "old school" artists out there for just about anything new that enters the arena. It could be the best thing out but, if it's new then it can't be good according to the old school crew. Which, by the way, are the same groups of people who bash texts like this one.

I learned that the best artists of today are not hoarding knowledge, in fact they are willing to answer novice questions. I would see really stupid questions on forums all the time. Remember the old adage, "There are no stupid questions, only stupid people"? Well, I have seen some stupid questions in the tattoo world. The cool thing is that as of right now there is no Tattoo University, no documented school of thought, no step by step to follow. You and I are in the midst of an evolving intellectual canon that is propelling the art and philosophy of tattoo. So of course the questions a newer artist or a complete "newbie" would ask seem stupid. What I started to see on some of the world's best artists' forums amazed me. I was seeing these awesome artists not only answer the stupid questions, but be sincere and positive and nice about it. I wasn't reading the negative insults or the 'bashing' that I had seen on the general forums. I believe this to be because of technology and a change in the school of thought.

I would also like to note that the best artists in the world will always say that they cannot really teach you to tattoo, it is too much an art. However, I notice the worst artists in the world will guard their secrets till the end, expressing a fear that a newbie might injure his or her peers (this is code for "My shop is not that busy or I'm not that good and I don't need anymore competition"). Let me say this now...There is this enormous technical aspect involved that is actually pretty basic, but even the technical aspect has such a wide spectrum to it that it is an art form in itself. Even the machine building and tuning is an art form and ultimately lies in the category of personal preference. So even with all the tricks and secrets there is no substitution for patience and experience.

Those who have been tattooed and have been tattooing for any period of time have seen the good and the bad out there. We know that there are some people who own a shop simply because they have never been challenged by the public. These shops and artists are just so obnoxious and callus; even if a client got a horrible tattoo from them, the client will still accept it

as decent. Then on the other end of the slide rule you have the shops that are immaculate and the artists that can do things in skin that most of us can't even do on canvas. You have to take the good and learn from the bad. It seems like an obvious thing to say and it is relatively applicable in all aspects of life, but please if you get one thing out of this book let it be that. Be an observer and let instinct be the judge.

I have learned many lessons about tattoo from a lot of great artists. Some I have talked to or apprenticed under, some I have emailed, and others I have read their books and watched their videos. I wish that I would have had information presented to me in the fashion that I have attempted to create here, when I was first starting out.

With this book I hope to share some things I have learned up to this point in a humble and informative setting. And as I continue to learn, I hope you will see and hear more of me in this exciting and evolving industry. But most of all I hope you walk away with something or look at a technique you personally use in a different light. I look forward to you propelling the industry into the next level and as you embrace the technology and the change in the world while still respecting the customs and traditions of the journeyman apprenticeship. Therein lays a harmonious balance between an old school and a new school of thought on tattooing. It's up to the next generation of 17 year old me to implement, sustain, question and improve upon this art.

A bit about the terms and language used in this book before you get started:

First, while I do consider this a textbook – the tone I use is informal and the language practical. My intent is to be informative and to do this quickly without boring you to death. You will notice that I use many different terms for the same objects, i.e. newbie, novice, scratcher. This is also to help train your brain into thinking and understanding that this industry is not in a neatly packaged box.

Secondly, another example; which deserves explanation, of an interchangeable term is "tattoo machine". You may be asking right now, "What is a tattoo machine"? The tattoo machine is what you probably have referred to as the Tattoo Gun. It is best not to call it a gun from here on out. What is wrong with calling it a gun? Well, for starters you may be laughed at by old school artists. They'll tell you that nothing actually shoots out of the tattoo machine, and you don't have to watch where you point it! In actuality, ink can shoot out of the machine and you kind of do have to watch where you point it. **The real reason for the use of the term "machine" is that it lets tattoo artists know when they are talking to another bon a fide tattoo artist**. Almost like a secret handshake, or Cracker-Jack decoder ring.

> *"And that is your first lesson - so write it down, it might just be the best kept secret in this industry. Are you worried yet? You should be...Personally I love saying "tattoo-gun" when I am talking to fellow tattoo artists, it just confuses them as to your actual knowledge or pisses them off; either way it is always worth doing. Its like, "are you really going to say that the ink that I lay into someone's skin is not legitimate" because I call the gear I use to put that ink in there a gun? It sounds funny and borderline insane but just walk into a tattoo studio and try to talk shop with someone using the word "gun", oh boy you will be in for a beating.*
>
> *When I worked at BoJo Tattoo in Germany, we used to joke that we were going to make holsters and walk around with our machines ready to be drawn like cowboys. Okay so now I am really deviating off topic.*
>
> *We have to ask ourselves as tattoo professionals, why do these petty nuances really matter to the point that people get upset? I mean literally upset to the point of trash talking or verbal judo. It is very unfortunate that the tattoo industry is so riddled with uneducated individuals who lack professionalism and standards that would actually legitimize this industry, or at the very minimum step it up to the next level of acceptance. I think that is where you get into the different schools of thought about where the industry should go, which also has a lot to do with your personal tattoo "upbringing" or the way you were apprenticed. I tried not to inject this whole textbook with industry philosophies, but sometimes it is very hard to stay away from those types of thoughts."*

1.2 Purpose

The purpose of this text is to familiarize you with the basic concepts that are a required foundation to begin a tattoo apprenticeship.

Who is this book for? This book is for those who have artistic ability. You can learn the fundamentals of art in a school of design, but even a university will only take you so far. You have to have some type of god given talent that you can build a base upon. You cannot become a tattoo artist if you are not already an artist. The alternative is you will just be another tattooist. It is one thing to have the technical ability to lay ink into skin, and have it stay there. It is another to create works of art that people are willing to pay you for. That is the difference between a tattooist and a tattoo artist.

If you do not have an ounce of artistic talent, meaning you can't even trace a line on paper, you may want to reconsider your venture. Humans are not a flat canvas, and tend to move around just a little from time to time. This is not to say that you cannot gain artistic skill, ever. This just means that it is extremely helpful for you to have some type of artistic talent and background prior to delving into the difficult art of tattoo.

I assume that you already have been tattooed, preferably multiple times, and have expressed interest to your personal tattoo artist in gaining knowledge about the art form.

Skin can be a very unforgiving medium to work in. Skin can also be really rewarding. Being a tattoo artist is one of the most amazing jobs in the world. It is not very often that people who work with art get to work on fun creative pieces, and have their canvas actually converse with them. To create a tattoo is to give someone a piece of art that they will take with them to the grave. Some collectors are so passionate about the whole tattoo process that they feel they have entered into a spiritual bond with

the artist. Whether it is formation of a spiritual linkages or just making a new friend, there is even more to being a professional tattoo artist than technical and artistic ability. The foundations of a good apprenticeship will always focus on the ethics of tattooing and customer service as equals in comparison to the actual art.

This text was designed as an accompaniment to a formal apprenticeship. It might also be used by someone who is interested in learning what the whole scene is all about and what is actually involved in doing tattoos.

This text will not make you a tattoo artist, it may not even teach you to tattoo on a level that would pass for professional. It will familiarize you with the lingo, the tools, the technique, and the overall aspect of the industry with normal vocabulary that should be easy for anyone to follow. You will see in this text over and over, "… will not make you a tattoo artist…" this is for good reason and cannot be stressed enough.

WARNING FROM THE AUTHOR

Please note that no product or material that is discussed in this text is associated with the author, the publisher, or any sponsors of this text. No consent was given to use any of these products by name, and the products are not related to this text in any way. If there is a product that is listed by name in this text it is because of an opinionated reference to a specific product or vendor by the author. The author reserves the right to state his personal opinion and preference regarding any product in the tattoo industry. That does not make those opinions fact. Always trust your own instinct and investigate all products prior to investing in them or criticizing them yourself.

1.3 Goals

So what are you going to get out of this material? I have laid out a few brief goals and milestones that you can hope to obtain or strive to reach as a new tattoo artist. It may seem overwhelming at first and you have to be a human sponge, so just try to soak it all in. This book will not make you a tattoo artist. This book will get you familiar with the fundamentals of being a tattooist. There is a big difference between being a tattoo artist and being a tattooist, someone who makes tattoos. The art form of tattoo takes a lot of time and practice. Even if you are a very good artist in another medium, you may find yourself struggling to get the same effects in skin. Each of the goals set forth here are important, to say that any one goal is more important than another would be misleading.

Goal One
The first thing you have to learn is the sanitation and its relation to the practice of tattooing. Common sterilization and sanitation practices can be directly copied and applied from medical and dental practices. The practices outlined in this text will be derived from several key medical sources and literature.

Goal Two
The next stepping stone to becoming a tattoo artist is the machine with which you practice. There are many simplistic parts that mechanically make up the machine. You must be familiar with all of them so you can setup, repair, and tune your machine for use.

Goal Three
Understanding the energy force behind your machine is the third goal of this text. You will need to learn how much voltage and amperage will affect your machines and in what aspect. What can be obtained simply by adding more voltage, and what actually is obtained by modifying the machine? These are questions you will be able to answer.

Goal Four

The fourth goal that I have set forth for you to obtain after completion of this text is to understand the concept of needle usage in tattoo. Different needles do different things, and are constructed in different ways. You will use needles like a painter uses brushes, and you will know when to use what type of needle dependent upon the task at hand.

Goal Five

Inks, or pigment, are very complex. There are people and companies that have dedicated themselves to the art and science of developing effective color that can be safely applied to the human body. You will learn the different types of pigments and the proper handling and application of these materials.

Goal Six

Stencil application is a short and fairly simple goal, but this can be a very tricky subject if you are not taught the correct way to develop line works and transpose those concepts into a stencil. Even more complex is the actual application of a stencil. Once you are through this chapter on stencils you will say, "That was it"? But believe me, this is something that many people have struggled with for a very long time and can be a nightmare if you do not have a few tools in your arsenal to tackle this problem.

Goal Seven

You will learn the basics of the tattoo process. From outline to shading and coloring, these concepts can be daunting and complex. There are thousands of techniques used but, in this text I present the most basic and fundamentally safe ways to technically transpose a concept from a thought to the skin.

Goal Eight

Tattoo aftercare is our eighth goal in the succession of this text. If not done properly, the tattoo's design and color may greatly diminish. Never underestimate the power of the skin's healing process and the importance of customer education on proper

technique. I assume you already have tattoos yourself and have seen the healing process first hand. You may have had work done by multiple artists and seen different aftercare techniques. This text will cover a few techniques that seem to be widely accepted and preferred, but are by no means the only way for a tattoo to heal.

Goal Nine

How you act, work, and interact in a tattoo studio atmosphere is very important. This aspect is often overlooked and underestimated by many in the tattoo world. A good work ethic is the foundation, but after completion of this goal, you will be better equipped to handle a multitude of situations that may arise. You will also be given the fundamentals of proper flow of business in a tattoo studio.

Milestones

In addition to the goals, there are a few milestones that will help you track your progress on the long road that is before you. These milestones are things that you really should be doing while reading this text. They are also indicators that you are learning, and progressing.

Milestone One
You will purchase the proper professional tools you need to work.

Milestone Two
You will have, or at least know how to, successfully run an autoclave.

Milestone Three
You will have built a tattoo machine from the frame up.

Milestone Four
You will make your own needles.

Milestone Five
You will properly set up your work area in preparation for a tattoo.

Milestone Six
You will have completed a real tattoo on a piece of fruit or "fake" skin.

Milestone Seven
You will have met with a tattoo studio employee with confidence, and obtained an apprenticeship.

Milestone Eight
You will have shared your knowledge about tattoo with someone who is just as eager to learn as you once were.

There are a lot of markers in between these milestones, and some will and should be repeated. The milestones represent an overall progress. Like a type of control that can show where you are at and give you something to look forward to while striving to obtain the goals.

Tattoo is not a science, it is an art. Some parts of tattoo are technical and should be approached in a scientific manner, but even within those technical aspects there are undertones of art. It is for that reason that no one can say a "right" or "wrong" way to tattoo. The ultimate test will be if the ink looks good in the skin, and if it heals fast and properly.

Did you notice that none of the goals mention tattooing a human being? That is because this text is the Basic Fundamentals of tattoo, and you cannot tattoo someone properly if you only know the basic fundamentals. You really need to get an apprenticeship to train and observe. I understand that by me telling you to do things in this particular order is very hypocritical on my part. I did not apprentice before I completed my first tattoo. I did not apprentice before I did my first hundred or so tattoos…but I also wasn't working at my fullest potential until after I had apprenticed.

I will attest that I didn't do a proper tattoo until I apprenticed. I struggled to get ink to stay in, I hurt people, I damaged skin, and I used unsafe and stupid techniques. Tattoo is something that you just can't learn in one day from reading a book or watching a DVD. It takes time and patience and you have to be able to have that feedback with a professional. If your machine is not doing quite what it is supposed to, you can't always get the answer from a book. You need to be patient and have some respect for the practice of tattooing, the rest will fall into place for you over time. If you insist on tattooing your underage buddies in Mom's garage, then at the very least you have to know some basic stuff about sterilization and risks involved.

"I didn't apprentice before I did my first tattoo, but I didn't do a proper tattoo until I apprenticed."

1.4 Brief History of Tattoo

It has been cited that early settlers and travelers have noted in their journals and logs about different indigenous people around the world as having been adorned with exquisite markings and designs all over their bodies. The actual word "tattoo" as we know it today is said to have been formulated by the western interpretation of the Tahitian word "tatau" (DeMello 2000). Even further back is carbon etches in rib cages of Neolithic cavemen's bodies found in the Alps (Time Magazine 1992).

The origins of tattoo date back pretty far. In fact, there is no proof of when or where the first tattooing process took place. There are carbon dated bodies of human remains found which suggest that tattoo has been in existence as long as man has been in existence. This text is not here to argue the fact of when or where the first tattoo occurred. It is important however to recognize that tattoo has existed in many forms prior to the western world's perception.

Whether it is the marking of a rite of passage for an individual, a score card that can be kept on one's body forever, or even a religious symbol; tattoos have been part of the human experience for ages, and it appears that they will continue to be an integral part of modern society for years to come.

The basis of the modern tattoo machine is still relatively unchanged from the 1820 discovery by a Danish inventor Hans Christian Oersted called electromagnetism (Brian & Cohen 2007). Oersted's invention is now known, in what is commonly implemented as a prime motor for the doorbell circuit, as the basis for all modern coil tattoo systems.

Modern tattoo is symbolized by the advent of the mechanized version of the emplacement of some form of ink or dye under the skin. The basic usage was first transposed from an invention patented in 1876 by Thomas Edison (U.S. Patent 196,747).

Edison's machine was not intended for the skin, but for creating embroidery patterns by means of an electric punch. This concept was further elaborated on in 1891 by Samuel O'Reilly, who took a modified version of Edison's now dual coiled mechanism and deemed it proper for skin tattooing (U.S. Patent 196,747). It is argued that O'Reilly was the inventor, even though it is actually Charlie Wagner who holds the 1904 patent for the "tattoo machine" (www.tattooarchive.com). This patent demonstrates that the "tattoo device" has an ink chamber or "tube" and uses the single coil method for movement of the armature bar. In 1929 Percy Waters received his patent for the dual coil tattoo machine, which was set in a frame (U.S. Patent 1724812). Another patent was issued in 1979 to Carol Nightengale, who made some substantial modifications to the frame (U.S. Patent #4159659). Some of Nightengale's modifications can be seen today in cutback machines, and fully adjustable frame styles. Nightengale's version was also the first patented design that utilized front and rear spring apertures.

While the history of the modern machine appears just as obscure as that of the history of the ancient process of tattoo, it is obvious that there were many individuals working toward the same concept. Even today there are many innovations such as the "swash drive" or bearing driven rotary machine, the "pneuma" which is run off air compression and cuts the coils and electromagnetism completely out of the machine, and the contactless machines which avoid the use of spark and utilize vibration to move the armature bars. Advances in coils from 6 to16 wraps are also available. Recently FK Irons has developed a system, that is patent pending at the time of this text, which utilizes one full sized coil in the front and one ½ sized coil in the rear to balance the electromagnetic harmonics of the circuit (www.fkirons.com).

Tattoo machines have evolved in many ways, but the primary goal has remained the same over the ages; to put ink into the skin. The speed and accuracy that this is achieved has evolved

over time, and the inks and pigments used have also changed. There are many exciting things being developed and with the information age of the Internet being upon us currently, the knowledge of machine builders and the number of tools available to tattoo artists around the world is expanding at an exponential speed. Even with all these advancements in the tattoo world, it is not uncommon to still see tattoo rituals performed in places like Japan and American Samoa the same way that they have been done for centuries.

Understanding the basics about the history and evolution of tattoo will ultimately help you understand and appreciate the basic fundamentals of the modern tattoo.

2.1 Diseases / Infections

Any profession that deals with the human body and particularly that which there is an open wound and sharp object present, requires the utmost importance in the focus on the prevalence of and possibility that a disease or infection might be introduced into the area. Tattoo is no exception to this by any means. A tattoo artist must not only be an artist, but he must be knowledgeable in many other sectors as well. The most important knowledge area is obviously that of biological fluid contamination and infection prevention.

So what are the methods that a tattoo artist will incorporate into his daily routine? Shouldn't the tattoo studio already have in place the proper procedures? You may be very surprised about the lack of proper sanitation and sterilization that currently exists in the tattoo industry. Even the studios that are in what could be calculated as the top ten percentile of the industry would be scorned upon by most medical and dental professions in America; even though there are far less instances of open wound in dental practice than a typical tattoo studio (author's non-dentist opinion).

Diseases and infections are not easily avoided by the simple act of wearing gloves. There is a lot more to the overall picture of preventative health in the tattoo world. The reason that many studios are not to what I would consider "in compliance" can be linked directly to the lack of enforcement by both local and federal governments. This subject could be another book altogether if anyone feels up to the challenge.

There has been an age old battle with the tattoo industry and the regulatory bodies in the state and the federal government. So, at the printing time of this text the best methods to follow are self policing and regulation, not even at a state level, but at a shop level.

Shop level…isn't that kind of a small footprint?
The answer is no. Since the only thing standing between you, the tattoo artist, and a prospective client is trust, your knowledge of the possibility of infectious diseases entering into that open wound is your first weapon. Once the artists are familiar with the importance of, and the actual reality of infection by the tattoo process, they can then educate the rest of the studio employees and their clients.

Why even bother with self-education, let alone educating your clients?
There are numerous reasons for education. The first reason, it makes you, the artist, a better member of society along with giving you a sense of pride in knowing that you are making a conscious effort to do the right thing. Sounds kind of ridiculous, I know. Yet this is called ethics in this profession and ethics are a far cry from ridiculous. The tattoo industry is evolving and the stigma of the stained tank-top wearing, drunken biker using a rusty old tattoo machine is all but gone. You, as a tattoo artist, need to be an educated professional with a strong foundation of ethics. This means that you not only know the type of diseases that are out there, but you are making a conscious effort to prevent and educate others about the existence of such diseases.

Another great reason to be self-educated is when you show your nervous first time customer your expertise and awareness of the possibility of infection and disease, it gives them a piece of mind that you are going above and beyond what the studio down the street is doing. Believe me, the more your customers know about the industry, the more they will feel like they have made an educated decision about their choice to get a tattoo from you. Word of mouth is the best thing in this industry, and getting the reputation as one of the cleanest artists around just may land more business than the guy who has the reputation as the best color artist around. I am not trying to downplay artistic importance, but simply to illustrate the magnitude of cleanliness.

The prevention of disease and infections will be covered in a

later chapter of this text. I would like to go over the types of infections that can arise from blood borne pathogens and cross contamination of materials used in the tattoo process. It is highly recommended that all persons who are practicing tattoo, regardless of state regulation, are trained and certified by the American Red Cross in the areas of Blood Borne Pathogens and CPR.

Most common blood borne diseases / infections:
The following material is taken directly from the Department of Human Services Center for Disease Control and Prevention, or CDC.

Hepatitis
Hepatitis means inflammation of the liver. Toxins, certain drugs, some diseases, heavy alcohol use, and bacterial and viral infections can all cause hepatitis. Hepatitis is also the name of a family of viral infections that affect the liver; the most common types in the United States are hepatitis A, hepatitis B, and hepatitis C.

Hepatitis B (HBV)
Hepatitis B is a contagious liver disease that results from infection with the hepatitis B virus. It can range in severity from a mild illness lasting a few weeks to a serious, lifelong illness. Hepatitis B is usually spread when blood, semen, or another body fluid from a person infected with the hepatitis B virus enters the body of someone who is not infected. This can happen through sexual contact with an infected person or sharing needles, syringes, or other drug-injection equipment. Hepatitis B can also be passed from an infected mother to her baby at birth.
Hepatitis B can be either acute or chronic. Acute hepatitis B virus infection is a short-term illness that occurs within the first 6 months after someone is exposed to the hepatitis B virus. Acute infection can — but does not always — lead to chronic infection. Chronic hepatitis B virus infection is a long-term illness that occurs when the hepatitis B virus remains in a person's body. Chronic hepatitis B is a serious disease that can result in long-term health problems, and even death. The best way to prevent

hepatitis B is by getting vaccinated (http://www.cdc.gov/hepatitis/HepatitisB.htm).

How is HBV transmitted?

HBV is transmitted through activities that involve percutaneous (i.e., puncture through the skin) or mucosal contact with infectious blood or body fluids (e.g., semen, saliva), including:

- Sex with an infected partner

- Injection drug use that involves sharing needles, syringes, or drug-preparation equipment

- Birth to an infected mother

- Contact with blood or open sores of an infected person

- Needle sticks or sharp instrument exposures

- Sharing items such as razors or toothbrushes with an infected person

HBV is not spread through food or water, sharing eating utensils, breastfeeding, hugging, kissing, hand holding, coughing, or sneezing.

How long does HBV survive outside the body?

HBV can survive outside the body at least 7 days and still be capable of causing infection.

What should be used to remove HBV from environmental surfaces?

Any blood spills — including dried blood, which can still be infectious — should be cleaned using 1:10 dilution of one part household bleach to 10 parts of water for disinfecting the area.

Gloves should be used when cleaning up any blood spills (http://www.cdc.gov/hepatitis/HBV/HBVfaq.htm#treatment).

Hepatitis C (HCV)
Hepatitis C virus (HCV) infection is the most common chronic bloodborne infection in the United States; approximately 3.2 million persons are chronically infected. Although HCV is not efficiently transmitted sexually, persons at risk for infection through injection drug use might seek care in STD treatment facilities, HIV counseling and testing facilities, correctional facilities, drug treatment facilities, and other public health settings where STD and HIV prevention and control services are available.

Sixty to 70% of persons newly infected with HCV typically are usually asymptomatic or have a mild clinical illness. HCV RNA can be detected in blood within 1–3 weeks after exposure. The average time from exposure to antibody to HCV (anti-HCV) seroconversion is 8–9 weeks, and anti-HCV can be detected in >97% of persons by 6 months after exposure. Chronic HCV infection develops in 70%–85% of HCV-infected persons; 60%–70% of chronically infected persons have evidence of active liver disease. The majority of infected persons might not be aware of their infection because they are not clinically ill. However, infected persons serve as a source of transmission to others and are at risk for chronic liver disease or other HCV-related chronic diseases decades after infection.

HCV is most efficiently transmitted through large or repeated percutaneous exposure to infected blood (e.g., through transfusion of blood from unscreened donors or through use of injecting drugs). Although much less frequent, occupational, prenatal, and sexual exposures also can result in transmission of HCV (http://www.cdc.gov/hepatitis/HCV.htm).

How is HCV transmitted?

HCV is transmitted primarily through large or repeated percutaneous (i.e., passage through the skin) exposures to infectious

blood, such as:

Injection drug use (currently the most common means of HCV transmission in the United States)

Receipt of donated blood, blood products, and organs (once a common means of transmission but now rare in the United States since blood screening became available in 1992)

> Needlestick injuries in healthcare settings
>
> Birth to an HCV-infected mother
>
> HCV can also be spread infrequently through
>
> Sex with an HCV-infected person (an inefficient means of transmission)
>
> Sharing personal items contaminated with infectious blood, such as razors or toothbrushes (also inefficient vectors of transmission)
>
> Other healthcare procedures that involve invasive procedures, such as injections (usually recognized in the context of outbreaks)

(http://www.cdc.gov/hepatitis/HCV/HCVfaq.htm)

Unlike HBV, there is currently no vaccine for HCV available and immune globulin administered after exposure does not appear to be very effective in preventing HCV infection.

Human Immunodeficiency virus (HIV)
HIV stands for human immunodeficiency virus. This is the virus that causes AIDS. HIV is different from most other viruses because it attacks the immune system. The immune system gives

our bodies the ability to fight infections. HIV finds and destroys a type of white blood cell (T cells or CD4 cells) that the immune system must have to fight disease.

AIDS stands for acquired immunodeficiency syndrome. AIDS is the final stage of HIV infection. It can take years for a person infected with HIV, even without treatment, to reach this stage. Having AIDS means that the virus has weakened the immune system to the point at which the body has a difficult time fighting infection. When someone has one or more specific infections, certain cancers, or a very low number of T cells, he or she is considered to have AIDS.

HIV is primarily found in the blood, semen, or vaginal fluid of an infected person. HIV is transmitted in 3 main ways:

> Having sex (anal, vaginal, or oral) with someone infected with HIV
>
> Sharing needles and syringes with someone infected with HIV
>
> Being exposed (fetus or infant) to HIV before or during birth or through breast feeding

(http://www.cdc.gov/hiv/topics/basic/index.htm)

So now that we have gone over some of the bad things that can happen in a "dirty shop" you should now focus on the sort of precautions necessary reducing the potential of spreading such bloodborne pathogens.

It is your obligation to protect yourself, your clients, and to educate your co-workers. If you see something in the tattoo studio

that is questionable, tactfully question it. This can be hard for an apprentice or a new artist in the industry. Think about it though: do you really want to be associated with a shop that is going to tear you a new one, just for questioning something that you think could have serious affects on your community?

Sometimes it is hard for artists to remain vigilant in regards to disease and infection prevention. That is why it is highly recommended for all studios to hold internal, mandatory, refresher training for all employees, even those who do not directly tattoo clients. Chances are, even the individuals who count the money will at some time clean tubes, take out biohazard rubbish, dispose of sharps containers, or run the autoclave every now and then.

> *"...it makes you, the artist, a better member of society along with giving you a sense of pride in knowing that you are making a conscious effort to do the right thing."*

The bottom line is that this stuff may be dry, it may be common sense, but it really is an important aspect of this profession, and it is simply not going away. If you have no experience in a tattoo studio, then it is imperative for you to review these lessons prior to even tinkering with your tattoo equipment.

Basic Fundamentals
tattoo tip
of Modern Tattoo

Clean + Sterile + Safe = Integrity

2.2 Autoclave

Some of the tattoo artist's tools are not disposable. Some of the equipment that is used during the tattoo process will be re-used again on another client. The preferred method is to use as much expendable material as possible during the tattoo process; however some things just simply cost too much money to discard or are not available in a disposable format. This is where the autoclave comes into play in the tattoo studio.

Any item that comes in contact with human skin, blood, or bodily fluids must be properly sanitized and sterilized. A majority of tattoo studios will use non-disposable tubes, tips, and grips, but it is less common to see needle bars reused. The needle bar is the portion of the needle that slips around the armature bar via a bent loop. The needles are then soldered onto the needle bar in groupings. These and many other items in the tattoo studio fall into the category of items that must be autoclaved.

How do we kill the potentially harmful organisms and biological materials that are not even visible to the naked human eye? Chemical sanitation and sterilization is not always an effective means to destroy these items. Some of your tools might be ruined by harsh chemicals as well. There is no way to completely kill everything in the 100% range, off our tools. The acceptable range that can be obtained and will adhere to medical standards is partially achieved in the autoclave process.

What is an autoclave? The autoclave is a machine that emits heat and manipulates the atmospheric pressure in a confined area. The instruments are placed in this confined area for a specific amount of time to ensure that an acceptable amount of microorganisms are destroyed. Autoclave is the final process in prepping multi-use materials, prior to their next usage. There are many types of autoclaves, with just as numerous variants in ability. The most commonly used type of autoclave in the tattoo industry is the steam element type. There are also dry heat and

chemical sterilization processes and equipment that can effectively obtain the same results that will remain within medical standards.

It is always best to consult a physician or reputable manufacturer of the autoclave that is in use in the tattoo studio that you will operate out of. Find out how to test your autoclave to ensure that it is actually working. It is also very important to understand the process that the tattoo studio uses to identify, label, and store reusable items after they have been sent through the autoclave process.

If you do not have an autoclave, you simply cannot utilize reusable equipment in your practice. You run the risk of passing along an unwanted disease or infection to the next individual that you use the equipment on. This is not common knowledge to the tattoo collector or client, and should be shared with them whenever possible. Even if the autoclave is available in your facility, it is always best practice to use disposable needles, bars, tubes, tips, and grips.

As mentioned earlier, the autoclave must be tested periodically to ensure that it is working. Just because the autoclave powers on and completes the cycles, does not mean that it has killed within the acceptable range. There are strips that can react to heat, and will change color. These are not preferred to spore testing. The only way to be sure that your machine is properly killing what it is being used to kill, is to run a spore test. The spore test can be obtained from numerous organizations that specialize in lab testing.

The actual spore test will include one or more augers that must be run through the typical autoclave cycle in your studio. These augers are then sent off where they undergo an incubation process. The lab will then determine if the augers developed microorganisms within the acceptable range. If the augers developed beyond the acceptable range, then there may be something wrong with the machine that caused it to not kill everything that

it was designed to kill. With that being said, you can see why it is important to date and label your materials in conjunction with keeping a log book documenting the auger spore tests. This might also be a state requirement or regulation that the shop may be subject to auditing for.

Here is an example scenario:

>Joe conducted a **weekly spore test** on his primary autoclave on 01 January.
>
>Joe ran 200 tube and tip combos though his autoclave from 01 January though 08 January.
>
>Joe conducted a **weekly spore test** on his primary autoclave on 08 January.
>
>Joe received his results from the 01 January test on 09 January; the results showed that his autoclave was **not** destroying the microorganisms within the acceptable range.

What should Joe do?

The good thing is that Joe labels all his tubes and tips' blister bags with the date that they were autoclaved. He also does not use his sterilized equipment until 2 weeks after it has been autoclaved. This ensures that Joe will never use a piece of equipment until his results from the lab have returned. Since Joe has all the equipment from 01 January though 08 January, he can now trouble shoot his autoclave, and have it re-tested.
It is possible to get false results from the spore tests. The important thing to remember is that you must always have backup supplies, you must know your autoclave settings and usage protocol, and you must follow the lab's testing guidelines thoroughly.

As a tattoo artist, you are not a certified trained medical professional. This begs the question, how can tattoo artists be expect-

ed to perform to medical standards? This is scary sometimes, even for those of us who tattoo for a living. You have to educate your staff in the tattoo studio, and you have to educate your customers to the process. Make the logs that show testing of your autoclaves are readily available to the clients, being transparent in every way. You should also work directly with your local OSHA and health departments.

The best practice is to use as much disposable equipment as possible. Even though the tip and the tube of the tattoo machine assembly does not enter the skin of the client, bodily fluid still comes in contact with these metallic reusable items. There are also lesser known items that should be autoclaved, to include the spray bottles that are used on a daily basis. It is always, however, important to check with the equipment manufacturer to ensure that your plastic materials are high enough quality to withstand the heat and pressure of your autoclave. There has been much advancement in the tattoo industry, but it is surprising that many of these new ideas have existed for some time in the medical field.

Autoclave rules of thumb:

The seals must be replaced on your autoclave and you must conduct preventative maintenance checks and servicing regularly on all expendable parts of the autoclave.

Equipment must be cleaned prior to sterilization with an autoclave.

The autoclave time does not start until the target heat and pressure range has been met.

Autoclave temperate should run at 121 degrees Celsius or greater.

Autoclave pressure should run at 15 psi or greater.

Autoclave timer should run for 20 minutes or greater.

You can be burned by prematurely opening the autoclave after the cycle has finished.

You get what you pay for when purchasing autoclave equipment.

You are risking lives with very serious diseases and infections on a daily basis.

It is recommended that all tattoo studios maintain a training program and keep records to document that 100% of their staff has received semi-annual training on the proper usage and standing operating procedures of the establishment in relation to the autoclave. Each time the autoclave is utilized an autoclave usage log should be filled out. Items should be labeled with the date and time of the autoclave cycle on their blister packs.

According to CDC (Center for Disease Control) guidelines:
"If spores are not killed in routine spore tests, the sterilizer should immediately be checked for proper use and function and the spore test repeated. If the spore tests remain positive, use of the sterilizer should be discontinued until it is serviced."

The autoclave is an invaluable tool in any tattoo studio, and will be prevalent. It is important to make sure you are familiar with the way your autoclave works, and it is also important to make sure that all employees are aware of the complete process of sterilization. The process starts at the time of the tattoo completion, and it ends when the reusable instrument is opened from its autoclaved individual wrapping. It is highly encouraged that the tattoo studio owner should contact the state health department and research the CDC's website for further guidance. This is by all means a medical process, and should be treated as such.

2.3 Disposables

Arguably, one of the greatest inventions or advancements in the tattoo industry is the disposable tube and grip. I say arguably because some artists appall them and refuse to use them. I swear by them and have been using them exclusively for the past few years. They take some time getting used to and are definitely a challenge, but the benefits far outweigh the learning curve.

What are disposables?
First you have to understand how the tattoo machine works, which is covered in a later section of this text. For this section just think of the tattoo machine as a sort of calligraphy pen and hopefully this will make sense to you. The tattoo needle resides in a tube, typically steel or aluminum. The needle goes up and down and draws ink into the well, or the tube's tip. This ink is standing in a pool inside the tube, much like a calligraphy pen that has been dipped into an ink cup. As the skin is scratched or poked by the needle, the ink will run down the needle out of the well and into the newly punctured skin.

Great, so what are disposables?
Disposables are tubes, tips, and grips that are made of plastic materials that are considered single use. You may have seen the signs in neon on a tattoo shop, stating that they use new needles every time. This is often true, but the tube and the tip draw in blood, and touch open skin just as much as the needle does. I have personally never seen a tattoo studio that advertises new tubes every time. The real reason that I think this technique has not caught on is because of cost.

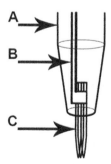

Fig 2.3 Needle in Tube: A. Tube, B. Needle Bar, C. Needle Grouping soldered to bar - tattoo ink (pigment) is drawn into the tube like a well of a pen

The newer tattoo kits that you can purchase from big warehouse suppliers will now give you the cheap tubes with rubber grips. They are not the best thing in the world, but it beats what they were doing a few years ago; giving out aluminum tubes to people who didn't own an autoclave.

Dental and medical professionals have started to use more and more plastic disposable supplies in their daily routine, why shouldn't the tattoo industry take note?

It is imperative for people who are just starting out to learn with plastic tubes and tips (in my opinion). Even if a tattoo studio has an autoclave and use it properly, it may not be working. Why not be 100% sure that your client is getting a clean instrument touching their open skin every time?

Another item that is considered a disposable that is new to the market is disposable inks. These inks come in small caps, or shots. The ink shot looks a lot like a single use contact re-wetting drop case, and will contain more than enough ink for a typical job.

Why use disposable ink?
The typical ink or pigment that is used in tattoo process is kept in a bottle, usually 1oz-8oz. The artist is supposed to open the ink bottle, and fill the caps with ink prior to starting the tattoo. The artist is not supposed to refill the same ink cap if it runs out of ink during the tattoo process; for fear that the bottle may touch some biohazard materials on the cap that is being filled. New gloves have to be put on before the artist can touch the ink bottle, and the entire work area has to be disposed of prior to the ink cap being refilled. This is to prevent the bottle from becoming cross-contaminated. This is a very big hassle, and is seldom performed in the manner I just described. The ink shot can be disposed of after it is used, and another ink shot can be pulled out of the box with clean gloves without disposing of the entire work area if the cap needs to be refilled. These are a little more costly way of doing business, and not many brands of ink

are available in shots currently.

There are always going to be benefits and drawbacks to introducing a new technology to the workflow process. If it deals with customer safety and there is a readily available solution out there, then there is no excuse for this procedure to not be utilized.

This is just an opinion, and a good foundation for a beginner to practice. You will see that a great number of artists do not use disposable tubes and tips, and even less will use disposable inks. Most clients are oblivious to the tattoo process, and would not even know the difference, which is probably why more shops do not use them. It is a good technique and way of doing business that will shed positive light on you as an artist and your establishment. Educate your customers and your fellow artists, but be prepared for negative criticism.

It is possible to do a 100% disposable tattoo. You can use single use needles and bars. Throw away the grommet that is attached to the bar. Use single use pigments or "shots" as some distributors call them. The tubes and tips that are typically metal and require an autoclave are also available in plastic disposable flavors. The caps that the ink goes in on the work station are also disposable.

2.4 Chemical Sanitation

The tools that are directly used in the tattoo process are typically the primary focus of sanitation. It is important to also remember that the surfaces around the work area are just as prone to bodily fluid splatter and contamination as the actual tattoo machine apparatus. The counters, floors, furniture and even your tattoo machine can and will be contaminated with bodily fluids. These areas, once contaminated, must be sterilized to the best of your ability before cross contamination occurs with the next client.

So what is the most effective way to sterilize these surfaces and equipment?
Sanitation chemicals come from all different suppliers and manufacturers. These chemicals are typically not usable on instruments that will come in direct contact with the human skin, because they are too much of an irritant. They are acceptable to use on surfaces that are required to be kept sanitized. It is important to always read the entire manufacturer's warnings and instructions it is also important not to deviate from these directions.

Usually these chemicals are not that expensive, and can come in a powder formula that is then mixed in a ratio with water or some other liquid. Do not deviate from the mixing directions, if the mixture is not followed properly then the chemical will not be effective.

There can also be some complications when using chemicals to clean your equipment. Leather armrests and furniture can be all but destroyed if the wrong chemicals are used on them. Your tattoo machines may corrode and get oxidation or rust rapidly after being exposed to these chemicals. To avoid having to clean a lot of your equipment with the harsh chemicals it is always recommended that you use barrier protection. You can bag your machines, clip cord, and even power supply. You can bag your spray bottles, ink bottles, and wrap your furniture in

plastic. This way, all you should be required to do is give them a good wipe down with alcohol after usage.

There are also a few lines of chemicals that are acceptable for use on stainless steel instruments. These are an excellent way to soak and clean instruments prior to their being autoclaved. These chemicals can come in liquid and powder forms and a prime example is putting the chemical in a plastic cup, with water; placing the cup in your ultrasonic, and then soaking your used tips and tubes in the cup while the ultrasonic runs its cycle. The tips and tubes will still have to be scrubbed and re-run through the ultrasonic, but it is a good proactive practice to begin the disinfection process of your tools immediately after usage. Then when you are ready to scrub your tools, they have already been soaking in some sort of chemical and the bulk of the ink and bodily fluid will have been removed.

The key thing to know about chemicals is that not all are approved for use with your instruments that will come in contact with the skin, and some may cause some serious damage to your expensive professional equipment. Always read the directions and do not skimp on the ratios. Seek advice from your local health department and or a medical professional.

2.5 Universal Precautions

What are universal precautions?

The CDC defines universal precautions as:
"a set of precautions designed to prevent transmission of human immunodeficiency virus (HIV), hepatitis B virus (HBV), and other blood-borne pathogens when providing first aid or health care. Under universal precautions, blood and certain body fluids of all patients are considered potentially infectious for HIV, HBV and

other blood-borne pathogens."
It is as it says...precautions that are to be used (universally) by all workers who may come into contact with bodily fluid, as well as any bodily fluids of all patients/clients are to be (universally) treated as if infected.

The CDC also goes on to define bodily fluids as:
- Blood
- Bodily fluids containing visible blood
- Semen
- Vaginal fluid
- Cerebrospinal fluid (around the inside of the brain)
- Synovial fluid (of the joint areas)
- Amniotic fluid
- Pleural fluid (surrounding the lung)
- Peritoneal fluid (of the abdominal cavity)
- Pericardial fluid (surrounding the heart)

Bodily fluids that do not require the use of universal precautions include:
- Feces
- Nasal secretions
- Urine
- Vomitus
- Perspiration
- Sputum
- Saliva

Although it is not necessary to treat the above fluids as contaminated, it is in your best interest and the interest of your clients to treat all fluids (universally) as contaminants. It is possible for blood to be undetected by the naked eye in fluids such as vomit or urine. Under universal precautions all patients/clients are considered carriers of blood-borne pathogens and the use of barrier control devices are suggested.

2.6 Barrier Control Devices

There are a lot of preventative ways to keep bodily fluids off of yourself, your client and your equipment using barrier control devices also called barrier protection. Avoiding contact with bodily fluids can be done through the means of nonporous articles worn by the tattoo artist, as well as covering furniture, equipment and tools.

Types of barrier control devices used under Universal and Standard Precautions are:
- Nonporous covering on all furniture
- Nonporous flooring
- Nonporous working surface
- Protective sheath covering tools (to be disposed of following procedure)

Basically everything needs to be of a **material that can be wiped down** and will not harbor germs and bacteria.

- Germicides (mixed according to manufacturer recommendations)
- Ventilation
- Proper Sharps disposal
- Proper disposal of biohazardous material

Every tattoo studio should have a **"dirty" room** where biohazard material is kept and regularly disposed of. In your work area you should have a rubbish can, or non-regulated waste and a biohazard can, also called regulated waste. Regulated waste is always signified by either a biohazard warning label or by the use of red plastic bags.

Personal Protective Equipment (PPE):
- Hand hygiene (soap and water method as well as alcohol-based hand rub)
- Gloves
- Protective eye wear
- Gowns
- Masks

It may not have crossed your mind, but while a tattoo is in progress thousands of tiny splatters of bodily fluid and ink will hit the artist. Some of these microscopic spatters will hit the artist in the face. Even fewer might hit the artist in the mucus membranes (mouth and eyes). This means you as an artist are potentially absorbing bodily fluid directly into your body from the client! Ever notice that the dental workers will wear full plastic face masks?

I am not saying *that you should wear the dental shield*, but at a minimum I would hope you wear glasses and a doctor's face mask.

Just to prove to you that there are a ton of microscopic spatters during a tattoo process, you should go out and get a **disposable face shield** and perform just one tattoo wearing it. You may re-think your whole way of doing business. This might seem awkward at first, and confuse your client – but once you explain it to them, and even show them after the tattoo – word will spread, and they will thank you.

2.7 Work Area Set-Up

The key to "work area setup" is **zone definition**. Zone definition means that the tattoo artist is aware at all times of his hot, warm, and cold zones. Knowing what zone your equipment is in will help you keep your work area sterile and protect your client. Avoiding cross contamination is the fundamental key when you are dealing with an open wound.

The **cold zone** is defined as an area that holds your sterile materials. This area is not to be touched during the tattoo process at all. For our purposes, the tattoo process begins once the skin of the client has been broken.

The **warm zone** is an area that can be touched during the tattoo process, but only with clean gloves. Clean gloves are gloves that are on the tattoo artist and have not touched anything in the hot zone.

The **hot zone** is the area and equipment that have touched bodily fluids, or contain other materials that are deemed as single use and have been set aside for this single application.

If you can remember your three zones, and remember the rules governing them, you will have **minimal risk of cross contamination**.

Warm zone:
All materials that are sterilized will be kept in your cold zone. The cold zone will be sealed off from your warm and hot zone by means of closed drawer or cabinet. Prepping your work area, or warm zone will begin by barrier protection on the furniture. Gloves will be worn during warm zone setup.

Any furniture that will run the risk of coming in contact with bodily fluid must be covered by some type of barrier protection. This can be as easy as wrapping the chairs with plastic wrap.

Even the artist's chair should be wrapped in plastic.
It is good practice to cover the counter top of your work area with aluminum foil or plastic wrap as well. Ensure you tape down the barrier protection. It is good practice to have steel medical trays or large mirrors that are not inside a frame as a work surface.

All materials that will be used during the tattoo process will be placed on the tray or mirror which should also be wrapped in barrier protection.

Some artists will use paper plates **on top of the wrapped tray**. The paper plate acts as a sort of pallet for inks and materials. Single use Vaseline packets should be moved from the cold zone to the tray.

Ink caps should be placed on the tray, using a small amount of Vaseline to secure them to the surface.

There are some artists who use *ink cap holders* in the form of metal table tops that have holes drilled in them. **These ink cap holders should be covered with plastic wrap**.

Tattoo machines should be assembled and setup.

Tattoo machines and clip cords should have barrier protection applied.

Inks should be poured.

If the artist is using single use ink capsules, then the amount of desired ink should be removed from the cold zone and placed on the tray.

After inks are poured, the ink should be placed **back in the cold zone**.

The client should have his skin cleaned with alcohol, and the

stencil should be applied.

The tattoo machine power supply should have proper barrier protection.

A sufficient amount of paper towels should be placed in the warm zone atop the barrier protected tray.

A new cup of water should be available, multiple if required; place the cups on the tray.

Hot zone:
Once the needle breaks skin, the hot zone is established.
The hot zone consists of the client, the machine, and any item that has bodily fluid on it.
This includes ink filled caps that have been dipped in, and any Vaseline that has been touched with a hot glove.

If during the tattoo process more ink is required, the following process should be followed:

- Tattoo machine is to be placed in the warm zone on the tray.
 Gloves are to be removed and put in a biohazard trash receptacle.

- Artist's hands are to be sanitized.

- New gloves are to be dawned.

- New ink caps are to be taken out of the cold zone and placed 3 – 5 inches from the ink caps that have been dipped in.

- Ink bottles are taken from the cold zone, and the new ink caps can be filled, careful not to touch any item that is

considered to be a hot zone.

- Ink bottles are to be put back in the cold zone.
- The cold zone is to be resealed.
- Tattoo process may resume.

The best method is to pull out 20% more ink caps than required for the job, and pour 100% more ink than is required for the job. This way you should never have to go into the cold zone while you are in the middle of a tattoo. Remember that ink is not expensive and neither are ink caps. It is far better to waste a few pennies by tossing out some un-used inks and caps, than it is to risk a clean bottle of ink in your warm zone.

Under no circumstance is the artist to refill an ink cap that is considered to be a hot zone item.

Under no circumstance is the artist to touch the cold zone with hot gloves once the hot zone has become established.

At no time is the artist permitted to leave the work area until the hot zone is completely removed by disposing of all hot zone items into appropriate receptacles.

The client is considered to be a hot zone until his tattoo is properly bandaged. This means that the artist must also have the appropriate bandaging materials out prior to activating the hot zone.

It may seem overwhelming, but zone setup takes practice and getting used to. All studios and work areas will be setup differently, and have their own little unique qualities. The zone definition will never change; no matter how the work area is setup.

Remember that after a tattoo is complete and if you are using non-disposable tubes and tips; the tubes and tips are still con-

sidered hot zone until they are sterilized. The studio must establish a policy that is known by all artists that instructs them as to the manner in which hot materials are transported from the work area to the cleaning area of the studio.

2.8 Manufacturers / Distributors

Note: none of these companies are endorsed or recommended, this is just a small random sampling to give the reader an idea of what is available in the market

Autoclave	www.medsupplier.com/autoclave
Autoclave pouches	http://www.scientificdevice.com/product_pages/autoclave_pouches.htm
Autoclave Test Kits / Spore Test	www.sporestriptesting.com/
Barrier protection	http://www.eikondevice.com/EDI_catalog/canphp/sections/disposables/candisposables-barriers.php
Chemicals	http://www.unimax.com
Dental Masks	www.dentistsproducts.com/dentist_masks/
Gloves Latex	www.dontheglove.com/latexgloves/
Gloves Nitrile	www.ammex.com/
Healing and aftercare products	www.tattoogoo.com/
Medicine Jars	www.quickmedical.com/exam_room_products/sundry_jars.html
Sharps containers	http://www.biomedicalwastesolutions.com/
Spray bottles	http://www.amazon.com/Empty-Metal-Spray-Bottles-Skrew/dp/B001B4ON7K
Squirt Bottles / non-Spray Type	http://www.pulsetattoogear.com/product.php?productid=16312&cat=256&page=1
Ultrasonic Cleaner	www.cleanosonic.com/

Vaseline	www.buythecase.net/brand/Vaseline/
Medical Trays	http://stores.medstor.com/Categories.bok?category=Stainless+Steelware%3AMayo+Trays
Products registered against HIV/HBV	http://www.epa.gov/oppad001/list_d_hepatitisbhiv.pdf
Sterilants	http://www.epa.gov/oppad001/list_a_sterilizer.pdf
Tuberculocides	http://www.epa.gov/oppad001/list_b_tuberculocide.pdf
Sterilants/high level disinfectants for equipment sterilization cleared by the FDA	http://www.fda.gov/cdrh/ode/germlab.html

"Appropriate disinfectants include:

- A diluted bleach solution (usually diluted 1:10 with water).
- EPA-registered anti-microbial products.
- Tuberculocides (List B).
- Sterilants (List A).
- Products registered against HIV/HBV (List D).
- Sterilants/high level disinfectants for equipment sterilization cleared by the FDA.

Any of the above products are considered effective when used according to the manufacturer's instructions, provided the surfaces have not become contaminated with agents or volumes/concentrations of agents for which higher level disinfection is recommended. The product label will give instructions as to the amount of disinfectant to use, the length of time it must remain wet on the surface in order to be effective, and PPE needed when using the product.

Large areas of contamination should be cleaned first with soap and water so to ensure the disinfectant works properly. Some disinfectants do not work in the presence of blood.

Fresh solutions of diluted household bleach should be made up daily (every 24 hours). Contact time for bleach is generally considered to be the time it takes the product to air dry. Store the bleach solution in plastic not glass containers."

*Taken from Blood Born Pathogen Online Certification Course

3.1 History of Machine

The tattoo machine has come a long way since its inception, but surprisingly it has really not changed too much. The basic concept is the same and even the general build is the same. The major differences are that of the materials used and the science of measuring the different variables in the way it runs.

The history of the modern tattoo machine can be traced back to the engraver tool that was introduced by Thomas Edison.(See the history of tattoo chapter for some timeline details). The concept of the tattoo machine is based on the premise that electromagnetic fields will perpetually pull down on the metal armature bar until the circuit is open, at which time the magnetic field is broken and the bar is released. When the bar is released the front spring will then retract to its initial placement, thus closing the circuit and repeating the process. This of course happens pretty fast.

While machines evolved from being single coiled to dual coiled it is still not uncommon to see a single coiled machine every once in a while, but they are not typically what is referred to as the standard tattoo machine. The evolution of the machine also includes the portion of history where the tube was included. The tube acts as an ink well or chamber to hold the ink. As the needle, which is placed inside the tube and attached to the armature bar, is drawn rapidly up and down; ink is drawn into the tube. This was a very big stepping stone in the history of the tattoo machine, because it allowed for more time to pass from the initial dipping of ink to the time that the artist had to re-dip. As with any advancement in artists' tools, this too would lend itself to assisting in the creation of more advanced works of art.

When the machine gained popularity there were a lot of individuals who decided to tinker and modify the existing design. Even today you still have tattoo artists who modify their machines, with metal bits and pieces in many forms, often hacking away or

completely modifying the frames. Another important milestone for the tattoo machine's history would have to be the rear spring. When the rear spring was added, this created an even more adjustable machine that could run a smoother cycle.

An artist should know and realize that there are many patent holders in the tattoo history books. These names are important, but they should never be looked at as the inventors and or creators of the modern tattoo machine. Many people were modifying and creating many things in the realm of tattoo, and tattoo machine innovation is just as alive today as it was one hundred years ago.

Important advancements to metallurgy and synthetic poly-material and ceramics, as well as modern coatings and treatments, have all played a synergetic roll in the tattoo machines we often see mass produced these days. In my opinion, even the handmade machines you see today will often have at least 20% of the machine's independent parts milled or created in mass quantity. It is very rare to find a 100% handmade machine (ie. washers and wire are always going to be fabricated in a factory somewhere).

An important thing to remember about the history of the tattoo machine is that multiple design geometries have been tested for years like that of the Percy Waters and the Jonesy, to name a few. These seem to be the tried and true angles and measurements for the basis of a tattoo machine. There are always going to be new geometry and fully adjustable machines that someday may completely defy all traditional geometry. Tattoo machines run using principals of science, and some people will attempt to measure every aspect of the machine; from the running duty cycle all the way down to the resistance of the metal frame. Every part of the machine can arguably be gauged with today's modern technology, and this will often help artists; who are very technical in their trade, to maintain the same working set of tools. However, when it comes down to the act of putting the inks into the skin, since skin is never the same, such variables

are not always easily measured...even ink consistency can change. It is because of these organic variables and the difference of artistic styles that tattoo machines have to be tailored to each individual, and even tailored to the specific job on a particular client's skin.

Tattoo machine history is not very old in the larger scheme of things. Unfortunately tattoo machine history is not very well documented either. It is because of the lack of solid documentation about tattoo machines, that there are not many names and dates in this text. The point that I would like to emphasize about the history of the tattoo machine is the fact that the general concept over the entire history of the mechanized tattoo machine has pretty much remained the same. That alone is enough to make me step back at times and just look in awe at what I am holding in my hand.

Eikon's Machine Gun Magazine has a very good story about a tattoo history museum, and I do not pretend to be an expert on modern history of tattoo.

3.2 Brands / Distributors

The vast ocean of tattoo gear available is almost unimaginable these days. You, as a beginner are probably familiar with the advertisements in the back of your favorite tattoo magazine or have seen the web banner ads online when you are logging into your favorite tattoo social network. If you are anything like me, you study every picture of every tattoo machine you get your hands on. You have looked at the pictures of tattoo artists, trying to figure out what they have in their hands. The available range from basic made machines to elaborate custom designed ones can be overwhelming.

How do you know which machine is a good one? Typically art-

ists will use what the professionals that they look up to are using at the time, or they take a friend's word for what is the best. The most important thing to remember is that the way you may view the tattoo machine now, as a new artist, will not be the way you view the tattoo machine after a few years or months of tattooing. This will be covered a little more in depth in the section regarding tattoo frames, but just keep it locked in the back of your mind that the frame (what you probably now call the look of the machine) is not the most important feature when selecting a machine.

As stated earlier, there are endless ads for big warehouse tattoo wholesalers out there. It has been my personal experience that some of the very best machines are the handmade ones that are very hard to come by. The very best machines that I currently use are ones that I have purchased, torn apart, replaced components on, and torn apart again. This is not to discourage you into thinking that there is no such thing as a great mass-manufactured machine out there. There are plenty of excellent, quality machines that are currently available to you from manufacturers; you may even be surprised by the cost of some of them as well. Typical tattoo machines can range anywhere from $80.00 to $700.00 and the price you pay is not always the deciding quality factor either. This will also be touched on in the portion about coils and metals later in this text.

A wise old-timer tattoo artist once told me that a good tattoo maker should be able to tattoo well with any machine, if given enough time to tinker with it. You will see your game improve by leaps and bounds if you switch from a lower class machine to a better made one. Better constructed machines made of higher grade materials will not only run cooler and smoother, but they will stay in tune longer and save you a lot of frustration while keeping your work consistent. While completing my apprenticeship I had the most out of tune and horribly cheap machines in the shop. It was that difficult training with cheap and old machines that eventually taught me that I could do pretty good work with anything. Once I was "allowed" to buy my own "real

machines" I was amazed at the increase in the quality and healing of my tattoos.

There are limitless companies that sell lower end materials and gear, however this text will not go into that aspect of the mainstream tattoo supply chain, instead it will focus on what I feel are a few basic solid pieces of equipment at reasonable prices. You can always find that $1200 tattoo machine or a $50 one for that matter in many vendor catalogs. Tattoo is just as much an art as it is a technical science, so the machine that you ultimately select to be your workhorse will have to come from your own trial and error. There is no right or wrong, best or worst tattoo machine. It is just a matter of opinion and what feels or works best for you. You have to remember that a professional tattoo supply company will not sell you gear unless you are working in a professional studio, or you are an apprentice in a professional studio and they will often ask for some sort of verification that you are a professional. This is due to the stigma that is placed over the concept of "scratching" or tattooing out of your house, or without skill. There are plenty of "scratchers" out there that own shops, but you have to respect the integrity of the supply companies that attempt to self regulate in this industry.

Please note that **I did not** receive any monetary compensation from any company mentioned in this text. The following is **strictly my opinion as an artist;** opinions on equipment that I personally have used or continue to use, a sort of equipment review if you will.

I have always liked the **Coastal Waters**™ steel machines from Papillon Tattoo Supply of Connecticut USA. These machines, in what they call "shader configuration" are perfect for me. The materials used are solid, the frame is a good weight, and the coils always seem to be pretty well matched. The only thing that I did not care for with this machine was the fact that it was fastened with cross tip screws instead of Allen key hex head bolts. Tattoo machines with screws tend to get stripped, in my experience. This is easily rectified though. I have never had a problem with

this distributor, and anytime there is something I feel is not right they are very quick and helpful. This machine is based on the Percy Waters style frame and comes in liner or shader configuration. I find it is about 90% ready to go, right out of the box. This is a perfect machine for someone looking to invest under $225.00 for a solid piece of equipment that will easily become a daily workhorse.

Another favorite machine that I own that lends itself to be extremely versatile in daily work, from heavy shading or solid color to lining with very little adjustments is my **Micky Sharpz™ Brass Hybrid**. This machine was purchased from Tattoo Bedarf in Germany, a licensed retailer and distributor for Micky Sharpz in that part of the world. I am also aware that there is a USA distributor as well, although I have not used them. This machine is very solid from the coils to the armature bar. I did not care for the distances that it had in the spring configuration, but this is personal preference and it is very unusual to find a machine that you will love directly out of the box. This machine can very easily become addicting, and may make you lazy because of its versatility. I often found myself cranking the voltage up to knock out some quick solid lines, and dropping it down to continue to shade. This machine never skips a beat, and refuses to heat up. I love the weight of this machine and it is a little more on the costly side for a standard mass produced machine, but that has a lot to do with the Euro conversion. I think I paid about $425.00 for this one. It is important to note that this is not the highest end Micky Sharpz machine, and they do offer limited and numbered series of these machines for a considerable amount more. Nonetheless this is a very stable machine, and you can tweak it to run in many configurations. Like all machines though, it is a matter of personal preference and you have to feel what is right in your own hand.

My liner of choice is the **Pulse Executive™**. This machine is extremely light and just does the job. I believe it was around $250.00, and even though I have not had it for a long time it has quickly become a favorite machine for all types of line work.

Pulse is another excellent company that is on the market and they really excel at prompt service and customer support. No, they did not pay me to put that blurb in here.

This may kill a few of you die hard artists, but I still use my **Superior Light Touch®** machine. This was the first machine I ever purchased, in a kit of all things! I have replaced everything on the machine frame with Pulse parts, and I run it with 8 wrap Shorty coils. Some artists really go for the heavy machine to offset the way they hold it, or to have that feeling of weight to control the work flow. I personally prefer as light of a machine as possible. Because I have been using plastic tubes and grips exclusively for the past 5 years, I don't have the luxury of the heavy grip to offset my machine weight. This requires me to tattoo in a completely different way as far as holding my machine than I did when I used steel tubes and grips, but that will be addressed in later chapters and like everything else in this text, my mantra once again: It's a matter of personal preference.

So as far as machines go, those are my top picks for good solid machines that can be easily adapted for a beginner tattoo artist and will get you out of the mind set of using the "toys" from the back of tattoo magazine catalogs. Remember, just because the frame is shaped like a marijuana leaf and it is dipped in chrome and highly polished doesn't mean it will do the job you think it will. It's more about the weight, the geometry, the materials, and ultimately how all the pieces work together to flow the electricity in a smooth fashion. All you new artists out there don't be sucked in by the nifty chattering skull contact screw!

I think that it is also important to note that there is this popular trend with the handmade machines. You will see a lot of really good machines that are completely handmade, to include coils. I am true believer that a machine should not look like it was hacked and welded sloppily. It is possible to have an awesome handcrafted machine that still looks clean and polished. I think that the trend of handmade machines that look really handmade is a sign that the builder does not take the time to pay attention

to the detail of the crafting of the materials. Usually the builders of handmade machines are really good tattoo artists technically, and they are the best ones to tune the machines and cut the springs. I am not at all saying that a machine that is rough around the edges is a bad thing. I just have a personal preference for a machine that looks clean and detailed, as well as it is reliable.

I have listed a few suppliers that you may want to check into for information about machines, some of these I have not personally used and some I have. I have also tried a lot of machines that are handmade and considered to be one-of-a-kind machines. This text is titled "Basic Fundamentals" because we assume that you don't have your own machines, or you are looking to upgrade. The tattoo industry is full of people who love to show off their vast knowledge of machines; you will be bombarded by artists who love to rag on you for your machine and I am not going to get too preachy in this text.

The quality of your work can be greatly influenced by the machine you use, but the machine you use will not solely determine the quality of work you produce. Remember to always remain humble about your machines, and try to learn as much as you

Buyer Beware. There are a lot of tattoo scams on the internet. The only way you can make sure you are buying a quality real machine is when you buy it from the dealer. You get what you pay for, and most **reputable tattoo supply companies will only sell to licensed tattoo artists,** *and will only ship tattoo supplies to a real tattoo studio. They may require some type of verification. So if you want good tools -* **GET AN APPRENTICESHIP!**

can from more experienced artists.

Common Tattoo Machine Builders / Distributors

Aaron Cain	http://www.aaroncain.com/
Dan Dringenberg	http://www.jokertattoo.net/tattoo-machines-20/
*Eikon™	http://www.eikondevice.com
FK Irons™	http://www.fkirons.com
+Hawk Machine	http://www.cheyenne-tattoo.com/
Joshua Carlton	http://www.joshuacarlton.com/
KingPin™	http://kingpintattoosupply.com/
Lucky™	http://www.luckysupply.com/
Marv Lerning	http://www.marvinlerning.com/home.html
Micky Sharpz™	http://www.mickysharpzusa.com/html/
Mike Young	http://tattoomachinez.com/_builders/edt/mike_index.html
National™	http://www.nationaltattoo.com/
Next Gen™	http://www.nextgenerationtm.com/
*Papillion™	http://www.papillonsupply.com/
+Pneuma®	http://www.pneumatattoomachine.com/
*Pulse™	http://www.pulsetattoogear.com/
Rollo-Matic®	http://www.taylorstreettattoo.com/rollomatic.html
Seth Ciferri	http://sethciferri.com/
Superior™	http://www.superiortattoo.com/
+Swash Drive®	http://swashdrivetattoomachines.com/default.asp
Technial	http://www.technicaltattoosupply.com/
Time Machine™	http://www.atimemachine.com/
Unimax™	http://www.unimaxsupply.com/
Work Horse™	http://www.workhorseirons.com/

* Author's Recommendation
+ Offer a non-standard (other than dual coil) style machine

3.3 Machine Parts

If you are anything like me, this is the first chapter you always skip to when you read anything about tattooing. I am always hungry to learn what different artists refer to different machine parts as, how they claim to tune the machine and their overall opinions in general.

"Opinion" is the buzzword when you are researching and learning about tattoo. There are some pretty commonly agreed upon titles for tattoo machine parts and areas. It is not uncommon to have one book refer to a machine part by a particular name, and then another book refers to that same part a completely different name while both books will utilize verbiage to the point you may think you are reading a dictionary. My focus will not be so much upon the title of the machine part, but more on what the machine part is utilized for.

This text is not going to emphatically insist that all tattoo artists refer to a part of the machine by a certain name. Although, this would be very helpful to the industry if a set of guidelines were established by a governing body. This governing body could also decide on the proper terminology to be used when teaching tattoo theory. This is all a pipe dream at present day, but there are a few corporations and organizations out there that are attempting to create the tattoo lexicon.

No matter what you call the parts of a tattoo machine, how they all function is the important thing to analyze. Each component has an important role. Some components can be argued to be part of a larger set of components. These sub-components make up what we will refer to as primary systems of the tattoo machine.

It is pretty much mutually agreed upon by all artists that there are at least two primary systems on the tattoo machine. Some will argue that there is a third system as well. Whether you

choose to acknowledge the third system is once again, like everything else in tattoo; a matter of personal preference. For the sake of maintaining some cohesive structure in this text, we will assume that there are two primary systems on the tattoo machine. The third, arguable system will be touched on later in hopes that the artist will be able to understand the complexity of its assignment. The first prime system is the Electrical System and the second is the Mechanical System.

Mechanical or Electrical, which comes first? This is another classic example of the chicken or the egg question that plagues humanity. If you are articulate enough, then it is very possible to claim either. I like to refer to the Electrical System as the originating primary system because it can be argued that the electricity creates the electromagnetic field, which causes the armature bar to pull down. This magnetism created the first mechanical movements. It can also be arguably reversed, in the case that some tattoo artists run their machines to a tuning that actually requires the physical movement of the armature bar by the flick of their wrist or their thumb. This flick will then set in motion enough resistance and spring energy to keep the cycle going; its driving force is the combination of the electricity and the spring energy. However you label the process of the systems, it is obvious that they require each other to work properly.

The mechanics of the machine will be covered later in this text. It is important to understand the concept that **the machine can be broken down into sub-groups or systems**. Understanding how each system works will ultimately help you understand the overall concept of how the bigger picture fits together, ultimately allowing you to own control of your fine adjustments based upon your mechanical machine knowledge.

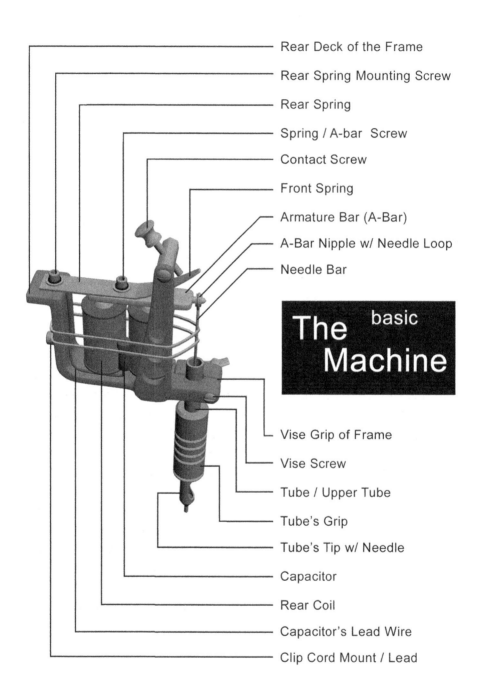

Fig 3.1 - Tattoo Machine - Computer Generated 3D Render

3.3.1 Machine Parts - Metals

Metal is all over the tattoo machine. 90% of the tattoo machine is made of some type of metal, and the type of metal will determine a lot of things about a specific machine. The most prominent part of the tattoo machine that is made of metal is the frame.

Tattoo machines work off of an electromagnetic coil. It is usually agreed upon by artists that the coil has to run in a horseshoe configuration to achieve synchronized pull. This can only be achieved if the cores inside the wire wrapped coils share a conductive base. Only certain types of metals will allow for the maximum effective conduciveness to occur. The general rule of thumb is that if your machine is made of anything other than iron or steel, then you are required to use a yolk. A yolk is the base-plate that the coils will rest on. The yolk is fastened to the frame by means of the screws or bolts that hold the coils on the frame. The bolts will pass through the bottom of the frame, through the yolk, and into the coil core. The coil cores are typically pre-tapped. This is very important to be aware of because a lot of cheaper frames are not steel or iron, and do not come with a yolk. The machine will run without the yolk, but it will run a lot better with a yolk installed.

A lot of artists will use different machine frames for different purposes. Typically a machine frame is made of iron, steel, brass, aluminum, a metal-ceramic polymer, and even plastic. It is arguable that the machine frame's purity of metal content will assist in creating a solid magnetic field. This magnetic field will help the machine consistently run in the same manner. Lower grade metals are argued to change in magnetic field strength the longer they have electricity running through them. This would alter the consistency at which the machine could optimally run in theory.

The purpose of this text is not to argue machine semantics or theory, but instead to convey the generally well known principles

and practices in the tattoo industry. I have not done extensive testing on tattoo machine metallurgy to measure resistance and magnetic field changes, nor would I really care to. With that being said, there are a few organizations out there that have done a great deal of research and have developed very scientific ways to measure numerous things on a tattoo machine. While this is becoming an acceptable practice in the tattoo industry, it is still very common for tattoo artists to use only their human senses to adjust and maintain their tattoo equipment.

Different metals have not only different resistance to electrical current, but different weights as well. Some artists will prefer to utilize a lighter machine, and some will prefer more weight. This is all just a matter of preference and there is really no right or wrong metal for a tattoo machine frame to be cast out of. It is common knowledge that brass machines will typically reduce vibration, while iron machines will allow you to not require a yolk, and aluminum machines are light weight. These are just rules of thumb, as it is possible for an aluminum machine to weigh more than an iron machine. The variety of tattoo machine metals is limitless and very interesting. I would encourage you as a beginner to experiment with different metals until you find the feel and electrical resistance that matches your style of tattooing.

It is also important to note that the machine frame's metal is not the only factor you have to consider. The coils, springs, armature bar, capacitor, and contacts in that order are also important. It is almost a balancing act of importance. A change in one area of the machine will require compensation or a change in all others typically. These are the things that will require experimentation. There are general rules of thumb, but you really have to want to learn how it all works. If you do not have the desire to gain the ability to tune and tear apart your machines on the fly, you will more than likely just be another mediocre tattooist.

3.3.2 Machine Parts – Frame

As mentioned in the section about metals, the frame is the bulk of the metal on the machine. There are infinite styles of machine frames available. Some machine frames are cast from a mold and others are milled out of a solid block of metal. Additionally, some machine frames are component-based; they will have all the different parts held together by bolts, instead of being one solid piece of metal. Machines that have a component-base frame can become loose, and require maintenance to maintain their consistency, but it depends on the manufacturer and quality, like all other things.

The way the frame looks on the side is argued to be only superficial by some, and countered by others to be a prime source of magnetic field origination. This second group argues that the amount of metal content in the frame will determine the effec-

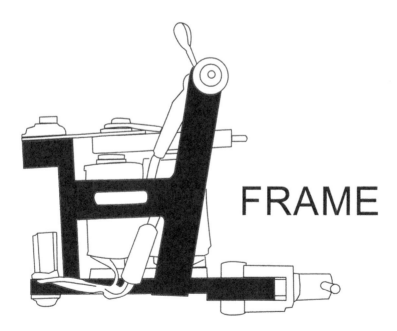

Fig 3.2 - Tattoo Machine Frame - Filled in Solid Black

tiveness of the magnetic fields created by the electrical system.

Important parts of the frame are the location where the contact screw is located in relation to the tube vise hole, and its overall geometry. The overall geometry is the location of the holes that are tapped in the frame in relation to one another. These holes are arguably supposed to be in perfect alignment to create optimal magnetic pull on the armature bar. The rear spring will attach to the back of the frame, thus controlling where the front of the armature bar will end up. If this geometry is not in relatively perfect alignment then the armature bar nipple will not move directly above the tube vise hole. This also goes to say that if the holes are not in alignment, then the armature bar will not be directly above the coil cores. When an armature bar is not directly above the coil cores, maximum efficiency of the electromagnets cannot be achieved.

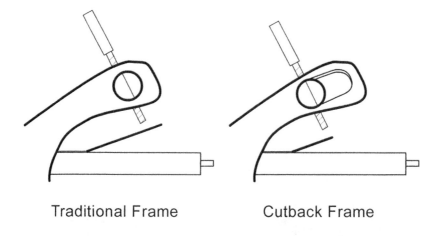

Traditional Frame Cutback Frame

Fig 3.3 - Traditional vs. Cutback Frame Style
Note that cutback typically has a shorter front spring and is intended to run faster than a traditional setup

Frames can reveal how a machine is intended to run by the creator of the frame. This is prevalent in the typically agreed upon style of the cutback frame. The cutback tattoo machine frame will have the hole where the front contact screw binds into,

tapped further toward the saddle or rear of the tattoo machine. This can arguably increase the speed of the machine when it is compared to the same machine frame with a contact post more toward the tube vise hole. It is commonly known that the term cutback comes from tattoo artists trying to speed up their machines by moving the contact screw further back. They would literally cut back the frame where the contact screw would mount, allowing them to relocate the contact screw and put a small front spring on the machine. Some machines have the ability to fully adjust the binding post mount, by having a notch milled out of the frame in a manner that will allow the entire binding to

How do you tell if your machine is a cutback? If the contact post assembly is moved further back than a normal machine it might be considered a cutback. The actual frame does not have to be cut in order for the machine to be called a cutback. If you have a contact assembly that is further back then you might have to use a smaller spring on the front. Smaller springs are typically stiffer than larger ones.

be freely moved from front to rear. While these machines are great for customizing of the overall performance of the machine, they can loosen up over time and must be observed regularly to obtain a consistent workflow. Some frames have so many adjustments that they are best avoided by a beginner tattoo artist. You will see some tattoo artists that are perpetually fidgeting with their machines during a course of a tattoo; making fine adjustments, and even pulling out the hex wrenches to make more major adjustments. Other tattoo artists can go weeks and

months without even touching the contact screw.

Like everything else in the world of tattoo, there is no such thing as a "best frame". You will notice that a lot of the frames available on the market have similar geometry to the tried and tested age old designs. It is always a matter of preference when selecting a frame. It is important to ensure that your tubes will fit the frame tube vise hole, or you will have to mill this out yourself. It is also important to know the type of metal that your frame is constructed from, in order to determine if adding a yolk would be necessary. Pay a lot of attention to the quality of the frame, especially in the tube vise area. The tube vise is one of the most used parts of the tattoo machine. An unforgiving and menacing vice will cause an artist a lot of unwelcome frustrations during the setup and tear down, and even possibly while tattooing; this is seen more with the lower quality tattoo machines. It is also possible to have a tube-vise that will damage your tubes by crimping or bending them.

A very attractive advancement in frame design is a notched out rear saddle in the frame. This is the area where the rear spring will sit on the frame. When this area is properly milled out it allows the spring to be set perfectly in alignment with the intended geometry of the frame, and ultimately requires a lot less time to obtain a straight configuration for that portion of the machine.

A lot of frame designers and distributors will spend time talking to a prospective customer about their frame. Usually a tattoo machine maker puts a lot of thought into the placement of all the components of his frame, so don't be afraid to ask questions about the frame, and its indented setup and use.

3.3.3 Machine Parts – Coils

The coils are the prime power-plant of the tattoo machine. In my

opinion the coils are the most important part of the actual tattoo machine. The coil is composed of a core that is wound with wire. There are typically two coils on a tattoo machine. The coils are joined by a capacitor.

As electricity flows through the tattoo machine it travels around the coils in the wire, creating an electromagnetic core. It is this magnet that will pull down on the armature bar and force the needle into the skin. When the armature bar is pulled down, the front spring that is attached to it loses contact with the front binding contact screw. When the contact screw loses contact with the front spring, the electrical circuit is turned off. While the circuit is off, there is no electricity flowing through the coils (or a very limited amount); causing the armature bar to be released from the magnetic field pulling it down. This obviously will remove the needle from the skin and complete the cycle.

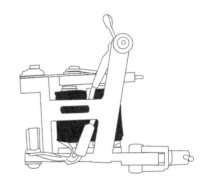

Fig 3.4 - Coils on Tattoo Machine

If this seems too complex to fathom right now, just remember that the coils are magnets. They are magnets like the kind you made in elementary school with a battery and a screwdriver that had wire wrapped around it. As the Armature bar moves it is turning the battery on and off very fast while the magnets are also turned on and off very fast.

Coils come in all different shapes and size variations. The most common variance is observed by the number of wraps that a coil will contain, usually anywhere from seven to fourteen. Popular wrap counts are eight, ten, and twelve. This simply is the count of how many times the insulated wire is wrapped around each core. There are different shaped cores on the market as well, while the most popular is the circular shaped core; however there is also octagon, square, and oblong shaped cores as

well. Coils will typically be sold in matched pairs. Matched pairs simply mean that because there is a variance during the wrap process, two coils will be selected that have complementing electrical properties, since that will increase the effectiveness while they work together. How these "effectiveness" qualities are measured is really up to the manufacturer.

A cheaper tattoo machine can be greatly improved upon, just by changing the pair of coils out with some aftermarket ones. There are dozens of distributors that make coils. Coils can typically range from $10.00 - $50.00 a pair. It is also possible to buy coils without a capacitor, as well as unattached in a paired configuration.

Coil wraps are the material that is used to cover the coil. Coil wraps can be heat-shrink tubing, or a sticker. There are limitless designs for the sticker coil wraps; the most common is the checker holograph style. The coil wrap really plays a limited role in the effectiveness of the coil and is for aesthetic purposes more than anything.

Experiment with different coil sizes (heights), and wraps. You may notice that less wraps will turn the magnets on and off faster because there is less resistance to complete the circuit. You may also notice that the more wraps contained in a coil, the stronger the magnet will be and can increase the hardness that the armature bar will hit. Like everything else in tattoo, it is always a matter of preference and there is no specific way to setup your machines. Coils are no exception to this rule of thumb. A new school of experimentation has led one manufacturer to utilize a longer coil in the front and a shorter coil in the rear. The shorter coil is mounted on a riser.

Steel wool is a commonly used item in coil setup. The coils have to be mounted to the tattoo machine frame by means of a hole tapped in the bottom of the core. Sometimes there is a hollow space above where the mounting screw will be located. This space is filled with steel wool to increase the solidity of the coil's

core, creating a stronger magnet.

It is important to remember that less wraps in a coil means less resistance. Less resistance means that the voltage can in theory get to the place it is going to, faster. The gauge of wire will also affect this. The resistance is often countered with capacitors. Taking that into consideration, you can see why a lot of people would think that more wraps should mean a stronger magnet. I believe that the opposite is really true as far as tattooing is concerned. This is because the magnets are turning on and off so quickly, in order to maintain a good solid magnet flow you want to not only control the strength of the magnet while it is on, but you want to ensure that is has no magnetism while it is off. It is like everything else in tattooing, a balancing act. There is no real best coil configuration out there. It is all a matter of how you like your machine to run for the style and speed you tattoo. I think that the coils are the most difficult thing for a new tattoo artist to grasp, and the hardest thing to really teach.

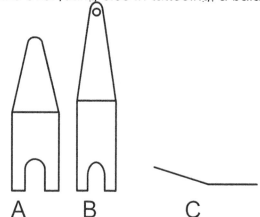

Fig 3.5 - Front Springs: A. shorter spring, B. longer spring with contact point, C. side view

3.3.4 Machine Parts – Front Spring

The springs are what give the tattoo machine its fluid motion flow. They are the physical mechanical component that will primarily determine how well the machine runs, and in what capacity. Springs can be thought of as the bridge between the mechanical system and the electrical system in the tattoo machine. The mechanical system refers to the movement of the armature bar and needle; while the electrical system refers to the current

and electromagnetic fields.

The front spring is mounted to the armature bar, and is the piece of metal that will make contact with the front contact screw. As the armature bar moves due to the magnets in the coils pulling it down, the front spring will move with it. As the front spring looses contact, with the contact screw, the electrical circuit is open. As the spring retreats back upwards it will hit the contact screw and absorb some energy and spring back down after the circuit is reopened. So you can visualize that once the cycle has started it is not just the magnets pulling down the armature bar, but it is a smooth balancing act between the magnets and the springs' ability to transpose the stored energy from being physically hit.

Some front springs will have a small amount of silver attached

The front spring which is also called the timing spring or the control spring has a lot to do with the speed of your machine. A harder front spring will make your machine faster because the front spring absorbs shock or recoil when the armature bar is retracted after a cycle. Because the armature bar gets pulled down by magnets then released when the magnets turn off, the rear spring has some tension on it and it bounces back up. When the rear spring bounces back up it has the armature bar and front spring attached to it. The front spring will shoot upwards and it will touch the contact point. If the front spring is soft it will absorb a lot of energy and flex. This flex will actually slow the cycle down while the circuit is re-closing and starting the cycle again. If you have a harder front spring then there will be less flex and the circuit can start over a lot faster.

to their tips. This is simply a spot for the spring to make solid contact with the contact screw. A majority of front springs do not have this contact point on them since it is not always preferred by artists.

Springs are available in different gauges and different metals. It is not necessary to match the same gauge metal on the front spring with the rear spring. Springs come in all different shapes as well as thickness ranges. Typically shorter length springs are designed for a frame that has the contact binding located further to the rear of the machine. The length and the harness of the springs can be a prime determinant in the speed of the machine.

3.3.5 Machine Parts – Rear Spring

Like the front spring, rear springs come in different gauges and shapes as well as a host of lengths and cuts. The rear spring has the important role of storing the bulk of the energy from the armature's bar movement transaction. The rear spring is mounted on the rear deck of the frame.

Often times there will be a deck clamp fastened on top of the rear spring above the rear of the frame. This deck clamp can be effective when it is compared to a circular washer because it will allow the balance of the energy to be evenly distributed across the width of the entire spring instead of the portion where the peak of the circular washer resides. An old school trick that many artists have adopted was to take a coin of some sort, and cut it in half. The coin was then tapped with a hole in it, and utilized as a deck

Fig 3.6 - Rear Springs

clamp. Now there are a lot of manufactures that distribute deck clamps in a variety of materials.

The rear spring's relation to the front spring and armature bar is important to the geometry of the frame. These four pieces of the tattoo machine should be aligned as much as possible to ensure that optimal energy is transposed. If the alignment is off, the needle will not enter the bottom of the tube's tip in a straight manner, and a lot of energy will be wasted during the mechanical systems cycle.

3.3.6 Machine Parts – Capacitor

The capacitor is a very important part of the coils as well. It technically is not part of the coils, but for the purpose of simplicity and general knowledge, this text will refer to the capacitor as a subcomponent of the coil. The capacitor is measured in microfarads. Usually a DC current capacitor is utilized in the construction of tattoo machine coils. DC means that the coils have to run in a single direction in relation to the electrical current or else the capacitors have the opportunity to explode. Pay attention to the arrows on the capacitor, as this will inform the artist as to which lead of the clip cord should be attached to which end of the tattoo machine and it is possible to run the voltage reversed. There may be some lack in performance or overheating and as mentioned earlier the capacitor may fail and explode. Capacitors may also be heat-shrink wrapped and you may not be able to see the rating number on the capacitor or the directional arrows. If this is the case, then observe the notched groove in the capacitor; this will notify you of the proper voltage direction.

Capacitors will store voltage. When the capacitor is full of voltage it lets out a burst of stored voltage, and then begins to store it again. It does this by the use of filaments. It is not that important to know how they work, but it is important to notice the af-

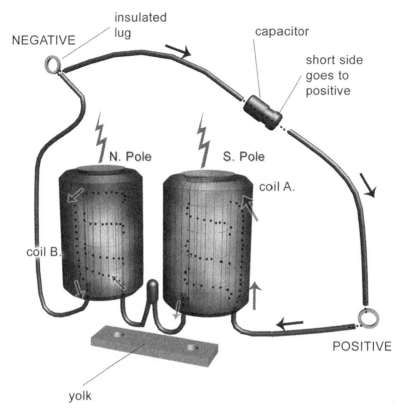

Fig 3.7 - Tattoo Machine Coils and Capacitor
NOTE: *The wires on the coils are wrapped in such a manner that they will create a horseshoe style magnet when electricity flows. The capacitor will store energy and release it when it has reached full charge. The yolk will provide a conductive base for electrified coil cores to connect on a non-conductive tattoo machine frame material.*

fect they will have on your machine. I have seen some texts and heard some artists say that the capacitor is only there to relieve the amount of spark that you see on the contact area of the machine. This is simply not true. The capacitor can actually change the speed that the machine runs! A really good trick to figure out the best cap for your machine setup is to have interchangeable caps with clips on them. You can have your machine all setup and running, and have it so that you can quickly remove the cap and swap it without having to tear the whole machine down.

You can then see which one will work for your setup by observing the way the machine runs. If you are using a meter that will gauge the duty cycle and speed you can take note of those measurements as well.

Do not be afraid to ask for specific caps when you order pre-wired coils. Or you can order coils that have no capacitor at all, and you can add the preferred size yourself. It is very simple to solder a cap to the coils. It is also important that you own a solder iron and are aware of the right types of flux for soldering with silver bearing solder. Check with your electronics supply stores, or professionals to get the same quality stuff that they use on circuit boards and stay away from thick paste flux, typically used in pipes.

Small capacitors can make your tattoo machine run faster. Not small size, but small rating in the micro farads. This is because they recharge like a battery, and are filled with some type of material that can store electricity. When they are recharged they will burst their stored energy to the circuit. The smaller the rating then the smaller the battery size, and the quicker they will fill and release. If you put a bigger cap on your machine then it will take longer to store the energy, but it will have that extra reserve juice to kick in when you are bogging down the machine with additional pressure.

3.3.7 Machine Parts – Armature Bar

The prime component, as far as movement is concerned, in the tattoo machine is the armature bar. The armature bar has two functions. The first function is to attach the needle to the machine. The armature bar's second mission is to act as a polar opposing force to the machine's magnetized coils; this also means that the armature bar assists the front spring with opening and closing the circuit.

Armature bars can come in a multitude of shapes and sizes as well. Some will have notches or holes drilled in them while others might resemble the shape of the number 8. These shapes and designs are to modify the weight and surface area that is in direct relativity to the magnetic cores. You will have to experiment with the different types of armature bars to see the different effect you can achieve. Experiment with metals, shapes, and lengths since each individual artist has their own preference.

A lot of rules of physics can be applied to the armature bar. This is important to note when you are trying to lighten or increase weight to the armature bar. Taking weight off the front will react differently than taking it off the rear or taking it off the entire surface in equal amounts. You still need the metal and weight for the balance and attraction for the coils. This is just another example of the great balancing act. The more you experiment with different a-bars, the more you will see the im-

Fig 3.8 Armature Bar (a-bar) shown in grey - in relation to the springs and rear of the frame

mediate difference you can make happen just by changing one component on the machine. It is always good to set a benchmark or standardized way you measure the changes when you swap out a part on the machine. That means run your tests the same way, and use the same voltage. It is also important to test the changes with a needle and tube on the machine, as it will greatly impact the performance of any part of the machine that was modified.

3.3.8 Machine Parts – O Rings

There is more often than not, an o-ring looped around the front spring. This will aid in the transition of energy created by the

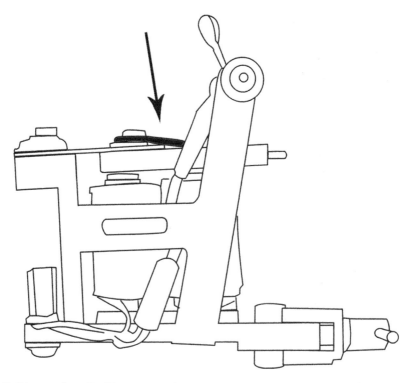

Fig 3.9 O-Ring - identified by arrow, the o-ring wraps around the front spring and the binding bolt that fastens the front spring to the a-bar

front spring hitting the contact screw. Different thickness o-rings should be experimented with. There are some artists and machine builders who swear by them, others that say they simply cut down on noise. I have personally not seen a drastic change when tattooing with or without. I believe that if you can get used to tattooing without them you will be better off, because they do eventually dry rot or snap. This will leave you trying to find the exact same style and hardness of rubber to replicate the tuning you had going before it broke.

3.3.9 Machine Parts – Contact Points

The contact point is another important part of the tattoo machine. The contact point is the tiny actual spot on the machine where the magic happens. Electricity flows through the machine and ends up in the contact point, and it needs to get back to the negative lead. The way that it does this is by means of the front spring. When the front spring hits the contact point the circuit is closed, and the magnets turn on. When the magnets turn on and pull the armature bar down the circuit is then open and the magnets will turn off. This cycle is repeated.

Typically the contact point will be at a 90 degree angle in relation to the front spring. This will ensure that there is optimal surface area between them, and provide for good conductive contact. The contact point does not have to be at 90 degrees, and this is where the tuning will come into play. Each artist likes to set up their machines differently. The rule of thumb, for a non-adjustable binding post, is to always put the machine's contact point at the 90 degree angle against the front spring. This is usually how the machine's frame designer envisioned the machine working. This will not work in theory if the front and rear spring lengths have been modified from the original setup.

I have heard some artists say that the machines that hold a

contact point at 45 degrees are European style setups. I have not really found this to be true overall though again preference varies.

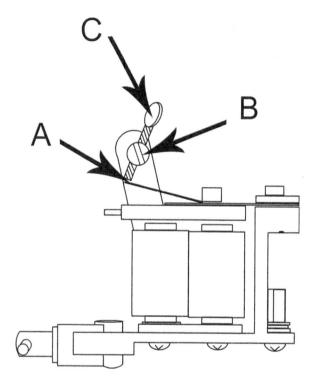

Fig 3.10 Contact Point / Screw on Tattoo Machine: A. 90 degree angle where contact hits the front spring, B. binding post used to fasten the contact screw - loosen this screw to change point gap of machine, C. contact screw head - top of contact screw - typically has some type of grip for adjustments to the contact screw

The contact point can be made of different metals. One would assume that the best quality metal would be the most conduc-

tive. Typical contact point metals are brass, copper, and silver.

If corrosion occurs, or the contact point becomes warped or worn, you may file the contact point to a smooth flat finish; this will bring the surface area back to optimal ranges.

Some artists will purchase contact points with a design on the top. You may have seen this design as a dice, skull, or almost anything that is imaginable. Do not be fooled by the clever novelty of the contact point cap design. This item really has no bearing on the actual efficiency of the contact point, and can cause your contact point to cost twice as much. It is simply an aesthetic device. Until you have reached a fairly decent level of tattoo skill, it is probably best to avoid these novelties. Stick with the humble machine styles, and you will earn your peer's respect.

Like everything else on the tattoo machine, experiment and play around to find out what works best for your style and your specific machine. Some artists will claim that a certain metal will increase the machine's efficiency; others will tell you that it makes no difference.

One note to keep in the back of your mind is that if your contact point is really spitting out a lot of spark, you may have an issue in your machine somewhere. It could be a bad capacitor, or too much voltage among other things. Keep an eye on your contact point, it will have to be adjusted as it wears down in order to maintain consistent tuning. You can also change the way your machine drastically runs just by increasing the length on the contact point by screwing it up or down towards the front spring.

3.4 Machine Build

The first thing a new apprentice should do upon getting their first tattoo machine is to take it apart. It is very important for a tattoo artist to know exactly how the entire machine works, and how it is assembled. There may be a time when a part needs to be changed out on the machine and with very little time to spare. Typically a tattoo artist has a whole host of machines, and a spare should always be ready. Nonetheless, it is always recommended that every tattoo artist who is starting their career be able to disassemble and reassemble their machine (actually it is pretty much a requirement).

Hopefully this section of text will take some of the mystery out of the actual construction of the tattoo machine and its components.

Each tattoo machine has different fastening pieces. Bolts, screws, and hex-head pieces are the common fasteners for tattoo machines. Each artist has his own personal preference. It has been this author's experience that flat and cross tip fasteners are easily stripped, and difficult to work with so I have come to really enjoy machines that have Allen key or hex-head bolts. A good solid tattoo machine will typically be made of higher quality materials, and the fasteners are no exception.

Since you should already be familiar with the parts of the tattoo machine, this section of the text will not go into too much detail of what each part does. Instead, this portion of the text will focus on the actual assembly of the machine. There are a lot of little tricks of the trade about the way you can put your machine together. It is not very difficult to do, and since most machines are very similar, once you have done it a few times you should be comfortable tearing apart anything that is used to tattoo.

REMOVING THE TUBE FROM THE FRAME

Before we attempt to tear down our tattoo machine we need to ensure that there are no detachable parts on the machine. Detachable parts are the rubber bands, needle bar, the tube, the tip, and the grip. If your machine came from the manufacturer with these items attached you should remove them. First take the rubber bands off the machine, this should be self explanatory. Next take the needle bar off the armature bar nipple. There may be a 50% grommet on the armature bar or there may be a 100% grommet attached to the needle bar. If you have a grommet that is seated inside the needle bar, it will stay with the needle, where as a 50% grommet will stay affixed on the a-bar (armature bar). Once your needle bar is removed from the a-bar it should slide loosely into the bottom of the tube's tip. Next you will loosen the frame's vise. Loosening the frame's vise will allow you to remove the tube and grip assembly from the frame. There are different types of frame vise tightening apertures available. This is a key piece of the tattoo machine, and it is a sign of quality when you have a sturdy frame vise. Once the frame vise is loose, you should be able to slide the tube, the tip, the grip, and the needle bar assembly

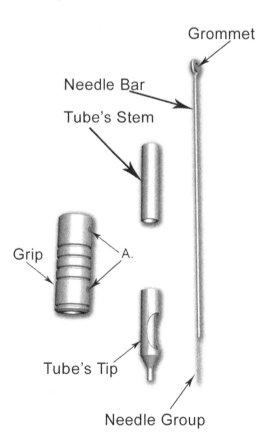

Fig 3.11 Tube, Tip, & Grip: A. note the holes where the screws that fasten the gip to the tube are located

down through the frame vise loop; remove it completely from the frame and set it aside on your work area. Pay attention to the direction that the needle grouping is soldered to the needle bar in relation to the way it is protruding out of the bottom of the tube, and make a mental note of this.

REMOVING THE GRIP FROM THE TUBE
You may have noticed that your tube has small holes tapped into the grip portion. It is okay to take the hex head bolts out of the grip, and examine the type of tube you have. Some tubes are single piece; where as other tubes are composed of two parts. The two part tubes are typically male and female ends, and lock together. It is not uncommon to see a two piece tube set that does not lock in place though. I recommend that you

When you clean your tubes, tips, and grips – you have to tear them all the way down. This includes taking out the screws that hold the grip onto the tube's stem. This is why it is recommended that disposable tube/tip combos be utilized. Some artists will complain that the plastic is a hindrance to their work. There are disposable tips and grips on the market that are all plastic with a metal tip attached; a little pricier, but a lot better than trying to clean the tubes properly.

use plastic tube and tip assemblies, but metal is more commonly used at the time this text went to print. The bottom portion of the two piece tube set is what is referred to as the tip. The tip can come in many different shapes and sizes. These configurations are specifically designed to work with different

needle groupings. You want to ensure that your needles don't move around too much in the tube's tip. But you also want to make sure that it is not too tight or it will restrict the flow of ink. It is important to know your grips intimately, because certain tube assemblies will not work with certain grips. As a tattoo artist you should have ten to twenty of each style tube tip that you use on a regular basis when using metal tubes and tips. This is for the sake of having enough clean ones on hand while the others are going through the autoclave process. Often times the tattoo studio will provide tubes and tips for you to use. This is dependent on the arrangement you have with the studio.

REMOVING THE CONTACT SCREW (CONTACT POINT)
So now that we have taken our tube off the machine, we are ready to disassemble the physical tattoo machine. On the top front of the tattoo machine (the portion that is closest to the client, and above the a-bar) is the contact screw. The contact screw is usually mounted to the highest point on the machine frame. The purpose of the contact screw is to be a point of completion for the electrical circuit of the tattoo machine. To remove the contact screw, first loosen the contact set screw. The contact set screw is located perpendicular to the contact screw itself, and holds the contact screw in place. Once the contact set screw is loosened the contact screw itself will be able to rotate counter clock wise until it comes out of the front binding post.

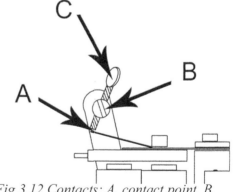

Fig 3.12 Contacts: A. contact point, B. adjustment screw on binding, C. contact screw (arrow points to the head of contact screw)

REMOVING THE FRONT BINDING POST
Usually on the opposite side of the contact set screw is another fastener, this is the front binding post mount screw. The front binding post mount screw will typically be a hex head, but it is

possible to have a flat or cross tip screw as well. This screw is insulated by plastic or nylon. Remove this screw and notice the wires that are attached to it. Pay close attention to the order that the wires go in relation to the insulating pieces. You should now be able to take the front binding post completely off the machine. Why is the front binding post insulated (separated by a plastic/nylon part)? The reason is that the tattoo machine is a DC circuit. The current has to have a positive and a negative. If the binding post was not insulated it would complete the circuit at the point where the top wires touch the frame. By insulating the wire the tattoo machine's circuit connection point is relocated to the tip of the contact screw allowing the machine to properly function. An important troubleshooting technique is to check out these insulators, as they often become worn down and will cause a "short" in the circuit.

Fig 3.13 Contact Binding Post Fastening Screw: remove this screw and the actual binding post will come off the neck of the frame - pay attention to the order of the washers that include insulated and metal washers

REMOVING THE ARMATURE BAR ASSEMBLY

The armature bar (a-bar) assembly is the prime moving piece of the tattoo machine. It is responsible for making the conversion of electric energy to physical energy (along with the magnets in the coils of course). The a-bar assembly consists of the a-bar (obviously), the front and rear springs, and the hardware. The a-bar is a unique animal, in the past decade it has changed so much that you could write a book about the a-bar itself. With

advancements in the way people are seeing their machines, and the commonsensical approach that is now being utilized in tattooing. The a-bar is becoming more and more an integral player in the tattoo machine. There are a-bars that look like a figure eight; there are also a-bars that are tapped out with additional holes and groves. This is to add balance and counter balance to the a-bar. Some machine builders will also swear by the influx in magnetism that can be altered by changing the design of the a-bar. A-bars, more recently, have been altered in a way that will allow the tattoo artist to use flat springs on both the front and rear of the machine. To remove the a-bar assembly from the tattoo machine you must locate the rear spring of the tattoo machine. The rear spring is the spring that is attached to the top rear of the tattoo machine. Usually there is some sort of riser or backing plate on the machine on top of this spring, but not always. If there is a riser on the back of this spring, or a washer that has been cut flat, you must remove it as well. Loosen the rear spring mounting screw from the deck of the frame. Once this screw is fairly loose, you should be able to slide the entire a-bar assembly off the machine. You should now be holding the rear spring, the armature bar, and the front spring (or altogether, the a-bar assembly).

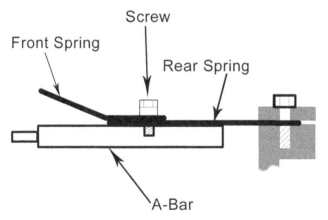

Fig 3.14 Armature Bar Assembly: note that the frame's saddle and the back plate (deck clamp) on top of the rear spring are grey in this image

REMOVING THE SPRINGS

Now that you have the a-bar assembly off the frame you can dissect this portion even further. You will notice that there are

three primary parts to the assembly. The heavy metal block is the armature bar, the spring that was attached to the saddle of the frame is the rear spring, and the triangular spring is the front spring. This makes sense because if we orientate the machine toward the client, the spring that is closest to the client (on the front of the machine) is the front spring. The saddle of the frame (which is closer to the artist's hand) is the back of the machine, so this is where the rear spring gets its name. The rear spring has a slight angle to it and sometimes it is not even noticeable. The front spring usually has a pretty good angle on it so that it reaches to contact screw's point. The springs should be held in place by a hex head bolt or a cross tip screw. You may notice some washers as well. Pay attention to the order of these parts prior to removing the springs from the a-bar. There are some models of a-bars that have angles tapped into them. This is so that you can use flat rear and front springs. The a-bar will have the proper angle already milled out, so that no angle is required on the spring.

REMOVING THE COILS
On the bottom of the frame are two fasteners. These are typically hex head bolts, but again they might be cross tip screws. Remove these two screws. These screws will hold the coils to the machine. Make note to which coil is your front coil and which is your rear coil. You may have a yolk as well. The yolk is a block of metal that sits in between the coils and the frame. You will also have to remove the rear binding post to remove the coil wires from the frame (see Fig 3.7).

You should be left with a naked frame. Once you have removed all the parts of the machine, you are now ready to re-assemble the parts. There is really not much to the machine, and it is important to be aware of all the components so that you can put it back together properly. To re-assemble the tattoo machine you can follow the same steps you did while tearing it down, only in reverse. This may have seemed like a very easy task, but it might be very daunting the first time you look at the tattoo machine. You should be able to tell how the machine parts work

together by the basic assembly mechanics of the machine. This will help you to troubleshoot the machine when a problem arises and quickly rectify any situation.

IMPORTANT THINGS TO REMEMBER WHEN BUILDING MACHINES

You can only bend the rear spring a few times before it is unstable. Too many bends in a rear spring will cause it to become brittle and possibly snap during a tattoo.

If your coils are too high, meaning they touch the a-bar, you can file them down a bit with a straight file. You can also remove a few coil washers if needed.

The a-bar can be modified to be lighter in the front by tapping holes in it.

Try not to over tighten the screws or fastening bolts.

There are tools you can purchase to properly align your springs and a-bars to the tube hole on the front of the machine. Proper alignment is very important. In order to get a maximum transfer of energy from the rear spring to the a-bar you have to get the springs in alignment with the frame geometry, and the a-bar. Pulse™ makes a nice one; it looks like a tube, but has a notch in the top for the a-bar nipple to set in. This will let you get the alignment just right from the a-bar to the tube-vice hole.

In order to achieve maximum energy from the rear spring you should use a deck clamp. The deck clamp will make a flush line and allow for optimum surface area of the rear spring to be utilized on the upward and downward movement of the rear spring.

If you over tighten the screws that hold the front binding post to the frame you may push the nylon spacers into the frame and short out the circuit. These spacers are the ones that are referred to as insulating pieces in the section about removing the

binding post.

Have your machine hooked up to a power supply while you are putting the a-bar assembly back on the machine – this will help you to properly tune it before you tighten everything down.

Remember you have a host of aftermarket parts available to you, and you do not have to keep the manufacturer's parts on the frame. Sometimes you can increase the performance of the machine by swapping out just a few simple parts.

It can be helpful to use a table vise to hold the machine in place while trying to re-assemble it.

There are a ton of things to keep track of. It may seem tedious at first, but this text only scratches the surface. There are other texts available about machine building and tuning. It is really important for you to understand how your machine is setup and how it reacts to certain changes. The ultimate test is how it works in the skin though.

3.5 Machine Tuning

Now that the apprentice is familiar with assembling the tattoo machine, and is able to do it in their sleep if required; it is time to focus on making the properly assembled machine run the way that will work best for his style of tattooing. Tattoo machine tuning can be a very guarded secret of some professionals, however a growing number of artists are willing to share their lessons learned. This text will go over some of the commonly known basic rules of thumb for tattoo machine tuning. It is important to remember that what one artist will use as a liner setup, another may use as a shader. There is no right or wrong way to setup the actual tuning of a tattoo machine; it is all relative to the art-

ist. Just like there is no right or wrong way to hold a pencil or a paintbrush, there is no right or wrong setting for a tattoo machine to run. The ultimate judge will be the client, and the final healed tattoo that comes out of the session.

It is commonly agreed upon by tattoo artists across the world that consistency is the key. Once the artist finds what works best they should make every attempt to document and remember the settings and configurations. This is where the art form meets the technical aspect of tattooing. If an artist is very talented graphically, yet he cannot consistently perform in skin, then he will more than likely not succeed as a tattoo professional.

Hit versus Momentum

When speaking of how hard a machine runs we are generally speaking about the hit of the machine. When we are talking about how fast or slow a machine runs we are referring to the momentum of the machine. The hit and momentum of a tattoo machine are not always directly related. This means that you could essentially have a slow running soft hitting machine, or you could have a slow running hard hitting machine. It can be really difficult to differentiate between the two quantifications of these attributes, and it often gives a lot of new artists' problems. Some tattoo artists will rely solely on the sound and the feel of the machine. Others will try to gauge these things by looking at the "ghost" of the a-bar nipple. An even newer trend is to measure all the aspects of the machine by using quantifying digital power supplies. These power supplies will provide a lot of statistical information about the way the machine is running. Digital readout power supplies are not as accurate as an oscilloscope, but some companies that sell these machines claim the chip sets that make up the computing components are very reliable (to the point that some artists swear by their usage).

> *"...An even newer trend is to measure all the aspects of the machine by using quantifying digital power supplies..."*

A-Bar Ghost

The ghost of the a-bar is based upon a few things: the human eye's interpretation of the reflection of the light off of the a-bar, the speed of the a-bar, and the actual light source that you have in the room. When the tattoo machine is set-up (meaning it has a needle in the tube on the frame) and it is running – then you should be able to see the ghost. Hold the tattoo machine up against a white background (like a piece of paper), and step on the foot pedal. You will notice the a-bar moving rapidly up and down. If your machine is running at 50% (meaning it is on half the time and off half the time) then you will see 3 a-bar nipples. A smooth flowing ghost is what you are looking for. If you watch close enough it will look like a steady a-bar moving in slow motion. This is very difficult to describe, and you really have to have the person you are learning to tattoo from show you what a proper ghost looks like in order to appreciate the beauty of a perfectly running machine. But just because the ghost can show you quickly if your machine is running at a proper duty cycle, doesn't mean this setup is perfect for your job or your tattooing style. This is simply a benchmark that is used by many artists out there. Some people say that you can only measure the ghost if you have lights that run at 50hz. The reason is that some fluorescent lights will run at a different cycle and make the ghost look a little off kilter because the eye cannot see anything other than what the light source reflects. Regardless of exactly how accurate the ghost is, it is a good way to visually tell how the machine is running.

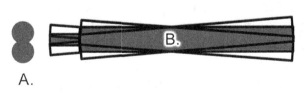

Fig 3.14 Armature Bar Ghost: A. figure eight when viewed from the front of the machine, B. simulated armature bar movement of a single stroke cycle

Spring Gauging

There are two springs on the standard tattoo machine, the front and the rear. In the standard spring setup: the rear spring is ba-

sically rectangular, while the front is triangular. Springs will generate resistance which is converted into potential energy when the magnets pull the a-bar down. How much energy each spring has the potential to possess is directly related to the gauge of the spring. The gauge of the spring is basically the thickness of the metal. It is generally agreed upon that a stiffer spring will make your machine hit harder, while a thinner gauge spring will make your machine hit softer. There are other factors to take into consideration in relation to the springs. The spring area or the length of the spring multiplied by the width of the spring will also increase the stiffness. When the ratio of the width to length is modified by adding more to the width side of the spring, the spring becomes stiffer. This holds true in reverse as well; when two springs with the same width are compared, the spring with the longer length will be less stiff.

Another important feature to pay attention to related to the springs, but not directly on the spring, is that of the deck clamp or fastening piece (the piece that holds the rear spring to the deck of the frame). If your spring is a certain width (x), yet the spring is fastened to the deck by a circular washer, a lot of the potential energy will be lost. This is because the width of the washer (y) is less than the width of the spring (x). The spring's pivot is now reduced to that of the counter pressure imposed upon it by the circular washer. This is not always a bad thing, and sometimes you do not want to utilize all of the rear spring's potential energy. If you do wish to take full advantage of the spring's width, then you should use a deck clamp with a flat end to fasten the rear spring to the deck. This is where you see a lot of artists with a coin that has been cut in half, fastened to the rear of their tattoo frame holding the spring in place. The bottom of the spring will be pressed against a straight edge (the frame), and with a deck clamp, it will now be pressed equally on the top and the bottom (allowing for maximum stored energy potential to be realized).

Contact Relation Triangle
Where is the contact point in relation to the deck of the frame

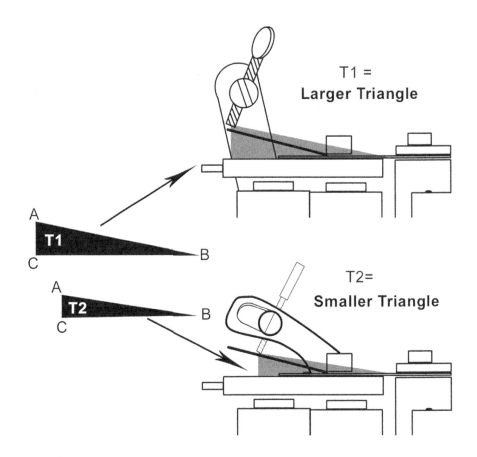

Fig 3.15 Contact Relation Triangle: right angle ACB can increase the speed of a machine or tell you a lot about your frame's geometry if you are unable to relocate the contact screw binding post on your frame

(as far as height and distance)? This is a very important question. Sometimes you cannot control the contact point on a tattoo machine. This is what we refer to as a fixed point machine. Other times you can fully adjust the contact point (slide it forward and backwards, often times it will have an arc milled out of the frame for it to be adjusted). When your tattoo machine is not running, and the contact screw's point (or contact point) is touching the front spring; there are a few measurements you can observe.

The **contact relation triangle** is one of them. Triangle (ABC) starts with point (A) being where the contact point touches the front spring. Triangle (ABC) continues with point (B) being where the rear spring is fastened to the deck. Triangle (ABC)'s last point is point (C), a 90 degree angle going from the a-bar up to point (A). Angle (ACB) will always be 90 degrees (or a right triangle). This triangle will tell you a lot about how the machine will run. Generally, when line (AB) is shortened, meaning the contact is moved more toward the rear of the machine, the machine will run faster. Machines with the contact point moved further to the rear are sometimes referred to as cutback machines.

Another way to speed up a tattoo machine is to decrease the distance of line (AC). Line (AC) can be decreased simply by turning the contact screw lower toward the a-bar, or by increasing the amount of contact screw that is exposed below the binding post (usually turning the contact screw clockwise – depending on the threading and setup of the machine).

Additionally, another adjustment can be made to the triangle to increase the speed of the machine. The distance of line (CB) can be adjusted by putting a shorter length rear spring on the a-bar assembly. The shorter the length of line (CB), generally the faster it will cause the machine to run.

Because there is no right or wrong way to configure any single machine, it is important to know what each adjustment will do to the machine; the Contact Relation Triangle is no exception. These are just general rules of thumb, and can be applied in different fashions.

The Dime Gap
Often times you will hear an artist talk about the importance of the dime gap. There is some debate as to which way the dime gap is measured, and if you should even use a dime at all. There are two basics ways that the a-bar assembly can be on the machine, rested and stressed. In rested position there is no

tension on the a-bar assembly, and typically the front contact spring is touching the contact screw's point. **Stressed position is when you push down on the a-bar nipple so that the a-bar rests on the front coil's core.** When the a-bar assembly is in the stressed position the distance between the front spring tip and the contact screw's point is said to be the distance of a dime. The other school of thought is that when the a-bar is in its rested position, the distance between the bottom of the a-bar and the top of the front coil should be the width of a dime. It is said that this is just an old timer's "guesstimation" technique, and I am not sure of many artists that actually will slip a dime in there.

The Manila Envelope
Similar to the dime gap technique, the manila envelope is another measurement that has some debate surrounding it. Some artists will tell you that when you put the a-bar in the stressed position you should be able to slide a piece of paper the thickness of a manila envelope between the armature bar's bottom, and the top of the rear coil. This is to measure the difference in the length of the front and rear coil. The front coil's core, according to some, is supposed to be slightly closer to the armature bar than the rear coil's core. This is just one use for the manila envelope, and there are numerous variations that have been lost in translation over time. Many artists that are very technical will measure these gaps with feeler gages and record the distances. This will help achieve repetitive results when you are changing spring configurations and attempting to get your machine back to its original running condition. However you decide to measure these little gaps all over the tattoo machine, it is important that you are aware of them and their functionality.

Armature Bar - Flaw in the Design?
The rear spring on a standard tattoo machine has to be bent (according to most tattoo artists), at least to some degree. This is considered a major flaw in the age old design of the armature bar. It is because the armature bar is perfectly level on both sides that this is required. If the armature bar was milled out

at a slight angle on the rear side of it, then the bend would not be required. This is actually being focused on by several a-bar manufacturers in the world today. There are different styles of a-bars available that have a slight angle milled out. This is really exciting because you take a large variable out of the guesswork of tuning the tattoo machine, "the bend".

Don't Double Bend the Rear Spring

As mentioned earlier, the armature bar requires that the rear spring be bent. When you are bending your rear spring there are a few things to pay attention to. First you will need to loosen the

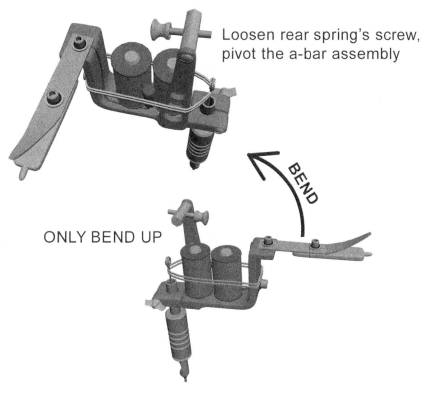

Fig 3.16 Bending the Rear Spring as in Machine Tuning: top image shows the a-bar assembly being loosened and rotated, bottom image shows the angle or direction of bend for the rear spring - Some artists will "roll" their springs

screw that holds the a-bar assembly to the deck of the frame. Loosen it to the point that you can rotate the entire assembly to the rear of the machine – so that the a-bar assembly is facing backwards. Then slightly push up on the a-bar and bend the entire assembly upwards. Then swivel it back around to its proper location, and tighten the spring back to the rear deck of the frame. It is important not to bend it back and forth too many times. Each bend that is made in the rear spring weakens it. These springs tend to snap as well. A spring that has been bent back and forth will become very weak and more likely to snap during a tattoo. Some artists will even tell you to discard a spring that has been bent too much, instead of bending it back. Remember you can always add more resistance to it by bending it more, but you should not try to decrease resistance by bending it back. A lot of professionals say you should "roll" the springs upward instead of "bending" them upward.

90 degree Rule (Contact Screw to Front Spring)

One widely known rule of thumb for tattoo machine tuning is that there should be a 90 degree angle where the front spring and the contact screw meet. The 90 degree angle (JKL) can be started by placing point (J) at the pivot of the front contact binding post (where the binding post holds the contact screw to the frame). The next point (K) would be the location where the contact point meets the front spring. The last point (L) would be where the front spring bends, and first touches the armature bar. You will see a lot of machines that have a very large angle, meaning the contact screw's point is facing more toward the front of the machine. You can even see machines that are setup with a very acute angle, meaning the contact screw actually is inverted and facing backwards. There is no right or wrong way to position your contact point, but the rule of thumb is 90 degrees. If you cannot achieve 90 degrees, then you can try to put a smaller spring on the front of the machine. This will decrease the distance of line (KL). You can also move the entire a-bar assembly forward or reverse to attempt to obtain a 90 degree angle. Some machine builders will specifically design the geometry of their frame to meet the 90 degree rule. This is to give the

tattoo artist some type of benchmark as to a starting point for machine tuning.

Size of the Front Spring
As mentioned earlier the front spring length can be changed to achieve different results in the tuning of the tattoo machine. The rule of thumb here is that the shorter the front spring, the stiffer it will be. The shorter the front spring, then the further back the contact's point will have to be as well. This will make your machine run faster. The smaller springs are typically seen on what is referred to as a "cut back" machine. This is the preferred setup for artists as a liner configuration because it tends to run a little faster.

The O Ring
When the rear spring (which has stored energy from the magnets pulling it down) is released by the circuit being opened, it forces the a-bar assembly to retrieve upwards which then causes the front spring to hit the contact point. When the front spring hits the contact point it will store some energy from the momentum of being shot upwards with some of that energy being recoiled back. To keep a smooth fluid motion in this movement – the o-ring will absorb a little of that shock. You have to experiment with different size and hardness o-rings. The softer the o-ring the more it will absorb. O-rings can be cut by the spring and dry-rot, so they must be inspected and changed out.

Stuffing the Coils
Coil tattoo machines have wire wrapped cores that are magnetized and will pull the a-bar down. The coils have a core that is typically made of iron. The core is tapped out to allow it to be mounted to the bottom of the frame. There are two solutions to making the core a stronger magnetic force. First you can use longer screws when mounting the coils to the frame. The core taps have to be measured. Typically I will stick a toothpick into the core's tapped out hole – and mark how deep it goes (add the frame's depth where it will mount and you get the idea). The second way that has been done for ages is to stuff the coils with

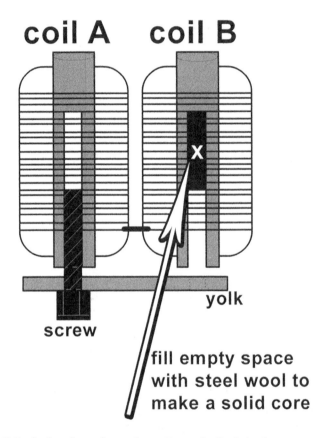

Fig 3.17 Stuff Coils that have been Over Tapped: Coil A. shows a tattoo coil with a screw through the yolk mounting as in on the frame, Coil B. shows the empty space that is often tapped into coil cores (no screw shown on Coil B)

steel wool. I suggest doing only a little at a time, because it can be difficult to remove if there is too much jammed in the core's tapped holes. This is not always required; some machines run perfectly with a little gap in the coil's core. These machines are designed to run a certain way, and the builder most likely took into account the core's hallow gap.

Voltage for Tuning Machine
After much research on this topic, I have personally come to be-

lieve that there is no right or wrong voltage. Each machine has its own unique running style. Each artist has his unique tattooing style. You cannot figure out if a machine is in tune in reality because what works for one artist may not work for another. The best recommendation is to try to go for as little voltage as possible when tuning a machine. If you can get a machine to run well with only a few volts in it, then when the time comes to crank it up, you will not risk heating it up. It is important to try to be consistent when tuning a machine, so that you can achieve the same results time and time again. Once you find something that works for you keep attempting to replicate it. Don't be embarrassed to jot down numbers and notes about how you got your liner to work perfectly that day, because when the time comes to replace a spring, you will have to achieve that same perfection again.

Fancy Equipment
Presently, a host of technology is available at reasonable prices that a few years ago just simply didn't exist. There are those who will shun the technology and say it is useless, these are the same people will say that they have been creating magnificent tattoos for years without these advancements. Others will look at the new technology as a godsend and cherish the advancements and attempt to not only implement them into their tattooing rituals, but hone their skills around the new technology. Like everything else in this art-form, there is no right or wrong (although both sides of the fence will tell you that the others are probably wrong). The truth is that people have been hammering out awesome art for years without advanced gear. There are people today who create insane artwork with old school mentality and tools. There are also newer artists that are creating some equally excellent work with new technology as their cornerstone. Either way it is important for a new tattoo artist to be aware of the technological advancements that directly impact tattoo machine tuning.

A prime example of technology making an impact on the tuning abilities of the artists is that of the digital power supply. Even the

power supply that does not give you all the fancy upgrades, but still has some digital read-outs. The power supplies that will give you load and duty cycle are also pretty handy. Usually these power supplies will come with some type of instruction or documentation to advise you on how to read the quantitative outputs. It is important to remember that technology is only a tool. It is a tool to be used by an artist in the case of tattoo. Technology will not make you a good artist, but it may enhance the speed and ability of getting results that you desire. As a new tattoo artist it is important that you realize the difference in quality equipment, and low-budget equipment. Until you have the means and dedication to invest in your trade, you should focus on trying to obtain these pieces of quality equipment one by one. Whether it is that quality arm-rest, or that solid set of coils; the tools of your trade are just that, tools.

Can you do a tattoo with a power supply that doesn't tell you the duty cycle? Sure you can. Is it even necessary? Not really. Will it help you be a better artist? Possibly, only you will be able to realize this with time. This is where mentorship is very important. The individual that is apprenticing you will help you avoid many costly and time consuming mistakes that he or she possibly made in the past.

Traditional Liner
The traditional liner setup, in my opinion, is a machine that runs really fast, hits hard, and has a pretty long stroke. To achieve this there are numerous things that can be done. The first thing to look at is your frame geometry. On a traditional liner the upright of the frame should be closer to the spring deck on the frame than it should be to the vice tube hole on the frame. This will move the contact screw further to the rear of the machine. This will allow you to keep using the "90 degree rule" with your contact screw and front spring (where they touch should create a 90 degree angle). Using this type of frame might require you to use shorter springs, especially regarding the front spring. Typically the softer the rear spring, the faster the machine will run. You still want to try to achieve a fairly hard hitting machine for lines too. Different artists line differently. You have to be care-

ful that your machine's speed matches your hand speed. If you have a machine that is running too fast and you move your hand too slow, you will might cause some excessive damage to the skin.

The Liner-Shader
I consider a Liner Shader to be a machine that I use for shading gradients and blending. This machine is a similar setup as a liner, but instead of a "hard & fast" machine it is a "soft & fast" machine. My Liner Shader will really bog down when I place my thumb on the a-bar nipple while it is running, but it will not stop. To achieve this I use a "cutback" liner frame geometry. I also use a softer rear spring (lighter gauge). I also like this machine to

The old school trick of the trade was the dime gap liner nickel gap shader. Take the armature bar assembly and press down on the armature bar's nipple (the spot where the needle bar's loop attaches to the grommet and then to the armature bar) and press down on it until the bottom of the armature bar hits the top of the front coil (the one closest to the frame's tube vise). You will notice a gap in between the contact screw's point and the front spring. This is the gap that you would essentially stick the coin (either a nickel or a dime) into. This is not really a solid way to measure and or adjust the speed of your machine, but it has been the time honored tradition for some time. Some artists will tell you to use the same technique, but stick the coin under the armature bar (in between the front coil and the a-bar) and use that as the measurement. Whether you are measuring point gap or air gap with your coins, you can see the general jumping off point, and like everything else: the proof is in the skin.

have a really short stroke because I move my hand pretty fast while using this machine. I think that the reason it works so well for me is because this is primarily a Mag needle configuration machine. I do not try to do solid tribal with this machine or run small round needles. I use it to get gradual fades and blends. I control a lot of the darkness of the color that goes into the skin

Liners usually run faster than shaders. If you are running a larger needle grouping for your liner you might have to beef up your setup to keep the speed up under more resistance. The more needles you have in a grouping the more resistance because they are hitting a larger surface area.

by the pressure of my hand, and how many passes I go over the skin. Because the machine runs so smooth and bogs down, it does not damage the skin; thus allowing me to make multiple passes over the same area. You have to find that sweet spot where the machine will bog down and still lay in ink, but it's not dying and snagging the skin. You also have to be careful of how much needle you have hanging out of the tube, and how hard you are pressing on the skin. This definitely takes some practice. Once you get the feel for the Liner-Shader configuration (as I call it), you will really enjoy using it for portraits and grey shading work, as well as subtle color work.

Traditional Subtle Grey Wash Setup
I recommend that when you are doing greys you use the same setup you would use for a liner, but the traditional setup calls for a softer hitting machine with a long stroke. The reason I call for a long stroke here is because the traditional method for shad-

ing grey wash is to do almost wispy movements with the tattoo machine. Like a wave. As the needle goes into the skin, and you start your movement you will press a little harder, then pull out as you lift out of the movement. This will make the point where you ended your hand movement the lighter of the area. This is similar to shading a pencil drawing with your bare fingers. Usually you start in a dark corner and press hard to get the graphite on the finer, and then wisp it out toward the lighter area. This same effect can be achieved with a tattoo machine. You do not move your hand as fast as you would with the Liner-Shader setup while doing this motion. Since it does not make too much sense to setup a machine specifically for this, you have to determine if you are more of a Subtle Shader or a Liner Shader artist. These are just suggestions for setups, and you will really have to define your own style and technique. Just know that the different variables are the speed, the hit, and the stroke length.

Traditional Filler (or Solid Color) Setup

There will be a time in almost every tattoo where you are trying to pack in ink. It might be a solid black tribal piece or it might be solid color. No matter what type of ink you are packing in, you need to use a different setup to get it in quick and solid. I prefer to use a long stroke hard hitting machine. The speed is variable depending on the size of the piece I am working on. This configuration can be achieved by trying to get as long of a space from the rear deck of the frame and the back of the armature bar as possible, and by using a longer front spring. I like to use pretty stiff springs as well for this setup. I also prefer to use a frame where the upright is closer to the front of the machine as opposed to a cutback style of frame. The frame geometry for this type of machine is usually the best way to configure it. What I mean by this is that it is possible to get the same effects using a cutback frame, and rotating the contact point so that the angle from the contact screw and the front spring is less than 90 degrees. I do not prefer to setup my machines this way though. I like to try to keep a solid 90 degree angle. This means that I rely on the frame's geometry to guide me in the tuning process. I feel that in most cases the frame maker has setup the machine

to run a certain way, and it is best to use that as a starting point when tuning. Tuning your machine is all a matter of preference, as long as you understand how to control the variables that are involved to achieve the desired effects then you will be well on your way to understanding and quickly resolving issues that you will face during the course of your tattoo session.

Bogging Down
When tattoo artists talk about their machines bogging down, it is not necessarily a bad thing as you might expect. Sometimes it is good to have your machine bog down to get a desired effect without damaging the skin. When a tattoo machine is running, and you hold it by the tube and grip backwards (so that the clip cords and the deck is facing away from your body), you can put your thumb on the a-bar nipple and feel the machine bog down. This means that the machine gets a little slower but it should not come to a complete stop. You want to try to achieve this effect by using as little voltage as possible on the machine. I prefer to run my machines with as little voltage as possible. When you use less voltage you can keep your machine cool. When you use as little voltage as possible you are also relying on the coils and the geometry and components more so than the brute force of making strong magnets. This will aid in tuning your machine and will help you get smooth results without damaging the skin

The working stroke of the tattoo machine is the distance the needle moves from the top of the front coil's core to the center of the armature bar's nipple. Most tattoo artists will tell you that this distance should be 1/8th - 1/16th of an inch.

too much when you are making multiple passes. Some jobs require your machine to really bog down; some require it to not really be affected by your thumb's pressure at all. Bogging down your machine with your thumb is also a good way to see the resistance of the front spring.

Stroke Length

There are a few factors involved in the stroke length or the "throw" of the tattoo needle. The throw is the distance that the armature bar pin or nipple travels. It will move in a circular fashion with the center of the radius being the fulcrum point where the rear spring mounts to the deck of the frame. If you can imagine, a circle going around that point – the length of the armature bar (like a compass – the needle and pencil kind). The greater the angle of deflection utilized raises the entire a-bar assembly, the longer the stroke of the machine will be. This will also require the contact screw to be raised up more toward the front binding post mount to accommodate the increase in the angle.

Tightening the Contact Down

Some effects can be achieved simply by tightening the contact screw, or moving its tip closer to the armature bar. Some artists call this the air gap, contact gap, or spring gap. When you take the armature bar nipple and press down on it, so that the rear spring flexes downward toward the base of the frame (and the armature bar rests on the coil's core); the distance from the top or front spring, and the contact screw's point is the gap we are referring to. You might think that because the contact screw is touching the front spring, it does not matter how far you tighten it down (or lower it). This is a very big misconception. Tightening down your contact screw can require you to use less voltage, it will also decrease the throw of the machine. It can make your machine run faster as well, if you leave the voltage alone – and tighten down the contact screw, you will notice your machine speed up.

Ten Wrap vs. Everything Else

As mentioned earlier in this text, the coils have metal cores and they are wrapped in wire. The number of wraps is how they are labeled for use and purchase. Typical tattoo machines will use

Typically your liner setups will have lighter armature bars than your shader machines.

ten wrap coils. This is actually very vague because you do not know the gauge of wire used during the wraps. You also do not know exactly what a "wrap" is. One coil manufacturer might call a wrap slightly differently than another manufacturer. You also have to take into consideration if the coils are hand wound or if a machine spools them. Eight wrap coils are also pretty common. You may see twelve or higher wraps every once in a while. The theory behind the wrapped coils is that the more wire around the coil, the stronger the magnet will be. This is also what I consider fuzzy logic because you cannot just rely on the coil's wrap. You need to know the diameter of the core within the coil and the material which the core is made of.

Remember that the electricity flows through the wire, through the capacitor, and around the second core before it finally goes up to the contact point. The more wire there is for the current to flow through, the more voltage will be required to get it there. The more voltage used, the more likely the machine is to get hot. Some artists will say that when a coil heats up it is not going to run as consistently as when it stays cool. This could be caused by the metallurgy changing or because the expansion of the wires and coils. Either way, in my opinion a properly configured tattoo machine should not get too hot.

I feel that coils and springs are the most important parts of the

tattoo machine. It is important for a new artist to play with these parts of the machine and learn the benefits of them.

Lining up the Geometry
It is important to know the geometry of your frame. The way the holes line up in relation to each other, as well as in relation to how they line up against the a-bar and tube-vise hole as the basis of your geometry. The key thing you want to look out for when tuning your machine is that your coils are in line with each other, that your armature bar is in line with the coils, that the two springs are in line with each other, and that the armature bar nipple is in line with the tube vise hole. You will also want to look out for the contact screw. You want to make sure the contact screw is in alignment with the front spring and has a good solid contact face.

1.5 coil setup
In the summer of 2008 I came across the FK (Fallen King) Irons patent pending "1.5 coil" setup. I have to start this section by stating that I have not personally tried these machines. I was immediately intrigued by this seemingly new invention. I had seen square coils before, and even very strange number of wraps on coils, but never 1.5 coils. What I mean by 1.5 coils is the actual height of the core. The front coil is standard height, but the rear coil is only ½ as tall. In theory this machine will have a stronger magnet in the front and a weaker one in the back. This is supposedly because more force is preferred on the front of the a-bar than on the rear. I am very interested in keeping an eye on these machines and this technique in building style. Be sure to check with the individual you are apprenticing under before you jump in and purchase something new!

Rotary Machines
You might hear of rotary machines every once in a while, or see them in catalogs of equipment. There are numerous styles and manufactures of rotary machines. Instead of using the coil and magnet mechanics, the rotary machine actually has a spinning mechanism on a cam. The cam will ultimately move up and

down, and with a needle attached to the end of the cam shaft. These machines are a lot less fluid in movement in my opinion. They offer a rigid pricking approach to hitting the skin. They are currently popular with the permanent cosmetic industry, and there are a few newer models of Swiss made components that are seen for sale on the bigger tattoo equipment distributor sites. I cannot vouch for the quality or efficiency of these machines. I am not even sure if they require tuning or just additional voltage to increase the speed. I see them (from an outside perspective) as being very limited. Perhaps the reason they are so popular with the permanent cosmetic industry is the fact that they are so simplistic. In the case of tattooing, when you consider the fact that the tattoo machine is equivalent to the painter's brush simplicity with the machine might not be a very good thing.

Stroke Control
A good rule of thumb to control the stroke of your machine is to look at the front spring. When you have the front spring in a stressed position (meaning it is touching the contact point), does it seem to flex? To "zero out" the front spring: unscrew your contact point screw all the way so that it is NOT touching the front spring. Slowly screw it in until it is just touching the front spring. When the contact screw is just barely touching the front spring it is going to make a harder hitting and faster machine. The reason this will make for a faster machine is because the spring does not have to absorb any energy before it makes contact with the screw, it will snap back down immediately. The more you screw it down (flexing the front spring), the slower and softer the machine will run. This is a good setup for black and grey shading, smooth effects. The reason for this is because it will take more time for the magnets to pull the armature bar back down, because the spring has to absorb the energy from hitting the contact screw.

This is just one aspect of controlling the throw. You can obviously control these things by using different gauge springs and different strength coils, as well as different weight armature bars. There are a lot of variables that are involved and some will

cancel each other out. You will have to play with your setup until you find the optimum way to configure your machines for the style of tattooing that you would like to do.

Armature Bar Rules of Thumb:

Light = Faster
Heavy = Slower

Keep an eye on the coil cores as well, ensure that the a-bar is over the coil cores to achieve maximum pull.

Faster Machine

How to Speed up your Tattoo Machine

1.) Lighten the Armature Bar

2.) Reduce the contact point's gap where it hits the front spring

3.) Reduce the gap between the top of the front coil and the bottom of the a-bar

4.) Use harder front springs

5.) Less wraps on your coils

6.) Softer back spring

7.) Cut back frame setup

8.) Crank up the voltage (last resort)

www.TeachMeToTattoo.com

Slower Machine

How to Slow Down your Tattoo Machine

1.) Use a heavier Armature Bar

2.) Increase the contact point's gap where it hits the front spring

3.) Increase the gap between the top of the front coil and the bottom of the a-bar

4.) Use softer front springs

5.) More wraps on your coils

6.) Add resistance to the rear spring

7.) Use a higher rated capacitor

www.TeachMeToTattoo.com

4.1 Voltage Theory

The tattoo process requires power. While it is possible to run a tattoo machine without a proper power supply (as in the actual power supply device), it is not suggested. You could very easily hook your tattoo machine up to some type of battery and it would run. The proper power supply will allow you a level of control over the primary energy that drives the coils. You can control voltage with a typical tattoo machine power supply, while some power supplies let you control more advance features.

In order to understand how the electronic aspect of the machine operates you must first grasp the basic concepts of electricity. Electricity can be broken down into three basic sub-components: voltage, current, and resistance.

An analogy to help illustrate the theory of electricity in a basic manner would be to think of it as a highway. Voltage would be the equivalent of the number of cars on the highway, current would be the rate of speed the cars are going, and resistance would be the number of lanes on the highway.

Typically a tattoo machine will run from 4 volts to 12 volts. There is no real rule of thumb for how many volts you need to make your machine run a certain way. There is also no real rule of thumb for how much voltage you need to line or shade; it is always a matter of preference. Some machines will require more voltage than others, as well as some artists will prefer to use more voltage than others. It is important to be aware that the voltage is only one aspect of how your machine runs. Voltage must complement the spring resistance, the geometry of the machine and the type of coils you are using.

Some tattoo power supplies will not display the voltage as in a digital meter. Typically you will have a ten turn pot style knob on the tattoo power supply. This means that the knob that controls the voltage will rotate ten full rotations from zero to max volts.

Each power supply has its own range and variable number of rotations. You have to refer to the manufacturer to know what style you have in your possession.

It is commonly accepted that the less voltage you need to use to obtain a solid running machine, the better. This is because you are stressing the electromagnets less, and your machine will not heat up as quickly. Higher grade tattoo machines will not heat up as fast as lower grade machines. It is recommended that you purchase a power supply that is specifically designed for tattoo artists.

To compensate for a higher rated capacitor you might have to add voltage to your machine to get the same effect. Try changing out your rear spring in conjunction with changing the cap, you have to remember that there are a lot of variables involved with tuning a machine and when you change one thing you are affecting all other components involved. A good way to tell that your cap is not rated high enough is that the machine will quit on you when you apply resistance (try to bog it down). Keep an eye on the spark that is flying on the contact point tip when you bog your machine, this is a good indicator of your cap's ability.

You should become familiar with a digital voltmeter or multi-meter. It is recommended that all tattoo artists own a multi-meter as it will allow you to troubleshoot a lot of components of your tattoo machine and power supply. You can test the continuity of your machine and any wire on the machine with a pretty basic multi-meter. You can also figure out which lead on your clip cord

is negative or positive by using the multi-meter. If you recall the section in this text about capacitors, it is important to make sure your DC current is running in the correct direction in relation to the capacitor.

Tattoo machines require DC or direct current. Direct current is the unidirectional flow of current. This is opposite the AC type of current, which means alternating. Alternating current is typically found in the wall outlets of your home. Since the electronic components in a tattoo machine work off of the DC type of current it is imperative that you use the proper power source.

While this text does not go into very advanced theory of electricity, the key things to remember about voltage are that it is the driving force in the tattoo machine. The voltage can control how fast your machine runs, but should not be the sole instrument in configuration of the tattoo machine or the sole means for changing the speed of your machine. This will be touched on later in the tattoo machine tuning section of this text.

4.2 Amps

"Amp or ampere is a unit of electrical current that measures the amount of electrical charge per second that exists."
Amps are important in relation to the tattoo process because the tattoo power supply will have a set number of amps that it pushes through the tattoo machine's coils. Too little amps will not run the tattoo machine efficiently, while too many amps may cause the machine to overheat and over work.

Since the tattoo machine is constantly turning itself off and on, it is important for the power supply to be able to provide a consistent flow of amps. This is why a standard DC power supply is

typically not sufficient for tattooing.

Your typical tattoo power supply will have between 2 and 4 amps.

Amps can be measured with your multi-meter while the fluctuation can also be seen. Higher grade power supplies will handle the quality of electricity in a better fashion than those that are lower grade. Amps typically are not adjustable on a power supply for tattooing, but there are some power supplies that will allow for the adjustment to be made.

4.3 Leads

There are usually two leads on a tattoo machine and four on the tattoo power supply. The leads are the areas where the electrical wires will make contact. The two leads on the tattoo machine are usually located on the rear of the frame. One lead is on the top rear while the other is on the bottom rear of the frame. Sometimes there will be contact posts where the clip cord leads will attach. The other four leads in the tattoo machine setup are on the clip-cord or power jack.

Fig 4.1 Clip Cord Lead Input on Machine Frame: A. top lead notch or hole (typically tapped into frame), B. bottom lead input (typically some type of threaded hex shaped nut)

It is important to know all the points where electricity flows through the tattoo machine. Some tattoo machines will have a phono-jack mounted on the machine while some may have RCA jacks. These types of jacks will take out a lot of the guesswork when it comes to the leads.

If your leads are reversed you could damage the capacitor in the tattoo machine between the coils. When a capacitor is damaged the machine will spark a lot more on the front spring where it makes contact with the front binding post. The machine will, however continue to run if the leads are mixed up.

The **four leads on the tattoo power supply** can take the shape of **four individual banana jacks**, **two phono-jacks** or even **two RCA jacks**.

The four leads that exist on a typical power supply are designed for the clip-cord and the foot switch. Each of these devices should have a negative and a positive end. **It is usually not important as to which lead plugs into which jack, unless you are using banana plug style where each jack is red and black**. In this case you should pay attention to which lead on the clip cord is plugged into which side because this will affect the way you hook up the tattoo machine in relation to the clip-cord is negative and positive (again to prevent damage to the capacitor).

4.4 Clip Cord

The clip-cord is my favorite part about setting up for a tattoo. When you snap the springs of the clip-cord back into place, and the tips slide into the holes tapped into the machine; you know you are ready for work.

There are dozens of types of clip-cords on the market. The typical clip-cord will have a phono-jack end on one side and two paperclip width 90 degree tips with a spring apparatus on the other side. Often the spring side of the clip-cord will be color coded red and black to represent the negative and positive current in

the DC circuit. The general rule of thumb is that the black end is the negative and it should be clipped on the top of the tattoo machine frame's rear. This is always in relation to the setup of the capacitor and is not the same on every machine.

A novelty that is slightly growing in popularity in the tattoo industry is the use of the clip-cord jack stand. The jack will usually be mounted on the rear of the tattoo machine in close vicinity of where the clip cord would normally attach anyway. The holes where the clip-cord would slide in are usually not hindered, so both the jack and the clip features remain accessible. The great thing about the jack stand is that you can have a clip-cord that is basically an electric guitar phono-cable. Meaning it is a male ended mono ¼ inch jack on both ends. This will eliminate the need to technically "clip" the cord into the machine. Instead, the artist would just plug it in to the back of the machine on one end and plug it in to the power supply on the other.

"...you snap the springs of the clip-cord back into place, and the tips slide into the holes tapped into the machine; you know you are ready..."

As with most equipment, when purchasing a clip-cord, you get what you pay for. Some artists have had the same clip-cord forever and just change out the spring. Clip-cords will range from $10.00 to $30.00, and will vary in color and in length.

It is also important to note that a simple fix for a finicky tattoo machine is to check all the components of the clip-cord. You may find that a quick solder job will repair something that might have otherwise caused you to throw out the clip-cord all together. Practice with your solder and iron and keep some silver solder on hand in the studio along with some heat shrink tubing. It will be a lifesaver.

Some artists say that if they have **RCA jacks** on the rear of their

machine that it is **less likely to snap the wires inside the clip-cord**. Others say that the stiff rear of the cord **will affect how they tattoo**. It is all a matter of preference and when you are familiar enough with the electronics of the tattoo machine you will be able to add a jack-stand to your machine within minutes if you desire one.

4.5 Brands / Distributors

The power supply is a key component to any tattoo artist's arsenal and should never be underestimated. Each piece of equipment that a tattoo professional utilizes can affect the tattoo quality. It is true that an excellent tattooist can create works of art that will heal perfectly with low grade equipment, but even the masters of the art-form will say that having good tools help make the job easier. The power supply or power pack is no exception to any of the above.

There are a host of power supplies available on the market that can be used with tattooing. It used to be common to see a tattoo artist using a generic DC power supply or even an electronics repair man's bench top power supply. In recent years there has been an influx in more stable and cleaner power sources developed solely for the use with dual coil tattoo machines. These machines can handle the spikes in voltage caused by the oscillation that are typically uncommon in most laboratory DC applications, which make bench top power packs unsuitable.

Power supplies can have variable voltage and also variable amperage. Some power packs will have features such as a digital LED readout that measures the volts. A very popular power supply that has emerged on the market recently has a chip set that will allow it to measure duty cycle among other things. Some artists argue that this feature will keep the artwork as techni-

cally consistent as possible. This is done by taking readings of each machine while they are running in optimal scenarios. The readings are documented and used as reference when the artist needs to make adjustments. On the other, there are artists that will argue this is overkill and too technical. These artists will even go as far as to say that a good tattooist will be able to feel the machine's consistency with his hands and hear the variations with his ears; the only adjustment medium needed is a voltage knob.

Another great feature that is becoming more and more prevalent in the tattoo industry is the memory feature. This will essentially allow the artist to store a memory setting of voltage for each machine so that the artist does not have to play with the voltage knob to get it back to where it was while the artist was using their liner machine setup ten minutes prior. This can be a handy feature if the artist is using only 2 tattoo machines and alternating back and forth between them.

Some power packs will have multiple output jacks as well, so the artist can have multiple clip-cords; a different clip-cord for each machine, this way the artist does not have to touch the clip-cord during the tattoo process. These power supplies will usually work by push button selector to choose which lead becomes active.

Tattoo power supplies, like everything else in tattoo, are a matter of personal preference. The artist will have to play around with different equipment to see what feels best. It is always good to know about reputable dealers of equipment since the cost of the power supply can be pretty hefty. Several tattoo power supply manufactures have been listed in this text. It is important to note that they are in no particular order. This is not a review of the equipment or a suggestion to purchase. I cannot vouch for any of these power supplies, they are just well known popular brands. This is merely a reference and a way for beginning artists to familiarize themselves with different manufacturers.

When it comes to power supplies, size of the box does not matter; the quality of the electrical components inside does matter and can make all the difference in the way your machine runs.

Several Common Tattoo Power Supply Manufacturers / Distributors

Critical	http://www.criticaltattoo.com/
Ems 250	http://www.eikondevice.com
Ems 300	http://www.eikondevice.com
Huck Spalding	http://www.spaulding-rogers.com/
Pulse	http://www.pulsetattoogear.com/
Superior	http://www.superiortattoo.com/
Technical	http://www.technicaltattoosupply.com/
Time Machine	http://www.atimemachine.com/

5.1 Needle Parts

Surprisingly, not a lot of people know how a tattoo machine puts the ink in the skin. It is also not very widely known that the "tattoo needle" is actually a grouping of multiple needles. Whether it is just secrecy or lack of questioning, the general public is always amazed when they learn how the tattoo machine actually works. It is imperative for every tattoo artist to understand the parts of the tattoo needle, how they are constructed into various configurations, and how to make them.

The most noticeable part of the tattoo needle is what is referred to as the needle bar. The needle bar is long cylindrical steel piece that is typically fashioned into a loop on one end and may have either a flat plate or nothing at all on the other end. There are different gages of needle bars. Some artists who make their own needle groupings will re-use the bar. This is typically not recommended. **The reason that reusing the needle bar is discouraged is there is a possibility for cross contamination between uses.** Needle bars are very inexpensive, and the risk definitely outweighs the savings that the artist will incur by reusing the bar. The needle bar's top end will attach to a grommet or nipple, which is fastened to the armature bar. (See figure 3.11)

There are two standard types of needle bar grommets. The first grommet style is the full circle. The full circle needle bar grommet will fit completely inside the looped portion of the needle bar, and is discarded after the tattoo along with the needle. The second type of grommet is the ½ grommet or nipple style. The nipple style will attach to the armature bar and increase the width of the armature bar nipple, allowing the needle bar's looped end to slide onto the armature bar and maintain a grip on it during the duration of the tattoo. The nipple style grommet can be re-used, as it should not come in contact with the client and it is covered by barrier protection from bodily fluid splatter.

The bottom of the needle bar will sometimes have a small flat

end on it. This tabbed end of the needle bar is typically used in flat needle configurations or magnum configurations. They come in different widths, and are permanently affixed to the needle bar.

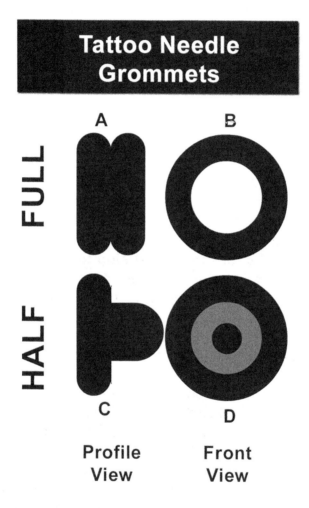

Fig 5.1 Tattoo Needle Grommets: 2 different versions or styles displayed: A. full grommet side view as in looking at the side of tattoo machine frame, C. half grommet side view

The last part of the needle is the portion of the needle configuration that comes in contact with the client, and punctures the skin. This is the **needle grouping**. The needle grouping consists of 1 or more needles soldered together in different shapes. The three basic shapes for needle configurations are rounds, flats, and magnums. When pre-made needles on a bar are purchased, they are categorized by their needle grouping configu-

ration. Historically the round needle configurations have been utilized to line, while the flat and magnum (mags) have been utilized to shade and color.

As mentioned earlier, the needle bars are sometimes re-used. When a tattoo studio advertises that they use new needles every time, they are referring to the needle configurations and this leaves open some ambiguity to the use of the needle bars. While the needle bars do not come in contact with the client's skin directly by puncture, they may come in contact with bodily fluid. This is the reason that it should not be acceptable to re-use needle bars. Needle bars that are re-used must be cleaned and sterilized prior to a new needle configuration being affixed to the bottom of the bar.

Because there are so many distributors of pre-made needles on the market today, the number of studios that re-use the needle bars and make their own needles is very slim. If you are an artist who makes his own needles, you should always ensure that you follow proper sterilization and sanitation technique when re-using the needle bars.

"...When a tattoo studio advertises that they use new needles every time, they are referring to the needle configurations and this leaves open some ambiguity to the use of the needle bars..."

5.2 Making Needles

There was a time when pre-made needles were non-existent. This is where the "new needles every time" signs posted on the front of tattoo studios. In more recent times there has been a boom in the manufacturing and distribution of tattoo needles from third party industries. This all but eliminated the need for the tattoo artist to even consider making his own needles. Some tattoo artists will still say that an apprentice should learn how to make needle groupings from scratch. Yet still today, some artists swear by their needles and make them religiously, or they use special configurations that are not available on the mass manufactured market.

Like so many other things in the tattoo industry, needle making

When you are dealing with coils you should not always have the mind set that more wraps is better. Less wraps on a machine will typically make your machine run faster. They will also require less voltage because the current can travel around the cores faster due to less resistance. There are a lot of variables in the wraps themselves, like what gauge of wire was used. You will also have to think about how big the cores are. The type of needle configuration you are running makes a difference in how you setup your machine!

is as much of an art as it is a technical trade. The overall concept of needle making is similar no matter what style of needles

an artist decides to use. The needle groupings, sometimes referred to as the needle, are actually individual pins that are soldered together to form different shapes. The styles and types of groupings are limitless. There are a few standard groupings that are commonly accepted as the basic groupings for tattoo artists. The standard groupings are round, flat, and mag.

There are a few items that will be required to make tattoo needles and quality does matter when it comes to these materials. The first item required is the needle bar. Stainless steel is the preferred needle bar. Needle bars come in multiple styles as well. The next item that is required is flux. The preferred flux to use is liquid electronic soldering flux. Paste flux will work, but it is more difficult to manipulate than the liquid kind. The next item that is required is a silver based solder, usually sold in different gages on a spool. Needles are also needed. Needles that are used for tattooing are typically sold in what is called loose needle packs. "Bug Pin" needles can also be used. These packs can come in different gages as well and different tapers on the ends. A needle jig is also required for round configurations, made of ceramic or Teflon coated metal. The jigs resemble drill-bit gages with different numbers of variable holes tapped in them. It is also recommended to have a straight razor blade, and a mirror for your work surface. The final piece of required equipment is the soldering iron. There are many types of soldering irons. I prefer the butane type with a small tip to the electric with a cord. This will allow the artist to work anywhere, and not have to be concerned with the cable from the iron. The iron will typically have a sponge and water to clean its tip off.

Needles with a longer taper will form a sharper point when put in a round configuration, and can be great for lining because they create less resistance when they hit the skin. There are no real rules for making tattoo needle configurations. As an artist you will have to experiment and see what works best for your style of tattooing. There are also some loose needles that have taper and pits. The pits are put into the loose needles to give them some sort of additional carrier for the ink. The concept is so that

the ink will settle in small microscopic pools on the individual loose needle while it is retracted in the tube's tip. The ink stays on the needle better when the needle punctures the skin. The pits will theoretically allow for more ink to get into the skin with less traumatic damage to the skin.

Some artists strongly oppose pitted needles. Their claim is that they are Teflon coated, and the coating will eventually come off during the tattoo session, and be lodged into the broken skin.

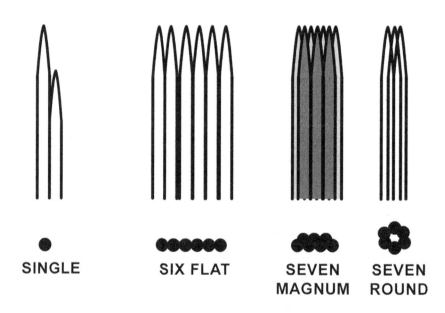

Fig 5.2 Needle Grouping Configurations: four random examples to demonstrate conceptual soldering - NOTE: Magnum can be stacked or woven

Other artists swear by them. When it comes to needles you will really have to experiment. Do not skimp on the needles though. You will definitely notice a difference when you use quality needles, in both pre-fabricated on the bar or loose styles.

Once the materials have been selected for the needle building, it is time to locate a good work area. The work area should be away from clientele view, typically in a back room of the studio.

Ensure that you have a medical mask on, and goggles or glasses. The vapors from the flux and solder are not suggested to be inhaled, and can sting the eyes as well.

Set up the work area with the mirror on the counter or table top. Tin the needle bar by dipping it into the flux and lightly coating it with solder. Set up your needles in the proper configurations in the jig, and dip your needle bar in the flux again. Touch the needle bar to the needles in the jig, allowing a drop or two of flux to slide down the needle grouping. Ensure that the backs of the needles are all flush using the razor blade. For round configurations the needle tips or points should be down inside the jig. Solder the needle grouping together, and then solder the needle grouping to the bar. It is a lot easier said than done, and requires a lot of practice. Each needle builder has their own little tips and tricks that they follow as well.

The single needle liner is fashioned with three loose needles, two of which are slightly above the third needle that will puncture the skin. The two needles that are located above the puncture area will give the third needle strength and prevent a wobbly or loose line, and will aid in the ink's dripping down into the skin along that third needle.

Flats can be fairly easier to make than the round configured needle groupings. To make a flat configuration, take the given number of loose needles you require out of the pouch. Use your mirror and solder setup as mentioned above. The jig is not required. Lay the loose needles flat side by side touching, and use the razor blade to ensure they are all evenly lined up. Tin the needle bar as mentioned earlier in this text. Dip the needle bar into the flux, and allow a drop or two of liquid flux to land on the loose needles on the non-tapered side. Using your finger, hold the needles in place and solder them together in a flat configuration. Then affix the configuration to the bar. The lower you solder on the needle grouping, the tighter the flat configuration will be. Likewise, the less you solder and in a higher location on the grouping, the more the flat needle grouping will act like a

wispy paint brush. This is excellent if you are able to control this type of needle grouping. Extreme care must be taken when using flat configurations, because excessive trauma can be cause to the skin. Some artists will not use flat needles, while others find them an integral part of their daily work. There is a common saying that tattoo artists throw around, "if you don't know how to use flats, you will cut the skin like a razor blade."

Mags are very similar to flats. There are also two commonly accepted types of mags, standard mags which are woven, and there are stacked mags. Standard mags or woven mags are made the same way as flats, except after tacking the initial solder on the flat configuration, the artist will take the razor blade and weave it through the points of the needle configuration. So that 50% are below the razor blade and 50% are above the razor blade. Then the mag configuration is tacked again with solder, while the razor blade is held in place. This will create double surface area in theory with fewer traumas. Stacked mags are simply two flat configurations soldered on top of each other, in staggered formation. With mags the combinations are nearly limitless. Common mag sizes are seven and fifteen. The seven "mag" would have four loose needles on the bottom of the weave and three on the top.

After the needle grouping is soldered to the bar, it is important to ensure that the needles are placed in the ultrasonic and then sterilized in an autoclave. After they are autoclaved, they should be marked with a batch identification number and expiration date. A log should be kept of all sterilization processes.

5.3 Pre Sterilized

There are enough distributors of tattoo needles on the market today that the typical tattoo artist does not need to bother with the hassle of creating tattoo needles from scratch. The important thing to pay attention to when purchasing prefab needle groupings on a bar is to their sterilization process. Some prefab needles will come from the factory un-sterilized.

Most individually packed needles on the bar will be sterilized, and blister packed. These will typically have a date stamped on the back to represent the time they were created, and when they are expected to expire. The needles don't really expire; it is the air seal quality that expires. This expiration date shows how long the packaging is going to keep the contents from being exposed to the outside microorganisms or contaminants.

Some tattoo needles on the bar will even come in prepackaged combos complete with the needle setup, tube, tip, and grip. All of these items are disposable, and sterile. This is excellent news for the tattoo industry. This will eliminate the possibility of cross contamination of bodily fluid exposure form one client to another a great deal. These materials used in conjunction with proper barrier protection and zone setup for work areas will prove your clients the maximum peace of mind and safest tattooing experience possible.

Disposable needle and combos should be the industry standard.

You get what you pay for with needles, and sometimes a little more money spent on a more reputable brand is worth the few extra cents per needle. Remember that just because you purchase pre-made needles on the bar that does not mean they are sterile. Check expiration dates as well.

5.4 Sterilization Process for Needles

Once the tattoo needle groupings have been made and tacked onto the needle bars, they have to be sterilized. The sterilization process is not very complex, but it is important.

Typically a group of the needles will be sterilized at once. The newly built needles on the bar should first be inspected by the eye using some sort of magnification device. A 10x loupe is industry standard and common for inspection of newly fashioned needles.

Once they have been inspected for quality of solder and free of barbs or damage, the needles will be sanitized in an ultrasonic. Typically the ultrasonic is heated, and contains some type of chemical sanitizer. This first cycle in the ultrasonic is to free the needles of excess flux and solder bits. The chemical of choice for the first cleaning is green soap, but will vary depending on what your shop provides. Once the cycle has run, typically ten minutes, then they needles are removed and placed into another cup in the ultrasonic again. This time the cycle should have a stronger chemical disinfectant. This cycle is focused on killing more of the bacteria than it is removing and cleaning the flux and solder from the needles.

Once the ultrasonic cycles have finished, the needles can be taken out and packed into the required autoclave-able pouches, and run though the autoclave. It is important to run them through the autoclave according to the manufacturer's specific directions for your autoclave. The autoclave should be spore tested, and the events should all be logged.

Once the autoclave cycle is complete, and the needles are in sealed pouches, they should be left to dry. Once dried, the needle pouches should be labeled with the date and identification number that corresponds to the log. It is not uncommon for needles to be autoclaved with the tubes they will be used

in. This way the artist can pull out the pouch when setting up his work area, and have the needle and the tube together in a combo pack.

The preferred method is to use sterilized disposable single use tubes, tips, grips, and needles on the bar. This will eliminate the studio from having to worry about any needle creation and sterilization procedures all together.

Some Common Tattoo Needle Distributors / Manufacturers

*Cam	http://www.camtattoo.com/
*Eikon	http://www.eikondevice.com
KingPin	http://kingpintattoosupply.com/
Mithra brand	http://www.mithratattoo.com/
Needle Jig	http://www.needlejig.com/
Pre-made Brand	http://www.newyorktattoo.com
Tat Needles	http://www.tattooneedles.org/
Needle Supply	http://www.needlesupply.com/
Lucky	http://www.luckysupply.com

Author's Preference

6.1 Lining Inks

A tattoo artist's inks or pigments are the best kept secret in the tattoo industry, aside from the tattoo machine tuning. More and more distributors are hitting the markets with just as various colors. Each vendor has their own mixture, which has its own signature consistency and chemical makeup. There is a very big difference in lining and coloring inks. Typically it is true for inks as it is for most other things in tattoo; you get what you pay for.

One of the most interesting things about tattoo lining ink is that it is typically not tattoo ink at all, but it is drawing ink. This is fairly disturbing when you think about it, because we like to think that the ink that is going into our skin is coming from FDA approved inspected facility. Unfortunately, most of the tattoo industry is self regulated. Tattoo artists have used drawing inks for outlining for years, and will continue to do so until there is a strict regulation imposed. While there are a few tattoo ink companies out there that have actually made a lining ink, it is hard to get artists to change their ways after so many years.

The most common ink that is used for lining is straight uncut or undiluted Pelikan™ brand drawing ink. Another favorite is Talons™. Some artists will use certain types of India ink as well. The problem with using a regular black tattoo ink instead of a drawing ink for lining is the alcohol content in the tattoo ink tends to destroy the purple stencil while it is on the skin. Tattoo ink tends to be thicker than lining or drawing inks as well, making it much more difficult to get proper line work done rapidly and with the required results.

Pelikan™ and Talons™ inks Should be autoclaved. Refer to your autoclave manufacturer's direction on how to sterilize a liquid. The consistency will change a little, but it will still remain better off than using a thick black tattoo pigment.

Lining ink can be purchased from a tattoo wholesaler or distribu-

tor, but it can also be purchased at an art store.

Most of the time, tattoo artists will swap the bottles out, or they will peel off the labels of their inks to keep their trademark styles and tools a secret from prying eyes. Tattoo wholesalers also sell empty bottles for pigments in various sizes.

While the regulation laws are pretty grey for tattoo pigments in America, other countries have imposed a lot more rigorous manufacturing standards. You will find that a lot of the pigments that come from Europe and even Canada have come under more scrutiny than those that are born in the states.

6.2 Mixing for Shading

There are just as many methods for creating different variations for shading in tattoo as there are ways to tune a tattoo machine. Ultimately it is up to the tattoo artist's preference. This text will cover a few of the commonly accepted practices for mixing up the shading inks. Some artists that do mostly color work will have large bottles of pre-mixed shading ink set up, while some artists who do a lot of grey work will still prefer to mix their pigments in the ink-caps prior to completing the tattoo.

Grey wash is a common technique for creating smooth black and grey tattoos. The grey wash method requires the artist to mix his inks either in bottles or in caps on the work space. The theory is the same and it is based upon ratios. The grey wash can be obtained by using alcohol, distilled water, or witch hazel as a primary agent. Depending on how many values of grey the artist wishes to have in their pallet, he will fill up ink caps with the same amount of the agent of preference. Then ink will be added to the caps one drop at a time.

An example of grey wash mixture would be three shades of grey and one solid black. This will require one ink cap to be full of solid black ink, and one ink cap to be full of **witch hazel**. Then three additional caps with equal amounts of witch hazel will be setup. The first cap will have one drop of ink, and the next will have two drops, and the third will have three drops. The problem with this method is that each time the artist dips his tip into the solid black, and then back to one of the pre-mixed caps, he will be increasing the amount of black in the caps. It is for this reason that a lot of artists will rely on their knowledge of tried and true mixing. This takes practice, a lot of practice. It is not possible to say that a specific mixture will remain consistent throughout a tattoo session. It is also important to note that blood and plasma will be added to the ink caps as the tattoo session progresses; ultimately diluting the mixtures as well.

Sumi™ inks are available as well to tattoo artists. These inks will have a very smooth grey appearance in the skin and are mixed in similar ways mentioned in the grey wash technique. There are some manufactures that are selling Sumi™ inks for tattoo purposes, but they can also be purchased at art supply in solid bar form. The bars must be ground and mixed with an agent prior to tattooing. Any time there is a material that is not intended for tattooing and the source is not designed for the use in the skin, it is important to autoclave the liquid.

Another common technique is the **true grey pigment method**. With the true grey ink method grey inks are mixed using tattoo white and tattoo black pigments. These are a lot thicker than the lining inks, and should more than likely be diluted with an agent as well. Different ratios will obtain different shades just like with the grey wash. While the grey wash is more forgiving, the grey pigment can be a little more difficult to achieve solid results. By using grey pigments (made from white and black pigments), the artist can achieve a darker overall tattoo.

Grey pigment process would entail the artist to lay down a light grey first, and then go back over the light grey with the darker

mixes, and even black. It is important to remember that tattoo inks will cover each other up, and mix in the skin as well. It is possible to have a light grey area colored in, and then by dipping the tip of the tube into the solid black, go back over a portion of the light grey area in a flicking motion. While using slightly more pressure in the area that the artist wishes to have a darker color, and lifting the needle a little more off the skin as he wishes the color to lighten.

Traditional tattoo methodology would have the artist work from darker to lighter areas of the tattoo, building up shadows and darker areas. **This is not always required**, but it is good practice. As a new tattoo artist, one should not get frustrated if the ink does not appear to be going into the skin properly. How easily the grey values will build depends on a lot of variables. These things require time, patience, and practice. It is also possible to over work and ultimately damage the skin.

To avoid needle or spotty marks in the tattoo while doing grey work it is important to use a much softer running machine than you would typically use during a lining session. It is also important to utilize circular smooth motions. Magnum needles will also efficiently help to lay smoother gradients, no matter what method of grey scale tattooing you select. Some artists will advise against using the circular motions, and insist on scrubbing motions. Typically a faster running machine with a shorter stroke will be very effective if you decide to use scrubbing style of shading. The important thing is to pay attention to the skin. You have to know when you are causing **too much trauma to a client's skin**. If you can get away with pressing hard and working fast to achieve smooth gradients without damaging the skin, then go for it. There is no right or wrong way to shade. It is really all about how the tattoo heals and how the tattoo looks. Spotty looking shading can also come from tattoo inks improperly mixed as well. You really have to experiment with different brands and distributors. Practice layering, even when working on black and grey pieces to achieve smooth affects.

If the skin is overworked then the artist may have the problem of the "ink falling out". This is a tell tale sign that the artist was not properly tattooing, and more than likely not a product of the client's aftercare. It is also important to focus on keeping the skin from being damaged to increase the healing time. This, like everything else in tattooing will come with practice. It is important for a budding new tattoo artist to follow the lessons he learns during his apprenticeship. It is also important to start off with small tattoos, to learn the mechanics of proper shading while doing grey work.

> *"...the ultimate goal of tattooing is to make a solid design appear smooth in the skin and have as little trauma as possible occur to the tattooed area..."*

Once the artist has determined his own personal style of tattooing, it may be very possible that he has to utilize more than one technique of grey shading. If there is something in the artist's arsenal that appears to work well he should annotate it, and try to replicate it with each tattoo he does. A useful tip is to find the ratios of ink that work best, and make larger 2oz – 4oz bottles of the inks premixed and label them. Having the inks premixed can save a lot of time and help the artist to maintain the consistency. Don't forget you can put an autoclaved ball bearing or stainless steel bolt in the bottle. This will help mix the ink when the bottle is shaken. The reason some artists prefer to use a bolt as opposed to a ball bearing is that sometimes the bearing will get stuck in the nozzle of the ink when you are attempting to pour it out.

The ultimate goal of tattooing is to make a solid design appear smooth in the skin and have as little trauma as possible occur to the tattooed area. This will allow for optimal healing time. If you are an artist that has a great deal of problems with gradients in your other mediums, you may want to reconsider tattooing, or work extensively in other mediums until you can fully grasp

the concepts of shading. Tattooing should be carried out in a fairly quick and methodical manner, because you are digging on someone's body. Typically the client does not want to be experimented on. Needle selection will also play an important role in shading. It is not just about the ink, the machine, or the needle. It is the balance of all of these things. This is why it is important for the artist to be aware of his ability and limitations of his skill in conjunction with his tools.

6.3 Color Inks

Tattoo pigments have come a long way, especially in the past decade or so. There are hundreds of manufactures of tattoo pigments around the world that manufacture beautiful color pigments. There are about five manufacturers that are the most well known in the United States. No matter what brand of color ink you select as an artist it is important not to pigeon hole yourself on one brand of ink. The ink manufacturers are constantly competing and improving. It is also important to note that most tattoo artists do not only use one brand of ink for all of their color work. Certain companies have certain colors that are more preferred than others. It is for this reason that most companies will sell ½ oz or 1 oz sample packs of their inks. It is highly encouraged that a new tattoo artist sample as many different brands and colors as possible, and annotates the effects and ease of use for each.

Color pigment does not always look good on every skin type. It is important to remember and educate your clients that what may look good on one person, might not look that great on another. The same effects cannot be easily achieved on everyone either. A commonly agreed upon rule of thumb is that the lighter the client's skin, the better the color will look. This is because the human pigment is not interfering with the tattoo pigment's

reflection of light waves. Typically tattoo ink will also look lighter after it heals in the skin, and this is a point that should also be taken into consideration not only while educating the client, but during the tattoo session.

Color inks typically can be mixed together, however some brands of color do not like to be mixed and some interesting things can happen. Color can be diluted with alcohol or witch hazel, and some artists will use glycerin to thicken their inks.

Color can be applied to the skin either as a gradient or as a solid color. It is important to note that when attempting to color in a tattoo with a solid color or solid black that sometimes you will have what is commonly referred to as holidays. Holidays are small spots of the tattoo where the ink either did not take or where, in worse case, the ink fell out due to improper tattooing. Holidays happen a lot while tattooing with inks that have a red base. This is because the skin turns red while tattooing, regardless if there is ink in the tattoo tip or not. This is why it is important to be meticulous while applying color, and work in slow methodical circular patterns to ensure that the colored areas are overlapped and fully filled. Keeping a balance and ensuring not to overwork the skin is also important.

There are two basic types of color tattoo styles, solid and layered. Each time you start a color piece it is important to first lay down a solid black and grey foundation. The black and grey foundation will help build the shades and tones for the color. Since the color is transparent it can be applied directly on top of the black and grey areas. This is why it is extremely important to be self –aware when you are shading. You should take care not to damage the skin too much while doing layers of grey or you will be unable to go back over those areas with color. If you are trying to go for a natural or shaded gradient color style you will have to use layers. If you are looking for a bold and solid color, more of a coloring book style, it is still good practice to lay down some black and grey before putting the color on top, but for more solid color you should work in smaller circles and use

a slightly harder hitting machine than you would while trying to lay down smooth gradients. These are all techniques that take some practice and will vary depending on your pigments, machines, and needle groupings you select.

It is also important to note that color can cover up other color. If an area is tattooed, especially with a very light shade of a color, and then a darker shade is tattooed nearby, then the darker color may drip or be wiped onto the lighter color, possibly causing some problems. Usually the common solution for this is to use Vaseline on the freshly tattooed areas to fill the holes in the skin, and prevent additional pigment from pouring into the freshly poked areas. This phenomenon is not always a bad thing, and can actually work to the tattoo artist's benefit more often than not as far as generating smooth color gradients and blending effects.

Never underestimate the power of the white pigment. White can be an awesome highlighting tool, and even better blending tool in the ink cap to change another pigment's composition all together. Experiment with mixing small amounts of white pigment with your other colors in the ink caps to get different variations. Remember to be liberal with your white, as you can quickly kill a powerful piece by over extending your use of white pigments. White is a very unforgiving pigment too, you can get a lot of spotty looking fills with white, if you do not use it properly. In addition, some skin-tones will not take white as well as others. Always use a plastic tube and tip when you use white in order to keep it pure, as some bits of pigment may remain in a clean tube and can quickly cause your white to discolor or become dingy.

Color can be a very rewarding tool in the tattoo artist's toolbox, but it takes a lot of time to get used to the medium of the pigment, as well as the mind set of the process. Experiment with different brands, and attempt to mimic or emulate your design styles in other mediums while working on skin.

An exciting advancement in the tattoo ink world is the advent of disposable inks. Disposable inks are inks that come in a single use tube, and the entire tube is disposed of after the tattoo. This eliminates 100% of the risk of cross contamination if used in conjunction with the disposable tubes and needles. Single use ink should be industry standard.

6.4 Brands / Distributors

As mentioned in other parts of this text, there are a wealth of tattoo pigment distributors and manufacturers out there. Some of the more popular and common brands are listed in this section. The author of this text does not condone, promote, or encourage the use of any single brand of tattoo pigment or ink. Nor does the listing of any particular company or brand in this text mean that the brand is acceptable for beginner tattoo artists. Most reputable tattoo manufacturers will not sell to anyone other than a licensed tattoo artist, or an artist that is an apprentice in a tattoo studio. This comes from the lack of regulation in the tattoo industry, and it is self policing. This text is designed for the beginner tattoo artist that is currently engaged in or actively seeking an apprenticeship.

Some Common Tattoo Pigment Brands / Distributors

Alla Prima	http://www.ftwtattoosupply.com/
Classic	http://www.eikondevice.com/
Dermaglo	http://www.eikondevice.com/
Dynamic Colors	http://www.dermagraphics.net/
Easy Glow	http://www.joecapobianco.com/
Eternal	http://www.eternaltattoos.com/
Extreme Ink	http://islandtattoosupplies.co.uk/
Fusion / Needle Jack	http://www.supplytattoo.com/
Intenz	http://www.mariobarthtattoo.com/
KingPin	http://kingpintattoosupply.com/
Kurosumi Colors	http://shop.technicaltattoosupply.com/
Micky Sharpz	http://www.mickysharpzusa.com/html/
Mom's Mellinum	http://www.elementtattoosupply.com/
National	http://www.nationaltattoo.com/
ONE Black Pigment	http://www.painfulpleasures.com/
Prizm	http://www.superiortattoo.com/
Silver Back Grey Wash	http://www.dermagraphics.net/
Skin Candy	http://www.skincandy.net/
Stable Color	http://www.stablecolor.com/
*Starbrite	http://www.papillonsupply.com/
Sun Ink / Luckys	http://www.luckysupply.com/
Waverly	http://www.waverlycolor.com/

*Authors Preference

7.1 Stencil Materials Used

The stencil application process can cause a lot of new tattoo artists some grief, but once you get the hang of it then it will become a breeze. The actual stencil process begins when the design is selected and finalized (for the most part). The stencil process ends when the artist throws the stencil away, this can often be at the end of the tattoo session. Why does the process not end once the artist is satisfied with the placement and design itself? The reason that this text will refer to the process as being over once the stencil is in the biohazard container is because you will almost always need to reference the stencil during your actual tattoo session. It is good habit to keep the stencil in your warm zone during the initial outline phase of a typical tattoo session.

Stencil materials can vary just as vastly as design and art styles can vary. The prime means to get an original or flash piece of line work into a transferable application is by means of a thermal paper. This thermal paper is also referred to as ditto paper, and sometimes improperly referred to as hectograph paper. There are a handful of thermal transfer paper manufactures out there, but there are dozens of distributors. This stuff is fairly inexpensive and easy to get your hands on. A good brand that is commonly used in professional tattoo studios is the Spirit Masters brand.

While the paper selection for stencils is not that vast, the chemicals used to apply the stencil are overwhelming.

The old school way is to use deodorant on the skin. This works with Speed Stick brand or any solid non-powder deodorant. **The problem with this method is obviously cross contamination. This method should never be used unless**

"...Never use DEODORANT to apply a stencil.."

you are giving your client a new deodorant stick every time. There are a lot of people who will use a deodorant stick that is travel size and then dispose of it after the use, but **this is rare.** If you are ever offered a tattoo by someone who pulls out an old deodorant stick, be sure to run like heck for the door. The reason this method is unacceptable is due to the fact that prior to the stencil application your tattooed area is shaved with a disposable razor blade. Often times the razor blade will nick or cause lacerations to the skin, causing bodily fluids to be transferred to the deodorant. **This is a prime example of re-using a hot item.**

Liquid applications are always the preferred method in stencil application. There are unlimited numbers of chemicals that are in a liquid form that can be applied to the skin and will achieve similar results. These chemicals have to be tested to by each individual artist to determine which works best. Products that are specifically geared to stencil application are also available. A popular and cheap method, that works excellent, is to use a spray bottle that is made of 30% alcohol and 70% water. The mix is sprayed on the skin and gently wiped with a glove to the point it forms a slick layer on the skin. Then the stencil is applied. Some artists like to use a green soap mixture as well.

No matter what materials you decide to use in your shop, it is always best to use a non-spray method. The non-spray method is achieved by using a squirt bottle. This bottle will be made of a soft plastic and has an "L" shaped tube extending from the top. These bottles are preferred due to the fact that the misting caused by spray bottles will trap airborne particles in the droplets on their way to the surface of the client's skin. Also, attention should be paid in order to keep the bottle tip from touching the client, again to avoid cross contamination. These types of bottles are rapidly becoming common for use with stencil application and even green soap dispensing. If your stencil material is more an oil than a water base, it can be very helpful to use

this style of a bottle. These squirt bottles are often autoclaveable as well.

7.2 Stencil Application

There are two ways to get that award winning design, you spent hours on, into a transferable medium. The first way to properly use Spirit Masters style paper is to have your completed drawing out, lay it on top of the whole packet, and re-trace it. This will let the purple or blue (depending on what you want to call it) ink transfer in a mirror image onto the thin tissue paper (typically brownish in color). Once you have the design on the tissue paper you can cut it out and apply it to the skin.

Some artists will use the white protective sheet, which has a waxy coating to catch the ink from the Spirit Masters paper. This works well for smaller designs, but this paper is not very conforming to the skin for larger pieces.

Another method is to use white photocopy paper with the design on it. Place it directly onto the purple ink side of the Spirit Masters, after taking the brown and white pieces off, with the design showing face up. The artist can then re-trace the design. This method assumes that you have a photocopier or you will print your design from some type of computer printer. Original pencil sketches can also be used, but this is not preferred due to the fact that the original drawing paper is far less sterile than a new sheet of paper. Not to mention the pen and pencil drawing will have weakened the paper, and when it is retraced it has a tendency to tear.

Yet another method requires the use of a thermal stencil copier. This machine will work in the same way a lamination maker

would, by pulling the design through with a belt fed roller while encased in some type of carrier sleeve. These machines used to be very inexpensive, but it appears that the prime manufacturers no longer create these machines. This trend has led to outrageous price gouging on the internet for very old and very used pieces of machinery. Be very weary when buying a machine like this from a third party. Several well known tattoo distributors offer a German made new machine that is specifically designed for this process. These new machines can run anywhere from $800.00 to $1500.00. This can amount to a pretty hefty investment for a beginner, but a majority of professional tattoo studios will have this type of machine available for their artists.

An old technology that is used in a new way is the stack fed dot matrix printer. This is a pretty cool way to print directly from your personal computer right onto the Spirit masters paper. The pressure will mimic that of hand drawn tracing stencil creation methods. 24 dpi (dot per inch) is preferred to get the detail required for a decent image. These machines will run from $200.00 to $900.00, and can even be found in pawn shops.

All of these applications will work. Some of these will produce a greater quality image and some will save you a lot of time. Some artists prefer to redraw the stencils by hand as opposed to printing them or using the thermal copier. This is really a good way to get intimate with the piece, because redrawing the stencil by hand will alert you of possible issues you will encounter when doing the real tattoo, and it will even help you start your plan of attack. The plan of attack is your game plan for how you will tackle the tattoo. You will need to know what needles to use, what shapes you will layout, and where you will begin. This can all be visualized during the stencil retracing process.

Once the artist has the design transposed to the paper that he wishes to apply to the skin, he must then cut it out. Cutting is another very important step. Cutting the stencil will allow it to be more malleable when attempting to wrap it around contours of

the human body. If possible, cut slits into areas that will require more bend or give. This will enhance the stencil's flexibility and allow the artist to create larger stencils.

After the artist has cut the stencil, they will apply the chosen agent to the skin. This can be stencil fluid, water, alcohol, deodorant, etc. Before the agent is fully dry, but not too wet, the stencil is held into place (purple ink facing the client). The stencil does not have to remain in contact with the skin for very long before it is removed.

Allow the purple ink to dry. Some artists will immediately begin the tattoo if the placement is acceptable, while others will wait 5 minutes or more. This can also be a good time to spend ensuring that the artist's warm work area is properly setup.

Stencil creation and design can be as much of an art form as tattooing. Knowing what works well for you is the key. It is important to always try new methods and view what other artist's are using in their stencil creation process. There is no right or wrong way to create and apply a stencil. Remember that it is the end result that counts.

7.3 Stencil repair / correction / re-use tips

Sometimes a stencil will tear during application. If this happens the best thing for the artist to do is to clean the skin and create a new stencil. It is possible to clean the damaged stencil area, while leaving the rest of the stencil on the skin, and re-apply the

torn portion. This can be achieved by re-wetting the area and using the same torn piece of the stencil again. It can be difficult to line it up properly.

If a stencil placement is not acceptable by the client, it is possible to re-use the same stencil a number of times. The best way to know how many times one can re-use a stencil is to utilize the same chemical agent that would be used in the studio, and practice reapplication. Countless hours have been spent on artists that create stencils and apply them to their own skin, trying to figure out which agent and paper combinations work best.

There will always be a major medical flaw in the stencil application process. This flaw is the fact that the stencil paper is not sterile. The stencil paper is placed against an already cleaned area of the skin. Often the agent is primarily made of alcohol and infection risk is very limited, but there is still minor risk. Stencil allergy is also a risk. Tattoo studios will more often than not, have a release form for their clients regarding known allergy disclosure and responsibilities. It is important to try to treat the stencil as if it were a sterile bandage at all times prior to the application. This holds true to the storage of the pre-used stencil paper, as well as the stencil paper that has the purple ink already applied to it.

> *"...stencil paper is not sterile, and it is placed against an already cleaned area of the skin..."*

Gloves should be worn during all times of stencil application, and the skin should always be cleaned prior to application with standard 70% alcohol. The alcohol can come in the form of a squirt or spray bottle, or even in the form of single use disposable swabs. The swabs are primarily efficient for smaller tattooed areas.

Stencils are considered biohazard material after they are applied to the client's skin, and should be disposed of after each use. At no time is a stencil to ever be re-used on a new client.

This is why it is not preferred to use markers on clients, unless you use disposable skin scribes or disposable pens. The odds of cross contamination are very minor, but it is a peace of mind for the client and the artist.

Some artists will not only have their line work on the stencil, but **light shading might be included as well**. This can save time while attempting to decipher the stencil once it is transposed to the skin. Awesome effects are achieved with a dot matrix printer and even thermal copier. Practice taking a piece of paper with your drawing on it, photocopy it, and then place the photocopy directly on the stencil paper. Then retrace the drawing directly on the photocopy. Do not place another piece of paper on top of the photocopy. This way the photocopy will be your actual stencil. You can crosshatch and shade lightly as well, and this will help you avoid using so many hard lines while tattooing.

Computers are an awesome tool to think about when making stencils. You should familiarize yourself with Adobe Photoshop® or JASC Paint Shop Pro®. These programs have really neat effects that can let you drown out certain colors and increase the difference in the light. This will allow you to see the hard shapes easier. And create a more realistic stencil. The stencil does not have to be the same thing as a "lined version" of the piece. Often times the lines will ruin a tattoo if they are used. Line work should be reserved for old school flash designs and lettering or tribal concepts. If you can avoid lining, you should at all costs. Even a blood line of a tattoo may accept some ink into the cut skin, and create a line on accident. Experiment with different stencil techniques, and use what method you find best for recreating the artwork in the skin.

Never underestimate the power of the stencil, and remember that it is not a bad thing to put a stencil on a client one-hundred times until the client is happy.

8.1 Outlining

Traditional tattoo methods include an outline. The outline is typically done with outlining inks, which have less alcohol in them than normal pigments. Sometimes the outlining inks are not even tattoo pigments at all, but this was touched on in the section about pigment. It is important to approach each tattoo as a piece of artwork. If you are working from flash or a pre-printed tattoo design, you will probably attempt to recreate every detail of the flash. This would include the line weight, meaning how thick the lines are.

A good rule of thumb is that the more needles you have (up to a certain point), the easier it will be to achieve solid and smooth lines. Another good rule of thumb is that the fewer needles you use; the more pain it will cause your client. This is especially true when using a single needle for lining.

The reason behind this is that less needles equal sharper overall footprint of the grouping. Sharper footprint will equal a deeper cut if you are not careful. This is all relative to the individual you are tattooing and your technique as well. Fewer needles require less force to penetrate or poke the skin. Two different configurations of needles that are used on the same setup tattoo machine will react in different ways. An example of the different ways would be if you had one configuration of a single liner and a configuration of five round liners. The five round liner configurations would require more force to penetrate the skin in the same manner as the single liner. This is because there is more surface area resistance with the exact same amount of mechanical force.

Some artists will tell you to hang your needle out of the tip of the tube about the width of a dime.

"...less needles equal sharper overall footprint..."

Others will tell you that the needle should not be visible at all. Some artists will even work with their needle hanging an eighth to a quarter of an inch out of the tube. It is all relative to whether the a-bar assembly is relaxed or stressed when you are looking at the tip of the tube in comparison to the length of the needle sticking out. Some tattoo artists prefer to use the tube's tip as a guide. This style of outlining will allow you to press pretty hard on the skin, and not cause too much trauma. It will also allow the tube to keep the needle steady. However you decide to setup your machines for lining, it is important that you remember as a new tattoo artist: shorter needle length in comparison to protrusion from the tube is better and safer.

A really good practice to use when outlining is to use diamond tips. Tips are the lower (touches the client's skin) portion of the tube, tip grip assembly. Tips come in round, diamond, or shovel typically. The reason that diamond is preferred is because the needle will move around inside the tube while it is dragged against the skin. The diamond tip will provide a guide for the needle group to sit in. If the needle is pulled against the skin it should find the grove of the tip and you will see the amount of shaky or "jaggy" lines decrease in your line work.

> *"...use diamond tips..."*

Some artists prefer to build up the weight of their lines by going over them a few times. This is especially true for artists who use thick lines in their work. Think of building up lines as three parts to each line. The first part is almost like the main body of the line and it will be filled in. The other two parts are the outline of the line. If you imagine two lines that are running parallel, and then filling in the gap between them. This will allow you to work with smaller needle groupings and still be able to have a variation of line weights throughout a piece.

Without going too much into the artistic technique of basic drawing and design, a variance of line weights is always the preference. Having a balance in the image of different line weights will help the image appear to be more complex and interesting. If you use only a certain size liner needle, and build all your lines the same size as in single pass with that grouping, then you will surely achieve a dull piece of artwork. This is commonplace for traditional flash, and sometimes the customer will actually prefer this style. Just keep it in the back of your mind that you are not limited by the amount of needles in the grouping of your liner as far as the actual lines that you can construct in your work. Bloodline is a common term that is tossed around a lot in mod-

> *"...it is called a bloodline because the tattoo machine will actually scratch the skin, and sometimes draw a small amount of blood..."*

ern tattoo.

Sometimes the artist wants to achieve a smoky effect or a light background effect, or even just create a piece of work that mimics reality and does not have the solid cartoon coloring book lines that are prevalent in traditional tattoo. One way, but surely not the only way to achieve this is by using the bloodline. It is called a bloodline because the tattoo machine will actually scratch the skin, and sometimes draw a small amount of blood when the lines are sketched into the skin without use of pigment. The blood is actually always there; usually the pigments are darker than the blood so they are not noticeable. More and more professional artists are getting away from bloodline style all together because it is possible to achieve the same effects

without even lining.

A typical bloodline will start with a stencil image on the skin. The image is traced with a liner grouping that is dipped in alcohol, distilled water, or witch hazel instead of standard lining pigments. The line is then traced the same way that it would be if there were ink in the tube. After the remnants of the stencil are wiped away, a red slightly raised outline will remain and act as a guide for the artist to fill or shade the color of the tattoo design. It is important to be familiar with your own stencil technique and application limitations. Sometimes the stencil will literally wipe away while you are attempting to outline. A good practice to increase the longevity of the stencil is to place a paper towel over the portion of the stencil covered skin that you are not currently tattooing. This will prevent the image from being wiped away by the pressure of your hand as you pass by it.

> *"...it doesn't matter which side you start from..."*

Some artists will tell you to always start your outline from the bottom, others will say from the top, while others will say the left, and still others the right. In reality it does not matter which side you start from. This is all a matter of preference. The reason that it is important to know which side you will start from is so that you can be cognizant of the stencil that still remains on the skin. **You do not want to wipe it away** while you are attempting to outline a portion of the design. How you approach the stencil in outlining will depend on the artwork itself and the body placement. If you are left or right handed will also play a role in this decision, but there is not a right or wrong answer. As long as you have the ability to transpose the stencil into a permanent outline or piece of work, then you can say that you started from the correct side (whatever the side you selected at the time).

When you are attempting to outline the background of a tattoo with "filler graphics", you may want to achieve a very subtle ef-

fect.

The reason you want these lines to "not be so solid" and bold is so that they do not detract from the main focal point of the image. This goes back to line weight variance in the piece. To achieve a very light looking outline for a background image or filler graphic, you can use watered down liner pigments. It is even possible to use Sumi™ inks for outlining. A fairly new product on the market for tattoo artists is liner inks. These inks are specifically designed for lining and shading. It is possible to use light shader inks for your lining and achieve these desired effects.

You may have noticed that some artists will use a light coat of petroleum jelly on the tattoo after applying the stencil prior to outlining. However, it is very important that you use very little petroleum jelly. What the petroleum jelly does is it relieves friction that is created when your dragging glove is rubbing the skin. It will also help capture the excess pigment after a stroke is made. By capturing the excess pigment that is left over from the tip of the tube while the stroke is made, it will make for an easier time to see where you are at while lining. If you did not use petroleum jelly during the tattoo process you might be left with pools of ink on the skin and a difficult stained skin area after each wipe. The Petroleum jelly fills the pores in the skin and creates a stain proof barrier to some affect. This really helps out in all aspects of the actual tattoo process. Remember to only use a very thin coat of petroleum jelly though – too much petroleum jelly will definitely cause problems with the way the ink goes into the skin, and it will clog your tube's tip.

It is important while outlining the tattoo that you remember to **stretch the skin**. You will only be able to stretch a small area at a time. It is important that you learn

"...stretch the skin when you outline and shade or color..."

which movements of the body will achieve the most stretching "bang for your buck". You will not have time to learn and experiment during the course of the tattoo. You should have a game plan in advance prior to even starting your outline. The game plan should consist of what lines will be done in what order, and what movements the client will have to do when you get to that specific line to aid in the skin stretch. Do not underestimate the effect of having the client reposition their body to achieve a tighter stretched skin. Sometimes a very difficult body part to tattoo can be made that much easier just by having the client reposition an arm or a leg.

Tips and corners of shapes in a tattoo, especially when doing tribal style pieces, should be attacked in a methodical way. As a new tattoo artist you may want to attempt to conclude your lines at a junction point or a tip. For example if you are tattooing a tribal piece on a client, and a portion of the tribal looks like the letter "v" you would want to do two strokes, each stroke concluding at the junction point of the "v". As you reach the junction point you will want to lift the needle out of the skin prior to end-

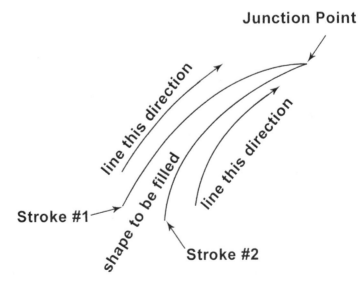

Fig 8.1 Suggested Outline Technique: pointed shape composed of two lines, completed in two strokes and meeting at a single junction point

ing the line. This will help you to obtain a sharper corner and tip in the tribal piece. If you were to start the lines at the junction point, you may go too deep and have a "blow-out" or cause the ink to expand under the surface of the skin. "Blow-outs" will happen from time to time, especially if you are not careful. They can be covered up typically, but if they occur on a junction point of a sharp tribal piece's corner, they will be far more difficult to conceal.

Round liner groupings are not the only groupings that are required for tattooing outlines. **It is possible to outline a tattoo with the use of magnum needles**. There are professional artists that will complete entire tattoos with only a magnum needle. Remember that the needle has many angles and aspects. If you hold a magnum needle on its side or corner you will get a very different effect that you would if you were to put it perpendicular to the skin as in normal usage.

While there are hundreds of time tested traditional techniques (try saying that 10 times fast) for outlining, each artist has to develop his own version of how to line. Because liner tattoo machines typically are the fastest running machines in the artist's toolbox, the artist really has to know his limitations and ability with them. The client's skin can be easily damaged by improper lining practices. You will want to practice with different needle groupings, machine settings, and tips. Pay attention to how your stencil application reacts to the lining pigments that you select. Also pay attention to the differences in lining pigments themselves as far as healing shades and visibility. It is also important to remember that you don't even have to line a tattoo at all.

"...you don't even have to line a tattoo at all..."

Modern tattoo is much more of an art form today than it ever has been, and the tools that are available will allow you to be more of an artist

and less restricted in your process. Throw out the rule book because all that matters when you outline a tattoo is that the skin heals well and does not get damaged or overworked, and that the achieved line weight looks good. If you can get the desired effect without damaging the skin, then you have succeeded.

8.2 Shading

Some artists will call shading "coloring", while other artists will tell you that the two are not even close to the same thing. It is this author's personal opinion that shading is defined as achieving any gradient or filling that is not obtained by use of a single solid pigment. I would define coloring as using a single color (could be multiple pigments mixed in the ink cap) to solidly fill in a selected area. This might seem like a subtle play on words, but it is very important as far as tattoo technique is concerned. Even though I define coloring and shading as separate techniques, they both are different than lining. This is why they are so often lumped together.

A lot of older tattoo artists used to have the misconception that you should have a "liner" and a "shader" tattoo machine. This was in essence to, well… line and shade. The problem with this train of thought, which I feel was brought on by tattoo supply companies advertising machines as "liner" or "shader" configuration, was that what one person called shading another called coloring. Lining has always pretty much been universal. Sure some guys will line a lot faster than others and maybe run different needle groupings, but the basic concept is pretty straight forward for lining. There is a huge jump in the technical aspect of machine setup that takes place from lining to shading and

coloring.

Coloring:
The best example I can give of coloring, in tattoo terminology, is when you fill in a tribal piece solid black. Coloring does not have to be black, but it does have to be solid filling of a color in an area. It is possible to achieve a gradient effect while still coloring. This is possible by taking for example a tattoo that is simply a circle. You could fill a circle in with solid red pigment. This would be coloring. You could just as easily take that same circle and use black pigment and shade it so that a good portion of the circle is dark along the bottom and gradually fades to skin, making a sphere. This would give a 3D effect. Then to make this black shaded sphere a red sphere you would COLOR the sphere in with red pigment. You would color on top of the already slightly shaded black pigment. So you have achieved a shaded look of red, but you only colored with red pigment, you shaded with the black pigment.

Most artists will tell you that when you color with tattoo pigments you should use small circular motions. These motions will allow you to overlap the areas you have already colored, and achieve a solid colored look. I prefer to color with a magnum needle configuration. Unless you are working on a very small tattoo, you really should not have to use a small round configuration of needles to color with. There will be times that you are doing very tight areas that will require

"...older tattoo artists used to have the misconception that you should have a liner *and a* shader *tattoo machine..."*

you to use a seven round loose needle configuration to color. The difference between a loose and a tight round configuration is that in a tight configuration, when the needles are soldered together they get put into a smaller grouping and then soldered again. This will bring the tips of the needles closer together. You

can have the same number of needles in two different configurations, but how small the hole on the jig is when they are finally soldered will determine how tight the grouping actually is. The needle taper will also play in this because the longer the taper of the needles, the tighter you should be able to make the grouping.

While some artists will make their own needles, others will prefer to purchase pre made needles. It is important to note that there are different tapers and different grouping tightness that will determine what you will end up getting.

> *"...it is a tight configuration, if the needles are soldered together they get put into a smaller grouping and then soldered again..."*

Shading:

There is an endless list of ways to shade in tattooing. Recall that it is **my opinion that shading is defined as achieving any gradient or filling that is not obtained by use of a single solid pigment.** This does not mean that you cannot shade with a single pigment. It just means that the single pigment does not end up solid on the skin. I prefer to run my shader machines a little softer hitting and faster than I run my coloring machines with a shorter stroke as well. This will let me push the color into the skin, and not over work the skin; ultimately allowing for use of layers and multiple passes without causing a lot of trauma to the skin.

Because I do not use a tattoo power supply that has an output on it measuring the duty cycle and other things, I cannot recom-

mend certain voltage or other numbers for a benchmark. Even if I did utilize that type of device, I would still feel a little wrong about telling you which exact speed and stroke is the perfect style for shading or coloring. This is because every artist tattoos differently. Some artists will use thicker pigments than others, and some will use different taper needles than others. Shading is the most artistic part of tattooing in my opinion and the only way to say that you are doing a good job is by looking at the way it heals in the skin. If you can achieve smooth gradients **without the spotty needle look** and you can get your colors to blend while still healing quickly, then you are shading properly in my book.

Some artists will shade with quick flicks of the wrist, and apply pressure at the starting point of the stroke, while gradually lifting up on the end of the stroke to create a dark to light effect. Others will "scrub" the needle against the skin, and use the pressure of their hand to vary the darkness. It is possible to work in circular motions and use different pigments with different values to achieve the subtle fade of a gradient as well.

Shading is definitely where your artistic skills will be visible more so than lining and coloring. In reality nothing is a solid color. This is because there is always light in the real atmosphere. I recommend that you take some art classes and if possible a 3D modeling class. 3D modeling software is mathematically correct and can help you to grasp different lighting effects from different light sources on multiple geometric shapes and figures. Photography is also a very helpful medium to assist the artist in learning about light sources. A digital camera is a great way to learn about light and will let you experiment with shapes and light's effect with shadows.

Some tattoo flash or reference material will be simple and basic with the color. You will see a lot of the old school style flash that will **simply put an undertone of black gradient with a solid color on top of it to achieve the effect of a shaded object.** In reality there are a lot of colors that will appear on an object that

you might only think of as having a single color. This is because of the way that light reflects off of colored objects. This book is not meant to be an artistic guide to tattooing, but more of an introduction to the basic fundamentals of tattoo equipment and applications. If you are interested in learning advanced techniques about tattooing and you feel that you have mastered the basics of lining, coloring, and shading then you should try to attend seminars at tattoo conventions or check out advanced texts.

Alejandro Navarro *tattoos Chad Felten courtesy of Arizona Tattoo Magazine, to demonstrate a simple traditional flash tattoo. The actual tattoo was completed in color and the color images can be seen on www.TeachMeToTattoo.com*
along with additional detailed commentary and forum questions.

This Page:
Detailed view of the applied stencil. The leg was shaved prior to the stencil being applied. The stencil was created by using a thermo-fax copier and hectograph or Sprit Masters® Paper. The stencil was applied to the skin using Stencil Stuff™.

Next Page:
The outline is started and the artist chooses to work from left to right. The artist chose to use 8 round liner for this piece.

This Page:
The artist decided to utilize a 7 Mag to shade this image. He started to shade in all of the solid black area first, he continues to slowly fade the black to create gradients. The gradients will help to puncture the skin and leave little black pigment as the fade out – this will allow the color to go in slightly easier and create a smooth transition where the colored pigment will overlap the black gradients that have been laid out..

This Page:
The artist begins to lay down the colored pigment on top of the black. He continues to use his 7 Mag, dipping it into his cup of water in between shades of color. He uses a light coat of Vaseline TM to keep the colors from blending into each other when that is not the desired effect. He uses two shades of green and a yellow for the vines and leaves.

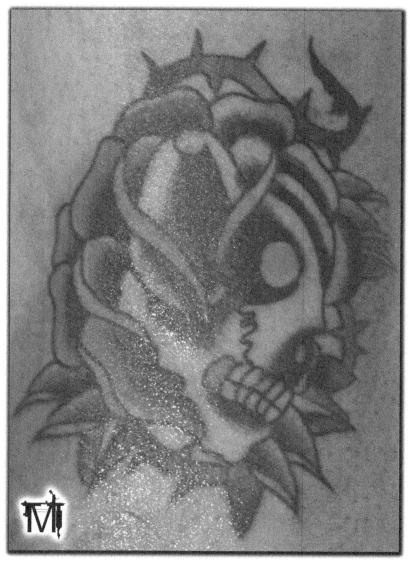

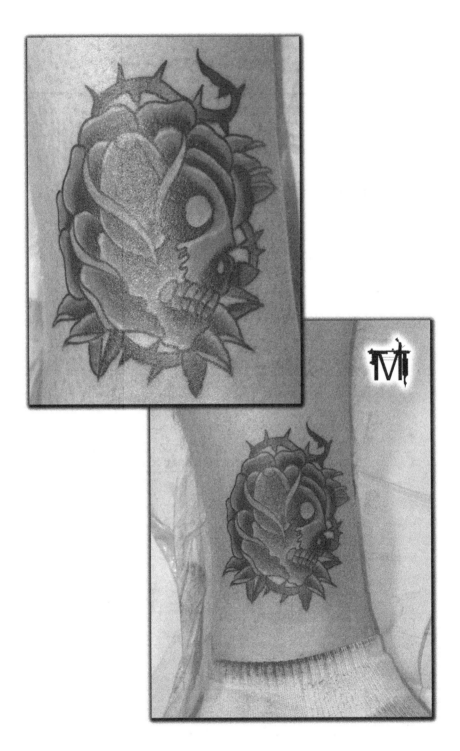

This Page:
The artist continues to color in all the greens and blends his yellows. He will shade in the bulk of the red for the center of the tattoo. After the majority of the red is filled in, the artist will clean up the tattoo and wait a few minutes for the plasma and blood to slow or stop, this will allow the artist to review any missed portions of the tattoo and go back in to correct. This is especially important to do when tattooing large areas of red pigment because the skin will turn red as soon as a needle touches it, even if there is little pigment. This can be misleading, but if the artist waits a few moments it will be more noticeable (the missed spots some artists call "holidays").

9.1 Bandaging

The type of bandage that is used in tattooing is a very widely debated topic. There are some artists that will tell their clients to use no bandage at all, while others will say to use a bandage for a limited amount of time. A very important thing to consider when dealing with bandages is the fact that a tattoo is nothing more than a minor abrasion of the skin, and should be dealt with in the same manner.

After the tattoo session is over, the tattoo will continue to sweat plasma, and possibly a little blood. When you complete a tattoo with darker ink you will not notice the plasma as much because it is not visible through the ink. When you blot the tattoo you will notice the blood and plasma on a paper towel. It is good practice to wait ten minutes or so after the tattoo is done, and let it sweat out. This will allow the blood time to clot and the tattoo will stop bleeding for the most part. After you have let the tattoo breath for ten minutes you can clean it with green soap and determine if there are any missed spots. If you are good to go, then you can spray the tattoo with a 50/50 mix of water and hydrogen peroxide. Some artists will tell you not to use this because it will pull out the pigment. It is a personal preference and you should experiment to find your own best results. After you have wiped down the tattoo the final time you can start to apply a dressing.

Some artists will put a small coat of Neosporin on the newly completed tattoo prior to applying the dressing. Once again you might hear that Neosporin, like hydrogen peroxide, will fade your tattoo. It is best to look for an over the counter triple antibiotic, that does not mention scar reduction. The scar reduction formula is typically known to bleach the skin and the pigment. It is not recommended that the client use a triple antibiotic topical every time they moisten their tattoo during the healing process, but it might be beneficial to utilize it once a day for the first few days after the tattoo is completed.

There are several bandage materials that I have seen used in tattoo studios. The most common is the paper towel and tape. Paper towels are not a horrible bandage material for a large tattoo, and will allow the tattoo to breathe. An excellent way to get the paper towel (which should be folded a few times) to the skin is to use surgical tape. Prior to putting the paper towel on the skin, make sure you spray the area where the tape will have to adhere to the skin with isopropyl rubbing alcohol. This will remove the petroleum jelly residue around the tattoo that would prevent the tape from sticking to the skin. It is helpful to have all the pieces of tape you will use pre-cut for that tattoo when it comes to the bandaging part of the process. Always make sure you are wearing clean gloves while applying a bandage to a client.

Another bandage material that is available is the medical bandage. These come in all sizes and are perfect because they have a special coating that will not let the healing skin stick to the portion of the bandage that is absorbing the blood and plasma. Often these types of bandages have adhesive on them as well around the edges. The only problem with these types of bandages is the cost effectiveness and the variation of sizes may not always fit the size of the tattoo.

A more controversial bandage technique that is often employed is that of the plastic wrap or cellophane bandage. Often regular kitchen style plastic wrap is utilized in tattoo studios, and some tattoo artists will prefer to use it because the client can see his tattoo and resist the urge to take the bandage off right away. Some artists will use plastic wrap and surgical tape and completely tape the entire thing down. This way no fluids will drip down while the plasma and blood continue to leak. This will often result in the surgical tape absorbing the bulk of the fluids. The plastic wrap method can also cause heat rash if the bandage is left unattended too long. This is because the pores are clogged by petroleum jelly after the tattoo process and the plastic wrap will trap in the moisture of the plasma and blood,

combined with the body heat and atmospheric temperature outside – there is nowhere for it to escape. This creates a breeding ground for bacteria and heat rash.

There is no one way to bandage the tattoo. It really boils down to how the client cares for the tattoo and keeps the bandage clean and maintained. However, if you think about the best ways for a skin abrasion to heal you may want to check with your local physician. Doctors have been treating abrasions for centuries, and will always have the best pieces of advice for healing and aftercare of a wound such as a tattoo.

One problem that a lot of tattoo clients have is their first few nights trying to sleep with a fresh tattoo. They worry about the ink getting on the sheets of their bed, the skin starting to heal, and the wound sticking to the bed linens; only to be torn first thing in the morning when the body part is pried away from the linens. To avoid this, I recommend that the tattoo is cleaned properly before bed and a very thin coat of A&D ointment be applied to the tattoo. Then the tattoo can be wrapped using the plastic wrap method listed earlier in this text. As long as the temperature is not too hot in the bedroom and the individual cleans the wound in the morning, this technique will help keep the tattoo moist and prevent it from sticking to bandages or bed linens. This is only necessary for the first few days, and should not be practiced throughout the duration of the tattoo. It is also important that the client cleans the tattoo with a mild antibacterial soap and warm water the next morning and properly disposes of the plastic (not to be re-used).

Most medical professionals will tell you that the first few hours of a skin abrasion is the most common time for an infection causing microbe to enter the skin. That is why it is always good practice to ensure that no client leaves your tattoo work station without having a bandage applied. The main reason clients take the bandage off as soon as they walk out the door is because they want to see it and show it off. Take a photo of the finished tattoo and print it for the client; this will save everyone a lot of

headache and might get your client to leave their bandage on. Plus it always makes the client feel special when you request to take a photo of their tattoo, but that should fall under the ethics or customer service section of this text not really bandaging.

This space left blank for
NOTES FROM YOUR MENTOR

(your studio's guidelines)

9.2 Healing durations

As a new tattoo artist you will probably be instructed on how to care for a new tattoo by your mentor. If you have been tattooed in the past I am sure that you have received a small printout with instructions on how to care for your new art. Every tattoo artist will have his own unique way of letting the client know how to care for a tattoo, and this will come along with a unique time line for healing. Some more complex tattoos will involve multiple sessions and layering of pigments. This layering is to help achieve a smooth blend of color or shading, and this is where the healing duration is more important than if the tattoo is a single session piece.

Every client will have a unique skin type. Some clients have quick healing skin, while others may have slower healing skin. The way that the artist tattoos is also a big factor in healing time as well. The more experience that you gain as an artist, you will find that your customer's healing durations will be quicker because you will have learned techniques that will cause less trauma to the skin. Overworking the skin is the primary cause for a bad tattoo, unless the tattoo was just poorly executed to begin with as far as design goes. A client's health and diet are important factors in skin healing as well, and should not be overlooked. An individual who is healthier and active will have a much easier time healing a tattoo than a client who is in poor health or is on certain medications. This is pretty common sense and more information can be obtained from a medical professional. As a tattoo artist you obviously have no control over the diet and exercise routine of the client, but it is always good to let the client know that their body's health will contribute to their skin's health and ultimately affect the healing duration of a tattoo.

Typically if you are tattooing properly you should not have much to worry about with healing duration and process. Some tattoos will heal in a matter of days, while others might take a little over

a week. It is general rule of thumb that a tattoo with a lot of solid pigment in a larger area (colored not shaded) will take longer to heal than one with a lot of shading. This is because there is more trauma caused to the skin when solid pigment is put into the skin in tighter areas of filling.

It is important to remember that if you are doing multiple sessions on a specific tattoo that you wait at least a month to go back over the tattooed area. This is to ensure that the tattoo is fully healed. It is not uncommon to see an artist wait a few months before wanting to go over a tattoo.

9.3 Healing Phases of the Skin

For this section, I have to first warn you that I have no medical training other than squad level combat medic training from the Army (AKA CLS). They don't go too in depth into this type of material in college level "Biology I" either. With that being said it is advised that you speak with a medical professional about the best practices for injecting pigment into the dermal layer of the skin. I have made every attempt to provide factual information from legitimate resources in terminology that is understandable for a tattoo artist. Tattoo process and aftercare techniques are mostly derived from a verbal heritage that is no more the intellectual property of the artists of today than it is of the cavemen of the past.

The human body has its own way of healing the skin after a tattoo or any other abrasion to the skin. The object of tattooing is to poke the skin with multiple needles, as opposed to scratching or cutting skin. You might hear the term of capillary action by pigment. What this means is that the small pokes of the skin

that the needle makes will inject ink into the hole and will spread a small amount under the poke. This will allow the actual surface area of the pigment coverage to be greater than the size of the poke. What this means to you as an artist is that you have the goal of injecting more area with ink in comparison to the size of the trauma caused. If you were to cause equal amount of trauma to the skin as coverage of ink it would take longer to heal. In short: less holes while getting more ink in there. If you can mentally imagine this and keep it in the back of your mind at all times while you are tattooing then you will always have a minimal trauma mind set.

"...speak with a medical professional about the best practices for injecting pigment..."

The human skin has a few layers that you should be aware of while you are tattooing, it is important that you are tattooing in the proper layer. If you are not tattooing deep enough the pigment will not last very long, if you go too deep then you run the risk of causing unneeded trauma and possible damage to layers that are not required. Tattooing is defined as embedding pigment to the dermal layer of the skin or the dermis.

A good way to think of the human skin is in 3 main layers: the epidermis, the dermis, and the hypodermis or subcutaneous layer.

The epidermis is the top layer of the skin and is visible to the human eye; it holds the sweat pores and is made up of differentiated stratified squamous epithelium (a bunch of cells that line most membranes in the body). The outermost layer of the skin is made up of dead epithelial cells. The epidermis has the job of protecting the body from unwelcome intruders. The epidermis

itself is typically made up of four layers depending on where it is located on the body.

Below the epidermis is the dermis, where the tattoo pigment is supposed to end up. The dermis has two layers itself: the papillary (closest to the epidermis) and the reticular dermis (the lower layer). It has been my professional experience that the technical makeup of the skin is not as important as just understanding that there is a limit as to how deep you should go while you are tattooing.

The third and final layer that we will discuss is the subcutaneous tissue. This layer is a fatty area that serves the purpose of absorbing forced trauma and storing an energy source in the form of fat. As a tattoo artist you have to realize that there are these layers of the skin that you have to be cognizant of, but they are so small that you can't really see the difference between them with a naked eye. The subcutaneous layer will help to absorb the shock from the pressure of the tattoo machine's downward force, but it is possible to penetrate this layer if you are not careful.

"...below the epidermis is the dermis, where the tattoo pigment is supposed to end up..."

In order for the tattoo to properly heal the skin will enter a swelling or inflammation phase first. This phase is the body's defense to help by squeezing the cells tighter and forcing unwanted foreign materials out, to include bacteria and possibly tattoo pigment. During the swelling phase of healing the body will trigger the cellular mending and migration process. The next course of action for the skin is for it to develop new blood vessels from old ones. Some medical professionals will say that vasculogenesis is what will actually occur, which is just the spontaneous formation of these vessels and is caused by some traumatic trigger in the body. Collagen and tissue formation will soon begin. Existing skin cells will attempt to stretch and move together to try to close

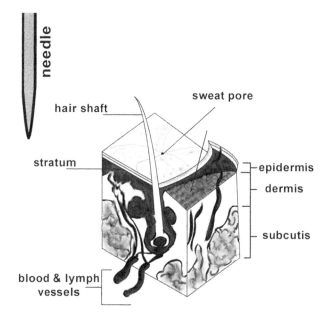

Fig 9.1 Skin Layers (simplified): tattoo needle shown for relation visualization, do not tattoo below the dermis

the newly formed holes or gaps in their layers. The cells will attempt to close all the remaining holes either by stretching or splitting. If the body makes too many cells at this time they will experience apoptosis (basically just self destruct). Some of the cells that are hit during the tattoo process will also undergo apoptosis because they have some type of trigger that will tell them they are now damaged goods beyond repair. Once the cells have stretched to close up all the punctured holes in the skin caused by the tattoo needles they will then grip the edges of the tattoo holes and begin the contraction process to return the skin back to its former self.

Because the skin will undergo this process multiple times in order to completely close the abrasion to the body, there will be a lot of cells whose role is just to get the wound closed. There are a few different noticeable processes that will occur during the healing of the tattoo, one of which is what a lot of tattoo artist will refer to as the "new skin" formation. New skin is usually seen in the first 48 hours after a tattoo is completed. It is very thin and acts like the body's immediate response to the trauma. While the rest of the healing process will take place under the "new skin" it will continue to try to push out foreign elements to include pigment. This is why it is noticeable to see some pig-

ment come off of a new tattoo a day or so after the tattoo was completed (typically in the shower while using warm soap water). This does not mean that all the tattoo pigment is coming out. Initially the pigment was in a place that the new cells could not force it out. Or it was in the epidermal layer and the body succeeded in doing what it was programmed to do, protect the organs from intruders.

Some signs of an improperly performed tattoo procedure will be excessive scabbing, rapid fading, and pits in the tattoo after healing. It is important to let the client know that sometimes a small portion of the tattoo might scab up because of an excess of bodily fluid that pushed the pigment out in conjunction with possibly an over worked area. If the tattoo appears to be healing properly, with the exception of a few specs of thicker scabbing, it is important to let the client know that the scab might be bonded to properly healing parts of the tattoo. If the scabbed area is scrubbed off or "picked", then it may take out nearby properly healing areas. The best practice is to refrain from itching the tattooed area, and shy away from heavy scrubbing in the shower. Using a triple antibiotic in the first few days of healing in conjunction with ice pack immediately after the tattoo will aid in proper healing. Keeping the tattoo moist with use of A&D ointment or petroleum jelly will also help prevent in the formation of scabs or overly dry skin which might cause less than adequately healed portions of the tattoo to peel out of small specs or sections. If proper precautions are taken during the tattoo process to not over work or over traumatize the skin, the likeliness of these occurrences will be kept to minimum.

It is just as important to know that the skin has its own process of healing, as it is for the tattoo artist to aid the body in that process. By properly tattooing and not overworking the skin the artist will not only increase the time that the tattoo takes to heal, but it will increase the amount of pigment that remains in the proper layer that was intended.

10. Tattoo Tips / Tricks

Over the years I have learned a lot of small lessons that might be helpful to some, and useless to others. Some of these tips and tricks don't really fit into a certain section of this text, and the ones that do fit into a particular section might be a little too far off in left field to really incorporate. When we first started TeachMeToTattoo.com in 2007 we had about 500 members (mostly from Canada and Europe) who were posting a lot of questions, and I have tried to take some of them off the forum and put them in this book. When we revamped the site in 2008 we lost the old forum (database crash) and pretty much all of our members too, I think mostly because the forums were the driving force behind the site.

If you have any questions or if you are a professional and have some tips and tricks you would like to share feel free to post them on the forum. The old forum is going to be made available for download in "CSV" format which will open in typical spread sheet application on your computer. The formatting is kind of garbled – but if you want to sift through it you might learn something. Hopefully within the next few years the forum will regain popularity and again be full of knowledge.

I would also like to mention the proposal of a tattoo wiki – which is being worked on as well by TeachMeToTattoo.com. This will be like an encyclopedia for tattoo related terminology and history, provided for free to anyone and everyone. Where tattoo professionals can register and contribute their lessons and "secrets" of the trade. I am a strong believer that there really aren't too many secrets about tattooing in existence and that the smallest things are just undiscovered by most. If the community would attempt to be more open and expressive about the knowledge and not fear legislation we would not have this hostility toward secret hoarding.

We all don't want to see the kid next door infecting his friends

and doing horrible permanent scribbles on their bodies, but when you think about it: as long as tattoo suppliers are willing to sell out of the back of magazines it is pretty much the tattoo community's responsibility to ensure that the safety information be passed along to everyone at a minimum. Everyone who tattoos knows that most people will not just become an excellent tattoo artist by purchasing catalog tattoo gear and playing around out of their home. There are a few exceptions though, don't get me wrong – some people are just talented in that respect. The tattoo community in my opinion should be pressing for schools for tattooing, local legislation that requires apprenticeships to purchase tattoo equipment, and even state licenses requirements. This is not to prevent your average Joe from opening a shop down the street, it's not about money. What it's really about is restoring (or creating) some level of professionalism in the craft. Tattooing has become so main-stream that it has a lot of opportunity to grow right now, but we have to fix the internal animosity before we can fix the external struggles with local legislation.

> *"...it is pretty much the tattoo community's responsibility to ensure that the safety information be passed along to everyone..."*

That is why we are not marketing this book as a "learn to tattoo" book. It is an **apprentice's accompaniment guide**. As long as you can buy tattoo gear from the back of a catalog or magazine, then you should also be able to purchase concise literature that will aid in properly using that equipment. I am really happy to see that a lot of companies have not lowered the bar on selling to unprofessional artists. This really makes me happy, but at the same time if there is no place to go to tattoo school and learn, how is the kid who can't get that apprenticeship supposed to get his foot in the door? Those of you who have completed your apprenticeships will say, "I did it. It was hard, it took a lot of bugging shop owners and artists, and drawing skulls, but I did it. If I can do it then it is possible," but I see a lot of really bad stuff in a

lot of really bad tattoo studios, passing bad ethics and skills off to bad apprentices also.

I really hope that someday soon a group of the top artists in the world will open a professional world renowned tattoo academy, and that they can secure federal financial aid approval. It will be at that time that the tattoo industry will take the next step forward. These "schools" that I have seen sprouting up in the past few years are really not that impressive, or professional. It's just some guy trying to hit a different angle to make a buck. Yeah there is some money to be made in the tattoo industry, and yeah there is enough for everyone. We need to be reminded that the craft is the important thing, and the artists that got into tattooing for the love of art and the thrill of being a professional tattoo artist are not the same ones who got into this to make a buck. The only real way to weed out those guys is to propel the industry forward and legitimizing it through educational efforts. Tattoo artists today are proving more and more that they are involved in their community and that they have the ability to be creative with publications and art exhibits. Only the artists themselves have the power to make the industry legitimate and welcome in their community, and to prove that they are contributing to the economy and education while providing a valuable service that people want.

These tips and tricks are in no particular order and some might be common sense, while others might have been touched upon in other sections of the book too. This is just an accumulation of random notes and lessons learned that we felt would be helpful to include in this text.

> *"...those of you who have completed your apprenticeships will say it took a lot of bugging shop owners & artists, and drawing skulls, but I did it..."*

Red ink rash

Also known as the "Red Effect" in some tattoo circles. The contents of a lot of pigments are not very well known to a lot of tattoo artists and even less known to the clients. There is such a thing as MDS sheets that are supposed to disclose the materials in tattoo pigments, but there is also a proprietary blend and percentage makeup that is often ambiguous. Sometimes clients will have an allergic reaction to certain pigments. That is why it is always recommended (but seldom practiced) that a prick test be done on an individual who has not had a tattoo before and is requesting color. Red ink seems to be the most reactive and more people have rashes with the pigment than other colors. I have seen swelling and itching occur at almost random times from red inks, and brand of pigment is not a discriminating factor. To my knowledge there is no cure or valid explanation other than it is a chemical allergy, none the less it is something that clients should be warned of.

Petroleum Jelly / A&D Ointment / Vaseline™

This is a pretty basic tip for tattooing, but if you are just starting out you might not be too aware of the benefits of petroleum jelly in the tattoo process. The most important use for petroleum jelly is the ability of it to seal open "pokes" while you are tattooing. You have to realize that the old school train of thought for tattooing required that the artist tattoo his colors in a certain order, dark to light. This was because when you tattoo a lighter color and then a darker color, the darker colors would sometimes bleed into the lighter ones. Since the skin was punctured, the darker colors would stain the lighter ones. To avoid this from happening you would simply tattoo all your darker colors first then move to your lighter ones. If you use a thin coat of Petroleum jelly it is

possible to tattoo light colors and then coat the area with a thin layer of petroleum jelly, and that will seal the punctured area and prevent darker colors from being absorbed by the open holes in the light area. Another reason that you use a thin coat of petroleum jelly is to help the side of your hand glide along the area of the body that you are tattooing. This will prevent friction and allow you to maneuver a little easier. Be warned though, do not use too much petroleum jelly it will clog your tube up and make it difficult to tattoo. Petroleum jelly while completing outlines is helpful as well because it will prevent the ink from pooling up on the skin and making your hectograph stencil difficult to see.

Bloodline

Sometimes the need will arise for you to want to create a piece of artwork that will not have a solid black outline. It is possible to lay down a stencil and outline it with nothing but alcohol or distilled water in the cap. This will scratch a red line or blood line into the skin. The bloodline will be visible and slightly raised after you complete it. It will be visible to the point that you can use it as a guide for filling and shading. This is really helpful for a lot of techniques. It is possible for the stencil ink to sometimes get trapped in the bloodline, but more often than not it will dissipate and will not stay in the final piece when it heals. It is also possible to complete a tattoo without even doing a bloodline or outline at all. You can just jump into the shading process and achieve a lot of soft edges in this manner.

Steel wool

Coils are the driving force in the tattoo machine. They pull the armature bar down when the circuit is closed. They do this by creating a magnetized core that is surrounded by wrapped wire. The coil cores are tapped out on the bottoms because they have to be mounted to the frame by some type of screw or hex bolt. Sometimes manufactures of coils (especially mass manufactured coil cores) are excessively tapped, meaning that they tap the holes in the core pretty deep. A hollow core will not be as strong of a magnet as those that are more solid. In order to create a more solid core, and arguably a stronger magnet is to fill

the coil cores with steel wool. It is important that when you are filling the cores with steel wool that you put only a small amount in at a time and test the screws ability to make a tight lock between the cores, yolk and frame. If you put too much steel wool in the cores you might have a problem getting it back out, and your screws might not thread all the way into the cores. Putting steel wool into every single pair of coils is not always the best thing either. It is good to experiment with this technique though.

Sandwich bag barriers

Your tattoo machines, like all other gear, should be barrier protected from bodily fluids. The best barrier protection that I have seen is plastic. A perfect inexpensive barrier protection that can be used is the sandwich bag. The style of sandwich bag that does not have a zip style seal is perfect to cover your machine and can be purchased anywhere. There are also some tattoo supply manufacturers that will sell barrier protection for machines as well as a lot of other pieces of equipment in your tattoo toolbox that are specifically designed for tattoo machines. Whatever you decide to use for your barrier protection, you have to use some form of cover for your machines. Some artists will tell you that they cannot hear their machine, or that it is difficult to make adjustments to the machine. This is simply not an acceptable excuse. All tattoo machines should be barrier protected at all times. This includes the clip cord and power supply too. It is even a good practice to slap a bag over your pedal. Have you ever seen the floor of a tattoo studio at the end of the day? It's pretty bad. If your uncovered machine accidentally bumps a client's open wound then you have just contaminated your entire machine. Most machines do not work well after being sterilized in an autoclave either.

Dot matrix printer

Dot matrix printers can create good stencils if the correct hectograph or spirit masters paper is used. Try to look for a printer that has a USB cable and drivers that will work on your computer. You can scan images and print them directly to the paper and use them right from there on your client. This is help-

ful for those of you who work in a shop that does not have a photo copy machine. Most bubble and ink jet printers will not work in a thermal copier because there is not enough carbon in the ink that is used on that paper. The thermal fax style machines with a carrier will usually only transpose images that have been photocopied or drawn with carbon based utensil.

Photo-shopping

As a tattoo artist you are first and foremost an artist. As an artist living in the 21st century you should brush up on your computer skills. I would strongly recommend getting a book on a graphic design software suite. Some will cost you $25.00, while others will cost you $500.00 or more. You have to figure out how much you will need the computer in your daily work. Some artists will never use the computer, but this is usually because they are not well versed in the usage and ability of it. You can save yourself a lot of time and achieve a lot of really awesome effects that will help in daily tasks in the tattoo shop. It might be feasible to sign up for a graphic design course at a local university or community college as well. There are online videos and tutorials that can train you in hours on how to do basic functions of graphic design software, if you are not much of a reader this might be beneficial to you. Search for resources online and don't be scared to talk to school professors or even professional graphic designers in your community. You might even be able to arrange a trade for time with someone who is handy with the software. The benefits of the graphic design software are definitely worth the time you will spend learning this new tool.

Scanner

Just like graphic design software, this is another really invaluable tool in your arsenal. If you are working in a busy studio, sometimes a photocopier will just not cut it. Sometimes a client will ask you to do things that will require a lot more time than you have on a certain image. If you have a scanner, a computer, and a graphic design software suite you will be able to get a lot of things done in a little time. It is always worth your time to improve

your educational backbone by adding another skill set to your resume. Every tattoo artist should know how to work a scanner, and every tattoo studio should have one. There are a lot of resources that will teach you about different dpi and color modes for scanning, and what formats are best for what styles of art. Sometimes a client will bring in a really good reference piece, but you might need to change a hue or contrast a bit to see some subtle things that will make the actual tattoo process a little easier. This can be done in seconds with a scanner most of the time.

Buddy system / freebie
When you are first starting out as a tattoo artist it is important to be aware of the marketing that is involved in being successful. You have to build a clientele that is loyal to you. Be creative when trying to entice clients for repeat business. A really good technique is offering a discount to a client that brings a friend next time he comes in. It is not a bad thing to offer to do a free tattoo every once in a while either. I have found that the most rewarding pieces that I have completed were for friends or for clients who have a really fun project. It is not always about the money; sometimes the portfolio building is also important. If you can create an awesome piece of artwork you will draw in three times as many clients when other people see that piece. Make sure you have some type of arrangement with the studio manager / owner before you (the new guy) run around advertising free tattoos though.

Drawing / practice other mediums
You really have to keep up with your drawing skills. It is easy to forget once you have been tattooing for a while that you once loved to draw or work in other mediums. If you are comfortable in pencil or charcoal you should work outside your comfort zone and jump into painting or sculpting. Give it a try you might even get some good reference work by creating something you didn't even know you were trying to create. Just remember that you will increase your understanding of light and color the more you are working on creative pieces of art.

Coils on old machines
Check out some of the tattoo supply companies, they have all kinds of coils for sale. You can revamp an old tattoo machine by adding a new set of coils and springs to it. Don't be scared to experiment while you are just getting into the tattoo industry. You need to understand and learn about what types of coils will have what types of effect on your machines. The tattoo artists should never be afraid to tear apart a machine and rebuild it in minutes. You don't want to be the type of tattooist that has a broken machine and simply purchases a new one. Tattoo machines are a really good investment and will typically last forever if you know how to change out the parts that require maintenance you can save yourself a lot of money too. I would really recommend that you use coils on old machines as a jumping off point to begin your own research on the effects of different types of materials and manufacturers on your own machines.

Tattoo seminars and conventions
Once you have the basics down you will want to learn more. You will be hungry for knowledge that might not be available in your studio. Even if you work with multiple creative and talented artists you will always be able to learn something new from professionals that offer seminars. These seminars are typically pretty cheap to attend, and you will more than likely pick up a few new tricks or techniques. Go to the conventions and talk with the artists, you might get a cold shoulder now and again, but typically you will receive a pretty positive response. Do not be afraid to ask questions and observe the professionals at these events. If you have a tattoo artist that you really admire, you should try to make an appointment and get tattooed by that individual. This might get you some time to ask questions, and worse case you can always learn by watching.

Aluminum foil work area
Barrier protection is a must in the tattoo studio. A really cheap and easy way to protect the work space (your table) is to use aluminum foil. Just rip off a new sheet before you start your session, and tape it down. Then you can put whatever you use

to hold your ink caps and machines down. When you are finished tattooing – you can just roll up the unused ink and petroleum jelly into a ball – and throw it into biohazard rubbish bin.

Alcohol mix for stencils
When you are applying stencils to the skin you will find a lot of stuff on the market to get the stencil to stick. As long as you are not using the old deodorant stick to do the job you are in pretty good condition. A mix of isopropyl alcohol and water is a perfect and cheap way to get the stencil to stick to the skin. Once it air dries then you will not have to worry about it coming off for a while. You will have to experiment with different proportions and ratios though.

Drawing with a pencil in the tattoo machine
If you are a new artist then you might want to practice doing some tracing or line drawing with a pencil. Use a tattoo machine and put the pencil or pen into the tube vise hole. This will help you get used to the weight of the machine and familiarize you with the different angles you might have to attempt to hold it when you are tattooing.

Looking at art books
Never stop looking at art books. Collect as many books as you can for reference. You will find a lot of books for really cheap at used book stores. The best ones are children's books and biology books in my opinion. You have to remember that you are not limited to flash when it comes to tattooing. You can also do amazing things in the skin with modern needle configurations and pigments. Don't forget your art, it might be hard to keep it in your mind when you are doing four or five tattoos a day; try.

Arm rest furniture
An awesome piece of equipment that every artist should have is the arm rest. There are thousands of different styles of arm rests available, and some artists have even fabricated their own. Just remember to use barrier protection. It has been my experience that the best arm rests are those that have minimal area on the bottom legs. This is so that you can get close to

the client with your rolling stool. The legs sometimes get in the way of rolling chairs or other equipment. Look for a non-porous material as well, that will stand up to chemical disinfectants.

Back brace
Ergonomics is an important thing to pay attention to in tattoo line of work. There are a number of devices from tube grips to back braces. A really good investment is the heavy lifting back brace, found at most big box stores. It is the same type of elastic brace you see the guys who are lifting boxes in warehouses use. This thing will save you a lot of headache when you are trying to keep your body and mind connected and free of lumbar pains.

Tool box nearby
Always, always, always keep a toolbox nearby. You will inevitably run into a situation that will require you to correct or adjust something on your machine. Whether it is tattoo springs, coils, or just a shim; you will want this stuff handy. Keep an assortment of shims and springs as well as a selection of hex-head wrenches (Allen Keys) available. You never know when you will need to change something on your machine in the middle of a session. It is always good to have a spare set of machines available too, no one likes to lend out their tools at work. Solder and flux are also great assets to keep around. Some tattoo supply companies will sell a "parts" kit that even comes in its own snazzy looking little plastic container.

Rubber bands on the tattoo machine
There are so many methods for keeping that needle bar snug against the tube. You can try to replace all your grommets with paper towels. Instead of using the rubber grommets on the top of the needle bar try using a piece of paper towel to snug it up a bit. If you crimp the grommet down after it is on the loop of the bar you will see improvement as well. There are also grommets that look like a nipple, and they stay on the armature bar and you do not need to put any grommet on the actual needle itself. It's all a matter of preference. You can use #12 rubber bands (usually 2 – 4), or you can use black hair tie rubber

bands, or you can even use the elastic band that is built into latex gloves (just loop it around a few times). Either way you go, try not to have the rubber bands overlapping and twisted.

White highlights
Never underestimate the power of high and low lights. You can complete a really awesome piece of artwork, but then you should step back and look for spots that would deserve just a hint of additional white. You can do the same with a hint of additional black. Be careful not to overdo the white though. Too much white highlights will begin to detract from the piece. Most tattoo pigment manufactures will have more than one type of white ink available too. Practice with these pigments. Some are great for highlights and some are great for mixing with other colors to lighten them without going for a translucent effect.

Forums online
A really good source of information can be found on forums. To get started look at your favorite artist's personal web site for forums. The really big stars in the tattoo industry have their own forum where they are usually pretty cool about answering questions. Try to ask your mentor in the studio as well though, because while the owner of the forum might be cool – sometimes the lackeys that frequent these same forums will get hostile fast if they see you as a "scratcher" or non-professional artist.

Cup of water on the work area
A good thing to have at your workstation is a small cup of distilled water for rinsing your tubes in-between colors. You can simply dip your tube's tip into the cup and run the machine for a moment. Make sure you run the machine near a paper towel after you dip in water because the water will stay in the tube's tip – and it will cause the next dip of color or pigment to become really watered down or diluted. This can be beneficial if you are trying to achieve grey washes.

Smelling salts / people passing out
Because the human skin holds a lot of the body's blood supply, as a defense mechanism sometimes the body will restrict the capillaries in the skin and send all the blood to another part of the body really fast; especially in moments of pain. You will see that if a person suddenly starts to sweat all over their body, or they lose a lot of color to their skin really quick they might faint or pass out on you. The best practice is to make sure that they have a full stomach before the tattoo session starts. If and when you do have a client pass out on you, the best thing to do is lay them on their back and bend their knees, while their feet are still on the ground. Use smelling salts to revive them. After they come to (usually a few seconds later) offer them soda or chocolate to get their blood sugars back in check. This is not medical advice and you should really consult a physician on the topic. Always make sure you have waivers signed before you tattoo, and be careful that if a client does pass out that they are not going to hit their head on anything. Certain conditions will make people more prone to passing out than others, again consult a physician for this type of medical advice and always question a client prior to tattooing them. Some people have a history of passing out when blood is drawn or they experience pain. It is important to stay calm and pay attention to the vitals of the person. Know when you should call emergency service personnel as well. This again is something you will have to consult a proper medical specialist about prior to tattooing any clients.

Stretch the skin
If you are having a hard time getting ink in the skin, remember to stretch the client's skin. Use your other hand to grab and stretch. There are so many ways to stretch the skin that you just have to experiment. You will develop certain body position favorites when you are tattooing a specific area that will generally provide enough stretch for the job to get done. Occasionally you will have a person that will require creative methods to be used. Shaky lines and spotty shading will often be results of improperly stretched skin.

Photos
It is good practice to take photos of every tattoo you do. This will help you catalog your skill level and your progress, as well as build a portfolio. Try to get the clients to come back after the tattoo heals and take another photo. This will let you see some things that you might not be able to see when you get done with the session. A lot can be said about a tattoo by the way it heals, and can give you some pointers on how you are working in the skin.

Spitting ink
Spitting ink from the tube while you are running your machine is a common issue that is always asked by newer artists. Some artists will tell you this is actually a non-issue. It can be related to the machine's speed being too high. It can be related to the tube's tip being too big for the needle grouping. It can be related to the rubber bands being too tight causing the needle bar to put pressure on the needles themselves in an awkward fashion. If the ink is going into the skin properly, and you don't mind a little splatter on the body part (use your petroleum jelly), then there is really no real harm in this. It can be an indicator though for a new tattoo artist if ink is just spraying out of the tube!

High needle or low needle out the tube
Some artists will tell you that the needles should not be visible when the machine is not running. Others will tell you 1/16th of an inch when the machine is not running. The real thing you need to be concerned about is how deep you are going into the skin. Some artists will use the tube on the body, while others will never let the tube's tip touch the skin. It all depends on your style of holding the tattoo machine. This is one of those things that will require experience and you should definitely have a professional show you from his or her past experience, how to setup your needles in the tube.

Face mask (bodily fluid splatter)
Just wear a full plastic dental shield one time during a tattoo session. See just how much pigment and bodily fluid ends up on that thing. You will never want to tattoo without some type of barrier

protection again. As a minimum you should be wearing some type of surgeon's mask and glasses. You might look goofy to some people, you might take some heat from your peers, but you will look professional and clean to the client. Plus you will be protecting your own mucus membranes from absorbing anything that splatters off your client's body, to include communicable diseases.

Deposit from customer

If you are going to do appointment based work, you should start to think about the deposit system. Even if you are doing a customer drawing for a client you should try to get some type of deposit from the client. Your time is valuable and worth money, and you will see a lot of people flake out on appointments. Most of the studios I have worked in had a strict 50% deposit rule that was nonrefundable. You have to use your common sense and best judgment in these situations, but you don't want to have empty chairs in your studio when you have reserved the time for a client.

11.1 Customer Care

One of the most overlooked aspects of the tattoo experience is the customer care side of the house. Customer care encompasses an enormous portion of the tattoo experience. I cannot tell you how discouraging it is for a client to anxiously want their first tattoo and finally muster the courage to step into the tattoo studio; only to be all but ignored by a snobby tattoo artist or counter person. There are certain aspects of business that have to transcend the traditional stigma associated with tattoo.

You will find that the tattoo studios that have a stronger focus on customer care are the ones with a larger "word of mouth" following client base. In the tattoo business "word of mouth" is everything. A wise old-timer tattoo artist once told me that one good tattoo experience will bring in two new clients, but one bad tattoo experience will cost you ten. This holds true just as much to the tattoo artist's skill as it does to the shop's rapport. The tattoo experience is the culmination of how friendly the staff is, how clean the shop is, how well the price of the tattoo is, and most importantly the quality of the tattoo work being done. If you can master these four basic concepts of customer care then you will increase your clientele guaranteed.

It may seem like common sense to some people, but you would be surprised. There have been so many times that I would be reading a book about a certain topic and the author would coin this phrase to describe some apparent breakthrough in the subject that the book was about. I would think to myself, this is actually common sense (this guy just made up a name for something everyone already knew). Well now I have written one of those exact same common sense passages, and I know why. You would think this whole chapter would be common sense, but I have personally seen enough bad customer care in tattoo shops that I felt compelled to write about it here. Which lends itself to the question, are the people who are running these shops really bad businesspeople or are they just inept to seeing the er-

ror of their ways, or perhaps they just don't care? We may never know the answer. We can rise above this as artists and tattoo professionals though, and strive to give our customers a positive and energizing experience.

As corny as it sounds, there is an intimate bond that a client forms with the tattoo artist. For some reason people in the hot seat will talk about their problems and lives with the tattoo artist. Maybe it has to do with being in such close proximity, maybe it has to do with the physical contact, or maybe it just has to do with the fact that the client is sitting there for hours with no one to talk to. It is important to help the client out by distracting him during his tattoo process. Conversation is a great distraction. Some clients are polar opposites of this though, and will even bring headphones to avoid all conversation in attempt to zone out. This may have something to do with the pain of the tattoo, or maybe they are just not as social as the next guy. As a tattoo artist it is important that you have the ability to read what type of person your client is, and to cater to them. If the client wants to talk, then you should listen. If the client wants to zone out, then leave her alone.

> *"...for some reason people in the hot seat will talk about their problems and lives with the tattoo artist..."*

Should a tattoo artist try to influence the customer's decision on a piece of art they have selected? This question has often caused a lot of debate in a few of the studios I have worked in. It has been pretty articulately argued both ways to me. I will attempt to lay out the arguments for you in this text.

Some artists believe it is their duty as an artist to inform their clients of a "bad" selection for a tattoo. Whether it is the design or the location, if it doesn't look good then the artist will refuse to do it. Some artists take this very seriously and will even argue

with the client.

Some artists will tattoo anything on a client, anywhere on the client. The customer is always right is the focus of these artists. Who am I to judge what this client wants? They obviously have thought about it for a long time and have settled with this specific design.

There is no right or wrong answer. Sometimes the client is just unaware of the actual ability that most tattoo artists have, or the fact that almost any image can be transposed to the skin with modern techniques. There is also no rule that says you have to be either type of artist. Sometimes it may be necessary to steer the client in the right direction and try to assist them in the design process. Other times it might be better left alone. If the client is dead set on a design then they will get it done that exact way; if not from you then from some other tattoo artist.

"...these are what we call the perfect client..."

Often times a client will come in with only an idea of what they want to get a tattoo of. They will use very vague descriptions, and allow the artist to have free reign. These are what we call the perfect client. They are fairly few and far between. The client you will more often than not encounter will be the client "B" style client. Client "B" always has it exactly in his mind what he wants; sometimes he will bring in a picture of what he wants. Client B's picture is never exactly how the tattoo is supposed to look, but the picture is always "something like this…only I want this changed". When Client B has a picture and requests the artist make modifications, but Client B makes specific requests: run for the hills. Client B says he wants the artist to use his imagination, and modify the drawing or image. Client B says he doesn't know exactly what he wants. This is anything but the truth. Client B has it in his mind what he wants, exactly what he wants. Client B is testing the tattoo artist's patience, and will have him redraw the sketch 100 times. Be very careful with your Client

B's, you might end up spending more time at the drawing board than you do at the tattoo stool.

It has always been my positive experience to collect a 50% deposit from clients who want large custom work done. This technique works for appointment only studios. This will allow the artist time to sit down and really put a lot of effort into a large custom piece. A solid drawing is the foundation for a solid tattoo. Most clients that walk in and have some idea of what they want are not the instant gratification clients who just want some flash off the wall. These clients are typically willing to pay 50% non-refundable drawing fee, and wait for the drawing to be done before being tattooed. These clients have thought long and hard about what they want, they have talked with their friends, and possibly even done some drawing themselves to try to convey to the artist what they want. This is where tattoo gets really fun. When it is collaboration between the artist and the client, ideas can bounce back and forth usually during a 10 – 20 minute consultation. During this time the client will provide the artist with sample images and sketches, the artist will measure the client's area and make a tracing of the body part, and then the artist will collect a deposit and set up an appointment. This will reduce stress for the client and the artist (who might be under a lot of pressure re-drawing a sketch right before the tattoo takes place).

There **are infinite ways to handle client's needs**.
Some artists will not do drawings and multiple consultations with their clients. Some will draw directly on the skin with a sharpie and rock and roll. You have to gauge your personal strengths and weaknesses as an artist to figure out what you can get away with. The key thing is to always let the client know that you are working for them, and that you want to make them happy. There really is no right or wrong way to run a tattoo studio, and for the most part as a beginner you will not be doing the major decision making in the studio. You can help influence the overall atmosphere in the studio by being outgoing and really easy to

talk to in the studio.

Here are a few simple rules that will assist you in winning your customers:

1. Always greet a customer when he walks in the studio. Introduce yourself, shake his hand and as cheesy as it sounds don't forget to smile. It is really amazing how a positive attitude encountered by a nervous or first time customer will really win them over and put them at ease.

2. Don't pressure the customer. Show them your flash; if you have flash in your studio, if you don't have flash then explain the shop's procedure for developing custom artwork.

3. Be transparent as far as sanitation. Explain to them the shop's policy on sterilization, and offer to show them a work area or even your autoclave and record logs.

4. Give them space. Let the client know you are there if he needs you, but don't hover over his shoulder while he is browsing the flash or looking at the portfolios. As much as it is a sales business, tattoo is not like a car. Sure, you have to pay the bills by getting customers, but tattoo is something that is on the client's skin forever. Usually the client is just browsing or he is serious about getting a tattoo. There usually isn't much room for middle ground.

Tattoo is a service industry, and you have to treat your clients like they are gold; especially when they are just browsing the flash, because each prospective client is actually three perspective clients. Unless you turn them off with your shop etiquette, in which case each turned off client becomes ten turned off clients.

11.2 Money

Money is an important issue when it comes to tattooing. It has always been my experience that the most fun tattoos that I have done have been those for friends, for free. This is because there is zero pressure in the time and work aspect of these jobs. Not many tattoo artists start out in a position where they have clients lined up to see them because of their reputation. This means that while in the tattoo studio the artist is making a living. It is important to always treat every tattoo like it is your most important, that goes without saying. However, when you are in the studio you typically have time constraints and other variables involved. You also typically will have to give a client the price of the tattoo up-front. This means that you have already set your own hourly wage.

Tattoo, like every other business exploits profit from the revenue minus the overhead. The overhead does include your time. In fact, the most expensive part of the tattoo is the artist's time. The fact that a tattoo is not the most pleasant feeling in the world is also another factor why speed is important, along with decreasing overhead. Less time spent on a tattoo means more time to do other tattoos, which equal more profit.

It is a balancing act that must be kept in the back of your mind at all times. As a new tattoo artist you will not immediately have a feel for what a tattoo costs. When I first started tattooing I would often under-quote a lot of my work. I would end up spending a lot more time than anticipated on some tattoos. In the beginning it is okay to be ambitious, but you should try to learn your limitations and your ability. You have to factor in the probability that something might happen, or the client needs to take extra breaks, etcetera. Quality should always be your first concern, then profit. For these reasons it is important that when you start tattooing in a studio, you listen to the individual you are appren-

ticing under. Do not be discouraged or feel like you are being asked to complete tattoos that are below your skill level. Learning to tattoo is not just about learning to tattoo well. It is also about learning the ways the tattoo shop works, and learning how long all the processes take. Sometimes you will be amazed on how much time it takes to properly setup and tear down your gear. You will also be surprised on how long it takes to do simple things like consult or modify a drawing. You do not want to be one of those artists who is always booked in what seems to be a never ending overlap of clients. Your clients will remember that they had to wait an extra hour for their appointment, because your last 3 appoints each ran over allotted time.

You will also have to learn about cuts. You will more often than not be in a situation where you will have to pay a certain cut or percentage of your profit to the tattoo studio. This is normal, but should be written and signed in a contractual form. Some studios will rent out seats. This means that you are essentially paying a monthly rent to the studio to use their area and some supplies. In a busy shop, if you are a pretty good artist and proficient with your time management, this may be a good arrangement. Beware that if you are renting a seat, and business is not so good that week, you will still be required to pay your rent. Just like the rent where you live. This arrangement requires the artist to budget his money, not just weekly when rent is due, but biweekly or monthly. It is possible to have one great week, and then two or three not-so-great weeks. Keep a spreadsheet or log of all your work, break down your hours and profit for the week. Keep your tips in a separate column. You can then start to see trends on which days are the best days of the week, and which weeks of the month are the best and worst as well. This will help you to budget your rent. This seems like common sense stuff, but you would be surprised at the number of people this concept escapes.

Tips are a great way to increase your money flow in the tattoo business. Often times the studio will set the price of the tattoo and the artist will complete the tattoo. The client will pay the

shop, and the shop will pay the artist. Usually tips are separate transaction and are paid directly to the artist by the client. Do not be afraid to tactfully explain the monetary situation of the studio to the client prior to doing the tattoo. This is really where customer care comes into play. Often times the client will tip not only based upon the quality of the tattoo they receive, but based on the quality of customer care they receive as well.

The important thing to remember is that you are at work, tattooing for a living. You have to make a profit, and the shop has to make a profit. There are a lot of pieces of advice you will get from a lot of people in the tattoo industry.

I remember when I was young and getting my first tattoo (at a real shop). I was broke, and I pointed out a small tribal on the flash wall. The artist did my tattoo and told me that I owed him $50. I only had $40 in my pocket, and I pointed out that the flash on the wall had a $40 sticker on it. The artist was furious (the tattoo didn't come out that great, but that's beside the point). Now that I am older, and have a little money, I can confidently go into a tattoo studio and show the artist what I want and ask him if he has time. I don't even mention money or ask how much it is going to cost. I gladly pay what the artist asks. The moral of the story is to know that you have different types of clients out there, looking for different things. I might charge one price to a customer who is a young kid working part time at a fast food place while he goes to school, and charge a different price to a middle aged business professional. Even though it takes the same amount of time, and the quality of work is the same. Tattoo is an art, and it is categorized as a luxury item. People (most people anyway) don't need tattoos to survive.

> *"...know that you have different types of clients out there, looking for different things..."*

I once saw a television show where people were taken to a very

upscale restaurant and given a six course meal. The waiter was professional and explained every detail of every succulent item to the customers as they received each exquisite looking dish. Then the waiter paused until the customer took a bite to receive feedback. This experiment was done with six different customers. Each customer had identical reactions; some even said it had to be the best meal they had ever had in their life. Behind the scenes they showed the preparation of the meal, which consisted of one of the television crew members preparing food items from a local dollar store and mini mart. This little antic dote is proof positive that the value of the experience is just as important as the value of the product, if not more so.

Now back to the discussion of overhead, because overhead affects your bottom line in tattooing. If you are in the position where you purchase your expendable items for tattooing (needles, barrier protection, disposable tubes, inks), then your bottom line is affected by these minor purchases. The cost of these items may seem like a lot to a new tattoo artist, but when you do the math they are very minimal. It is always important to use high quality items and not to skimp on the barrier protection. Often times a studio will provide the expendable items (minus inks). If this is the case, and your studio does not offer enough barrier protection items or high enough grade items, it might behoove you to go out and purchase these extras for your own use. These things will also make a big impact on your clients and make their tattoo experience with you seem a lot more professional than the guy down the street. These are just suggestions, but can be very important and hard learned lessons. These are things that are often overlooked or taken for granted during an apprenticeship or perhaps the location that you are apprenticing in does not have such a strong focus on such things. It is always important to take all things as a lesson, good and bad.

11.3 State Laws

This text is not a legal book, and any laws referenced here have the possibility of being inaccurate. Anything found in this portion of the text relating to any type of state law should be researched by the tattoo artist prior to engaging in any activities pertaining to the context of this text. This section of this text book is not to be used in lieu of any legal advice from a trained legal professional with extensive knowledge of a particular state. In other words, don't use this section as your sole means of reasoning for any tattoo practices; use this text as a jumping off point and somewhat of a reference to help you figure out what may or may not be acceptable in your state.

The lack of federal control over tattoo has left it up to local legislation to mandate what can and cannot be carried out by a tattoo artist. This means that the state or lower officials can and do dictate what type of tattoo laws are on the books in your area. Some states are almost a free for all, while others provide for a tight noose of bureaucratic hoops for a tattoo artist to jump through. Some states will require an artist to be licensed by the state or county. There are regulations about tattooing in non-permanent structures and special conventions or events. A few states have outlawed tattooing all together, citing primarily the health risks concerned.

The importance of referencing tattoo laws in this text is not just to show what you are able to do in your neck of the woods. It is to open a new tattoo artist's eyes to the actual complexity of the government. If you have lived in one state your whole life, and tattoo has been a common thing it may surprise you to learn that it is outlawed in other parts of America. Tattoo is not on top of the lawmakers' agenda typically. Even tattoo artists will usually agree that there are more important things in the community that need to be addressed. That is why in many parts of the country tattoo has gone unchallenged for so long. This is self policing, and it requires local artists who practice professional tattooing to ensure that they are keeping the moral obligations, that hold in their communities true. There may be some minor type of oversight by the state government, but for the most part even in the

heavily controlled areas of the country, tattoo is pretty much a sleeping dog mentality.

Could the sleeping dog be better off left alone? Is it possible, that in efforts to provide a solid foundation of transparency, tattoo artists might just shoot themselves in the foot? Can tattoo studios be trusted to self police in a fashion that is acceptable to public health standards? What is the give and take involved in letting states regulate tattooing? Is the state biting off more than it can chew, and tax payers are willing to pay for? Is the risk to the community actually that great? Will tattoo legislation in your state become a bureaucratic mess, full of taxation and excessive nuisance by a new government agency; an agency that was created with the sole purpose of monitoring the quality of the sterilization standards that are supposed to be self imposed in the first place? These and many other questions about tattoo have been asked, and should continue to be asked. The answers will come in time.

Tattoo is rapidly changing. It is changing as an industry and as a way of life for the customers as well as the businessmen. Tattoo will always be an art and a skill. More than ever tattoo is gearing itself more toward artists. There are techniques and tools available to artists today that allow them to create virtually anything in skin that they would in other mediums. It is important for lawmakers and concerned citizens to approach tattoo as an artform, but it is also important for it to be approached as a health issue to the community.

As a new artist it is important for you to assist your community in actively engaging the legislature. The law makers need to know that we exist, and we are actually citizens in the community who care about the community. This means that tattoo shops have to try to get a positive handle on their image as a whole. You will always have that bad apple in the bunch, but it is ultimately up to the artists and studio owners to ensure that the harmonious balance is maintained to ensure the longevity of tattoo as a culture. Remember that tattoo is a freedom, and it is not even a

freedom that is enjoyed in every state.

11.4 Customer Comforts

Comfort is not the same thing as care. While customer care deals more with the aspect of how to treat your clients while they are a customer or prospective customer, comfort will deal with the aspect of how the client is treated while in the hot seat. Tattoo can be a long and sometimes painful process. It is up to the individual artist to take in account the comforts of the client. The ultimate goal is to ensure that the tattoo looks good when it heals. This requires the customer to sit still, and to get the whole piece finished. No artist likes to let an unfinished piece walk out his door. This does not apply to multiple session tattoos for obvious reasons. There are so many things that you as an artist can try to incorporate into the tattoo process that your clients will greatly appreciate.

Pain tolerance is a very debatable issue in the tattoo community. Individual clients have individual needs and pain tolerance levels. It is always best to ask the client if they have a tattoo already prior to taking on a big piece. It is also important to talk to the client about the nerve locations in the skin. Different parts of the body have larger clusters of nerve endings. These areas are more prone to pain than other areas. A good measure to use, that may sound corny, is to use what I refer to as the tickle test. If an area on the skin is very ticklish, then it is probably very painful to be tattooed. This is not always true for every client and every body part, but it is a quick test.

Some tattoo artists believe that a client must earn his tattoo. This means that the client should endure the pain at all costs and take breaks when the artist is prepared. There is nothing wrong with this school of thought, like everything else in tattoo it is a matter of artist preference. On the other side of the spec-

trum there are artists who feel that the client's needs should always come first. The first school of thought will point to the fact that the client knew what they were getting into when they agreed upon a design and a location for their tattoo. This is again perfectly fine, if it is the style of the artist.

Pain can be combated in many ways. While I was apprenticing in Europe we often had clients come in with Emla™. Emla™ is a topical numbing cream that in America requires a prescription, but not in most European countries or Canada (to the best of my knowledge). The first time I had a tattoo with Emla™ applied I was amazed. I did not even know that my boss (who was tattooing me at the time) was even touching me with the needle. About fifteen minutes into the tattoo a prospective customer came in (as we were tattooing after hours and the shop was closed, but the door was not locked). My boss stopped tattooing me and met with this customer for about twenty minutes. When he began to tattoo me again, the sensation was quite different. It was still far from painful, but it was different. By the time the tattooist was about an hour into the process the Emla™ wore off and I was feeling not only the new needle hits, but the areas where he had initially tattooed. This was a very unwelcome feeling and I felt that it increased the pain. I was very impressed with the product and I would use it for all small and quick tattoos I would do. Every time I tried to use it on large pieces it would always end up hurting the client more. I eventually learned that I would not offer up the Emla™ to any client unless it was a certain circumstance that required it.

There are many other legally obtainable topical creams and gels available today and used mostly by cosmetic tattoo artists. The primary ingredient is Lidocain in most. There are some that only work once the skin has been broken, and some that work before the skin is broken. Usually you have to apply the cream 30-60 minutes prior to the tattoo and cover it with some type of plastic and tape it off. Once the initial topical cream wears off, then the additional creams and or gels can theoretically be applied to the broken skin. I have not tried to experiment with these numbing

agents, but it is important to know of their existence. Anything that can help an anxious client who has a very large piece or a very long sitting cope with the pain is always helpful in my opinion. This again is always a matter of personal preference, and there is no right or wrong process.

There are many stories circulating of certain numbing agents causing side effects like poor healing or faded color. I have not seen these things personally, and if you wish to experiment then let the client know that you are experimenting. I do not recommend getting in the habit of using these methods every time a tattoo is conducted. It is also important for tattoo artists to be tattooed themselves every so often. This is just a friendly reminder of what a tattoo feels like in my opinion.

Tattoos are obviously going to feel like, well... a tattoo. This is usually understood by clients, and they have gotten up the nerve to get the tattoo they want. It is important to cater to the pain involved, but it is also your responsibility as an artist to get the job done. This can be a fine line of forcefulness and compassion. Yet another required skill, especially when dealing with certain individual clientele. It is up to the individual artist to assess his client and try to make the tattoo experience as positive as possible. Sometimes this involves talking to the client, and sometime this involves leaving him alone with his headphones.

Aside from pain management another important avenue to experiment with is the ambiance of the work area. This can be achieved by the type of music you play, the images on the walls, and the seclusion of the work area. These are all individual preferences, but can often times not be modified (do to the studio's setup). If the studio has separate work areas you can try to control a little more of the atmosphere, but sometimes an open work area allows for the artists and the clients to converse. It is not possible to make recommendations as to music, because that will lie in the tastes of the clients. It can be helpful to not play very particular music that certain clientele will not enjoy though. This again is where the harmonious balancing act that is played

comes into effect.

One thing that the artist does have a lot of control over is the body positioning. The body should be in a comfortable position not only for the client but for the artist. Stretching the skin is VERY IMPORTANT. When the skin is appropriately stretched the ink will go in easier, and the tattoo process will be quicker and less painful. This will take a lot of practice, but soon it will be second nature to a new tattoo artist.

A very helpful piece of equipment that I strongly recommend that every tattoo artist invest in is the arm rest. There are a whole host of styles available today. Some are plusher and have a lot of padding, while others are simply made of plate metal. It is important to find an armrest with a lot of adjustable features. You will never know how much you will use one of these pieces of equipment until you have one. They can increase the sturdiness of the client's body part or even be used by the artist to rest his arm on. Experiment with these items, and pay attention to the base of the armrests prior to purchasing. The smaller the footprint of the armrest the easier it will be to maneuver around it with the client's chair or the artist's stool.

Ultimately the tattoo is an uncomfortable process, and we typically don't equate comfort of the client with the tattoo process. This should be exact opposite. The more comfortable the experience is, the longer the client will be able to endure the tattoo session and ultimately effect the end result. The body position will also increase speed and comfort. The end result is to obviously have an excellent piece of artwork, but the end result should be to make the client content with the overall experience of the session. This will win over your clients and guarantee repeat customers as well as recommendations by word of mouth.

Chapter 12

12.1 Closing Remarks

It is important to remember the time you were searching for answers and turned to this text; always share your knowledge with other less technically experienced artists. This text was designed with a few objectives in mind, and I hope that my objectives for writing it lined up with your objectives for reading it.

This text is not going to give you all the answers you are looking for, no text will. That is why an apprenticeship is so important. There are things you have to experience in a real working studio that you will never get to by tattooing your buddies out of the house. Not to mention you will never purchase real tattoo equipment because most distributors that are worth a damn, will verify that you work in a studio. Never stop asking questions, and never think you know all the answers when it comes to tattooing.

It is always difficult when you are discussing anything tattoo related. There are so many styles of tattoo, so many techniques, and so many opinions on proper procedure. I found that while writing this text I was really tested. Not so much tested as in "do I know what I am talking about," but tested in the sense of knowing how judgmental tattoo artists are as a group. I was pretty worried about writing this stuff down and hammering it all out in plain English when I started, and now that I am finished the realization has fully born its fruit. I really do not intend for the tone of this text to be overbearing and matter-of-fact. It is exactly opposite, and I truly hope it reads that way as I intended. If it does not have that feel to it as you read, then perhaps this is my sole chance to slant your opinions - in this section:

I am a strong believer that in the world of tattoo, "it" has been a long time coming for the new generation of artists. I think that the time truly is upon us in this decade that the evolution has begun. This is not just empty rhetoric, but a true sentiment that I hold close to me. I love tattooing, and every time I hold a tattoo machine I have the feeling that it is Christmas, and I am 8 years

old again with a new toy. It is an excitement that you have knowing there is this blank canvas sitting in front of you. You have the ability to pick any color and generate something unique. It is because I have this love for tattooing as an art form (I hope you have similar feelings of your own about tattoo) that I can honestly say that "it" has arrived.

As horribly cliché as the tattoo related TV shows have been (and if you are anything like me you cringe at them), they have really acted as a catalyst for change (if not increased acceptance) in the industry. The broader acceptance as well as the evolution of the tattoo supply chain and sanitation aspect, creates for a perfect storm in my opinion. There will be those of you who completely disagree, and think that tattoo was doing just fine. You may be in the boat that says, "Tattoo is becoming a pop-trend". You might even say that texts that teach someone how to use tattoo equipment are bad for the industry. Like I have said countless times in this book, everything related to tattoo is an opinion; there is never a right or wrong answer. The same theory goes for industry goals and fundamentals.

I have heard the argument about safety and diseases and infection raised quite often. You really can do a direct comparison to a lot of things though.

For example: automobiles. When you go to an auto-parts store (one of those do it yourself joints), and pick up a manual on how to change a part on your car. Isn't it actually more dangerous than a text like this? I mean think about it (place your thumb and index finger on your chin, tilt your head to the side and look upward to the sky). Most people who are changing parts on their car and need a manual probably don't know what they are doing, and probably want to learn. They will more than likely do the repair with or without the manual as well. The worst part, when you compare this to tattooing is that most of them (those who fix their own cars) don't want to be professional mechanics at all. Here is where I get to exaggerate my point (so bare with me). Worst case, someone changes a part on their car incorrectly

and while they are driving later that day; the part falls off, the car crashes, and they kill a few people.

I also like to compare this text and tattooing to teenagers and sex. You can tell them not to do it, and you can tell them to wait. You tell them about prophylactics, and hope they use them. The reality is that if the kids want to have sex, they are going to have sex. At a minimum with this text, the kid who got his "kit" (and you know this is YOU if you are sitting there right now with your new KIT spread all out on the floor of your dirty apartment) just might use **disposable** tubes and needles. The kid is going to do tattoos anyway. He will tattoo his friends, himself, that fake skin, and his dog. We have to step back and figure out as an industry how we can fix the big problem.

If you wanted to go and cut hair at a salon you have to train with books (yes, real books), and record "x" amount of hours in the classroom. Then take an exam, for a GRADE! However, you can still go to the Big Box store and nab some clippers off the shelf for $10.00 and shave all your buddies' heads. I am not sure if it is actually illegal the way tattooing all your buddies at home is in most states. I am the first major opponent to letting the government get involved with the tattoo industry, but seriously... $10.00 clippers technically require a license!

The point I am trying to make is this: We all started out trying to learn. We all tattooed our friends and ourselves, some of us with some very not-so-safe (and possibly toxic) techniques. We all agree that an apprenticeship is the only way to go, especially if you want to be a half way decent artist. The government obviously has its hand in a lot of things, and we don't want it to be involved in tattooing. If a kid feels the hunger to tattoo, and you

"...something that tends to scare me more than the kid scratching his friends at home, are the shops that just don't care..."

know what that hunger is, he will tattoo. He wants to learn!

There are real risks for certain diseases and infection out there. Something that tends to scare me more than the kid scratching his friends at home, are the shops that just don't care. These are legitimate studios in your cities and towns that are simply what we would refer to as "dirty".

I said earlier that the tattoo industry has "arrived". In order for the true potential for the industry to be realized there has to be some type of standard. While getting a tattoo is not the same thing as getting a blood transfusion or brain transplant, there are still some minor risks that have to be mitigated. The actual risk is not quantifiable at present in my opinion, largely because there has not been enough effort to conduct studies on the scale that should be. The bottom line is that people trust the tattoo artist. They trust you to do the right thing. No one will ever know what you did before they sat in your chair. Just as important as quality work, is quality sanitation and sterilization practices. Just because someone has completed an apprenticeship does not mean that they will pick up these quality practices (any of them). Simply saying "get an apprenticeship" is just not good enough.

So what is the answer? I will leave that to the larger tattoo community to debate. I do strongly feel that the community of tattoo artists is large enough, and the concept of tattooing is main-stream enough that there is a need for some type of formalization of the tattoo trade. Those who really oppose it, do so (in my opinion) out of fear for their profit margins.

If there were a legitimate place (not one of those 6 week long schools you see online) that some one could learn to tattoo, and become certified, there would be tattoo studios popping up all over the place. There would suddenly be real competition for quality artwork. Just because you know the secrets of getting the ink to stay in the skin, wouldn't guarantee you a job. There would be so many tattoo artists out there, that the price of tattoos would drop and selection of studios would increase.

The ones who are scared and really oppose this are the ones who don't really have artistic skill (again this whole section is just an opinion).

"...I really hope that one day there is a Graphic Arts Major available with a Minor in Modern Tattoo Technique, or even a Masters in Tattoo Design and Application..."

I was thinking about it recently, that degrees cost a lot of money and take a couple of years. The idea behind a 4 year degree is that you come out of the school knowing a trade. Not only do you come out knowing the trade, but you are expected to be an expert on the most modern skills in that trade and ready to jump right into the workforce at an entry level position. I was thinking to myself, wouldn't it be amazing if I could have spent my $50,000.00 on 4 years of tattoo school, learning from the best in the industry? Too bad this idea, if ever came to realization, would receive so much flak from those who want to keep this industry a secret for reasons that I cannot comprehend. Not to mention most people need student loans just to go to college these days, and what financial institution would back a tattoo school 4 year degree loan? I really hope that one day there is a Graphic Arts major available with a minor in Modern Tattoo Technique, or a Masters in Tattoo Design and Application. Perhaps when all the stars are aligned, and the insecure artists in the world get their heads out of their asses they will realize that this art form has out lived its current business model, and there are people creating works of art in skin that most couldn't even do in canvas.

In some cultures, it is important to point out, that the tattoo artist is a very revered member of the community. The position is

actually one of stature as well.

I once read in a very famous tattoo artist's book about what the future of tattoo innovation might hold for us. If you look at the forefront of a lot of technical and medical research it comes from the universities. Before tattoo can fully be realized it has to be fully accredited. The whole globalization and commercialization is totally against the whole tattoo lifestyle (anarchy and punk rock – all that jazz). I am in no way saying people will be showing up to work (to tattoo) at the studio with a business suit, have Aloha T-shirt Fridays, and 401k's. Maybe that is why there is such a stalemate. Maybe there is just no drive or ambition for the concept, and I am the only wacko in the world that has this view. Who knows..?

Do we really want tattoo shops dotting strip malls across the nation like discount hair salons?

Would the increased competition actually increase quality of work and end up benefiting the consumer in the end like all other industries?

Are tattoo secrets really secrets at all, or are they just things you haven't figured out yet?

Are you guarding tattoo secrets because you are insecure of your own quality of work and ethical business practices that you think someone else might be a better business man (or worse, a better artist) than you - if only he had the technical knowledge?

The basic fundamentals of tattooing don't just require you to know how to put ink into skin. The basic fundamentals of tattoo encompass not only your tattoo skill, but your work ethic, and responsibility to your community as well. I encourage you to challenge the "old school of thought", but respect it. I encourage you to push the envelope in your art, but realize your current limitations. I encourage you to be open to criticism, and learn from the individual who is taking the time to teach you.

I appreciate you taking the time to review this text and I hope it was informative and inspirational to you. I hope you picked up on a few tools of the trade, so to speak. I really hope that you begin your tattoo career and journey with a collection of positive imagery as well.

Most of the preceding jabber in this chapter was not really directed at those who need to know the Basic Fundamentals of Modern Tattoo.

Or was it?

> *"...the basic fundamentals of tattoo encompass not only your tattoo skill, but your work ethic and responsibility to your community as well..."*

13.1 Bibliography / Sources

Periodicals

R.M. Brian & R.S. Cohen, "Hans Christian Ørsted and the Romantic Legacy in Science", *Boston Studies in the Philosophy of Science*, Vol. 241 (2007).

"Blood borne Pathogens Resource Package", *Division of Occupational Health & Safety, General Industry Order*, Section 5193, Title 8, California Code of Regulations, (March 1993).

Elizabeth Henderson MD, PhD & Louie Thomas MD, FRCPC, "Sterilization and Disinfection: Helpful Hints in Office Practice", *The Canadian Journal of CME*, (1993).

Vaughn S. Millner & Bernard H. Eichold II, "Body Piercing and Tattooing Perspectives", *Clinical Nursing Research*, November 2001.

Books

Margo Demello, *Bodies Of Inscription: A Cultural History of the Modern Tattoo Community*. Durham, NC: Duke University Press, 2000.

Samuel L. Stewart & Phil Andros, *Bad Boys and Tough Tattoos: A Social History of the Tattoo with Gangs, Sailors, and Street Corner Punks* 1950-1965. Bimghamton, NY: Harrington Park Press, 2001.

Clinton Sanders, *Customizing the Body: The Art and Culture of Tattooing*. Philidelphia: Temple University Press, 1989.

Steve Gilbert, *The Tattoo History Source Book*. New York: Juno Books, 2001.

Amy Krakow, *The Total Tattoo Book*, New York: Warner Books, 1994.

Laura Reybold, *Everything You Need to Know About the Dangers of Tattooing and Body Piercing*. New York: Rosen Publishing Group, 1997.

Beth Wilkinson, *Coping With the Dangers of Tattooing, Body Piercing, and Branding*. New York: Rosen Publishing Group, 1998

Internet Sources

Alliance of Professional Tattooists, "Frequently Asked Questions." www.safe-tattoos.com/faq.htm

American Association of Nurse Anesthetists, "Anesthesia Risks of Tattoo and Pierced Tongues More than Skin Deep," Aug 26, 2004. www.aana.com/press/2004/082604.asp

Charles Booth, "Now Everybody Gets Tattoos," Tennesean, December 31, 2002. www.tennessean.com/local/archives/02/12/27100689.shtml?Element_ID=27100689

Kristopher Kaiyala, "The Skin Game: Once 'Graffiti,' Now Body Art," MSNBC.com, Nov 2, 2004. www.msnbc.msn.com/id/6124648

"Regulation: Attacks from Within?" Body Modification E-zine, June 15, 2003. www.bmezine.com/news/pubring/20030615.html

Hoag Levins, "The Changing Cultural Status of Tattoo Art," 1998. www.tattooartist.com/history.html

Kelly Luker, "Needle Freaks," Metro, July 26-August 1, 2001. www.metroactive.com/papers/metro/07.26.01/cover/tattoo-0130.html

"The Risks of Do-It-Yourself Tattoos," February 25, 2004. www.msnbc.msn.com/id/4370500

Lauralee Ortiz, "Permanent Makeup: Tattoo Technique 'Looks Natural and Saves an Awful Lot of Time," Detroit Free Press, Feb 10 2004, www.facialart.net/FREE%20Press%20Feb04.htm

"The Iceman's Secrets" Time - The weekly Newsmagazine, Oct. 26, 1992 . http://www.saintjoe.edu/~ilicias/The_Iceman's_Secrets_(1992).html

Nick Baxter, "Community Forum," 2004 - 2009 Posts. http://www.nickbaxter.com

Unknown Author, "Charlie Wagner ", http://www.tattooarchive.com/history/wagner_charlie.htm

Unknown Author, "Tattoo History of Sam O'Reilly ", http://www.tattoo-archive.com/history/oreilly_samuel.htm

Other Resources & Recommended Books
(in No Particular Order)

Machine Gun Magazine – Eikon Device ™ / Bill Baker
(A MUST HAVE for any new tattoo artist – Bill Baker is a genius, and very articulate.)

Reinventing the Tattoo – Guy Aitchison / Hyperspace Studios
(While this book is more about the artistic layout and process of tattooing for beginners, it does not focus on actual technical aspect of Machine information as much as I believe Guy has to contribute to the industry. He does have a good forum for individuals who purchase this book – and he has the second edition due out in 2009, supposed to have some more detailed information along those lines. Either way, this is a must have book – good walk through of the tattoo process.)

Suits Made to Fit – NS Kolectiv – Arian Lee
(Good art reference book.)

Haunted – Dave Fox – Presto Publishing
(Good art reference book.)

Kustom Graphics: Hotrods, Burlesque, & Rock n Roll – Koreo
(Good art reference book.)

Art of Modern Rock: mini #2 – Dennis King
(Good art reference book.)

Mitch O' Connell Tattoos – Mitch O' Connell
(Good art reference book.)

The Japanese Tattoo – Sandi Fellman
(Interesting big color photo book, traditional Japanese tattoo body suits.)

Secrets of Tattooing – Erick Alayon
*(Decent tattoo book, good information for beginners, can never have too many tattoo instructional books, great to see other

people's process and opinion.)

Hanamichi – Hori Benny / Presto Publishing
(Good art reference book.)

USGOW – Self Titled
(Good art reference book.)

Scratch Art: A Collection of Scratchboard Art by Tattoo Artists – Guy Aitchison & Michele Wortman
(Good art reference book.)

Rides of Passage – Bruce Bart / Curse Mackey
(Good art reference book.)

What's Not TA Like – Joe Capobianco
(Good art reference book, master of pinup tattoo – this is a MUST HAVE book for sure.)

Joe Capobianco Sketchbook – Joe Capobianco
(Good art reference book, master of pinup tattoo – this is a MUST HAVE book for sure. This book is every tattoo artist's dream come true.)